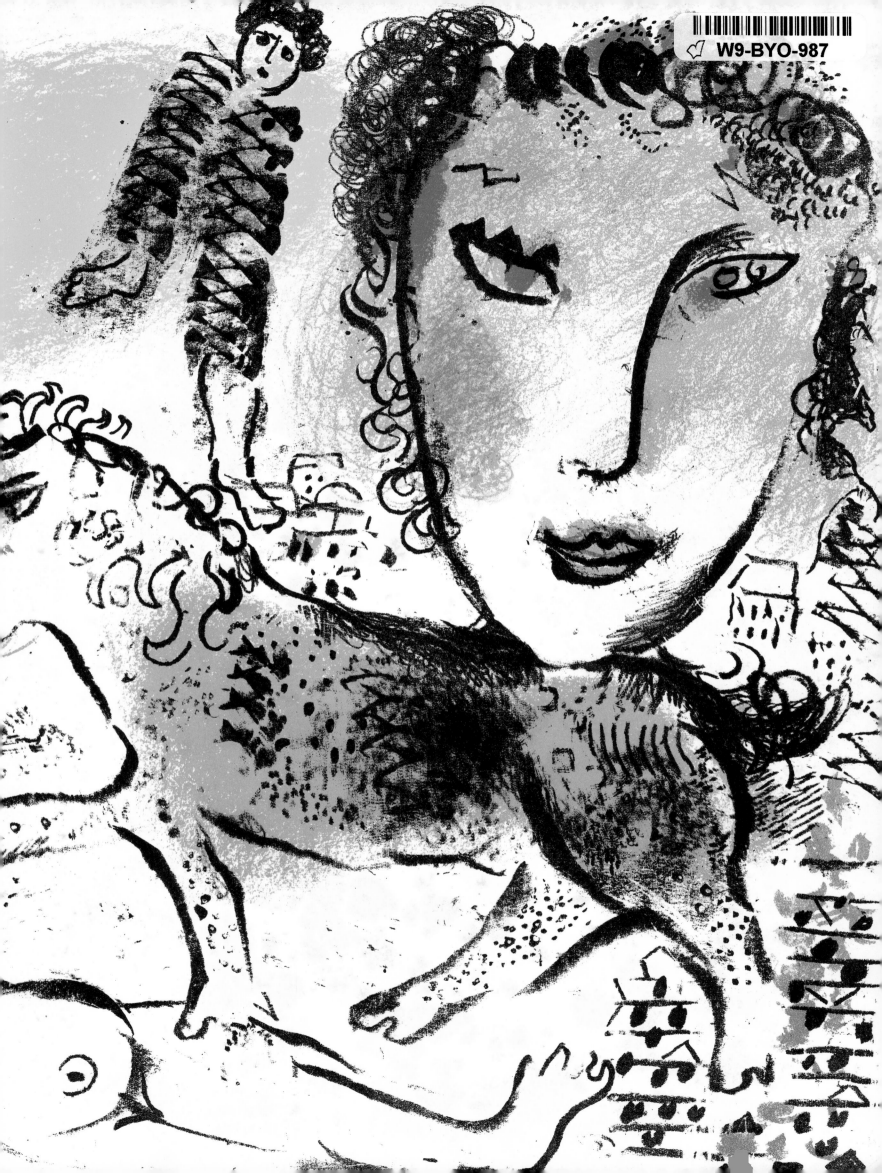

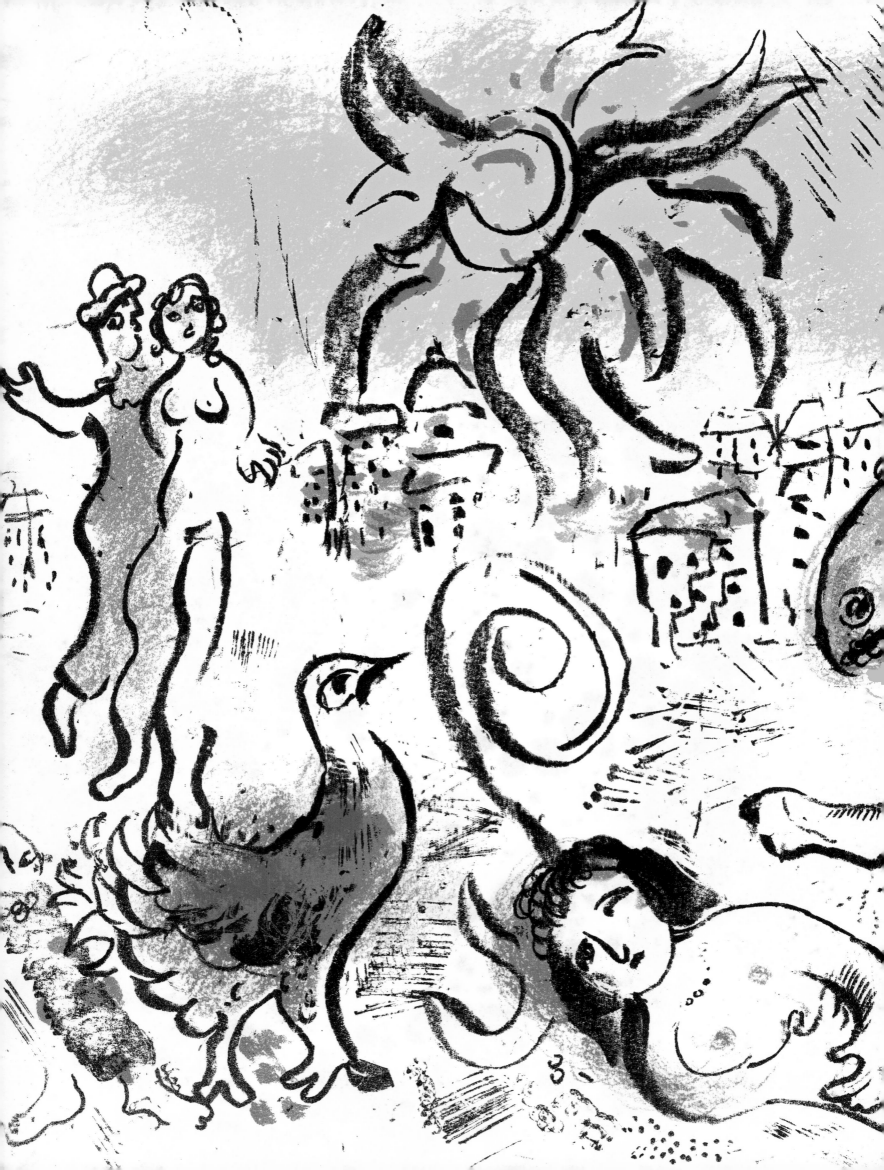

CHAGALL
MONUMENTAL WORKS

CHAGALL MONUMENTAL WORKS

Special issue of the XXᵉ siècle Review
Edited by G. di San Lazzaro

Original Lithograph by Marc Chagall

Layout by Christine Gintz
Translated by Wade Stevenson

© by XXᵉ siècle, Paris. Printed in Italy by Amilcare Pizzi, Milan.
ISBN 0-8148-0573-6

TUDOR PUBLISHING COMPANY - NEW YORK

(*Photo Daniel Frasnay*).

Chagall in front of "The Red Roofs" in Vence. *(Photo Daniel Frasnay).*

The use of the term "monumental" in connection with his work will frighten Chagall a little. However, one need only leaf through this special issue of XXᵉ siècle to see that we did not go out of our way to glorify this painter of large building spaces, this artist whose brush has come close to changing, one might say, the face of the world. Even the size of the Sistine Chapel, one of the greatest monuments of Italian art, doesn't amaze us if we compare it to the ceiling of the Paris Opera House, the murals of the Metropolitan Opera House in New York, or the huge tapestries and mosaics of our great painter. We have, of course, not neglected this grandiose aspect of Chagall's work, but, for us, a simple work illustrating the writings of Gogol or La Fontaine—or his more recent marvelous and virtually unknown Daphnis and Chloe—is just as monumental as the ceiling of the Paris Opera or the murals of the Metropolitan Opera.

In our context "monumental" means, above all, "eternal." And we hope that our great artist he who is all modesty and whose work has celebrated only the humble, donkeys and goats, draught-horses and not parade horses, will not be offended by our use of the term. There is nothing truly awesome about his prophets, and even his Moses looks like a poor relative of the superb law-maker sculpted by Michelangelo. Marc Chagall's work is the eternity of man, the tenderness of the kiss, a bursting shimmer of colors, and his Biblical Message is a message and song of love.

We must now ask how Chagall achieved this unquestionably monumental quality. In my opinion it was done very simply: through that synthesis of the arts which Gropius sought so intently; but the Bauhaus gave us few examples as probing as those which, on the other side of artistic creation, Chagall offers for our admiration. The genius of the artist does not reject the skill of the artisan: the painter, the sculptor, the designer for the theater and the ballet, the lithographer, the engraver, the ceramist, the author of so many marvelous stained-glass windows, and the creator of the astonishing models for the tapestries and mosaics are all one being, like that many-armed Hindu divinity.

To this unique individual we owe a body of work that is as unique as he is. It is with profound gratitude that we offer this new homage to him.

We would like to thank all those who, by giving us access to their precious archives, helped make this special issue possible, particularly Mrs. Vava Chagall, Charles Sorlier and Charles Marq, A.C. Mazo, Maurice Mourlot, the Editions Sauret and Mrs. Ida Meyer-Chagall.

And to Marc Chagall, who kindly created a large and beautiful lithograph for this issue, I express my deepest gratitude.

SAN LAZZARO

The Large Paintings of Chagall
Monumental Paintings

by Gilbert Lascault

It is important to remember that several of Marc Chagall's canvases are enormous, monumental works: *Homage to Apollinaire* (1911-1912), $82^1/_4$"×78"; *Golgotha* (1912), $68^1/_2$"×$75^1/_2$"; *The Cattle Dealer* (1912), 38"×80"; *To My Wife* (1933-1934), 52"×$77^1/_2$"; *The Red Roofs* (1953-1954), $90^1/_2$"×$83^7/_8$"; etc. Today, at a time when, as a popular song puts it, "everything is mini in our lives," the right of an artist to paint large-scale canvases must be defended. We should acknowledge that large pictures create their own particular aesthetic effects, which the critical eye accustomed to viewing small reproductions tends to overlook. This is an unfortunate consequence of the extension of the imaginary museum which reduces everything to the same scale—that of the postcard and the book.

There is every reason not to consider modest, discreet works as necessarily minor. But it would be equally absurd to disregard the power of works that unfold in space. We must learn to appreciate again the action of the painter who is not content with simply trying to center a wall or a part of a wall differently, but who wants to substitute his canvas (sometimes from floor to ceiling) for the architecture. By the bold multiplicity of his figures he seeks to replace the habitually neutral environment (often grey) of museums and apartments. Large paintings refuse to make any compromise with the neutral appearance of walls, which they neither orient nor enliven but struggle against and seek to exclude. Avoiding its share in the grey banality, art no longer tolerates playing a lowly role; it wants everything, and at once. Upon walls that help man to protect his wealth and the platitudes of his daily life, it distributes its carnival of colors, hoping to explode this mediocrity by the space and dynamism embodied in it.

A small or medium-size canvas often only escapes from its decorative function by responding to a critical one. Its frame then redoubles and clarifies the limits constituted by the walls. Its strictly geometrical, rectangular form recalls the outside authorities who come to organize our lives and who, often unknown to us, rigidly structure what we believe is the space of our freedom.

There is a critical force in Chagall's large canvases. They do not aim at producing an illusion of reality nor attempt to make us believe in the illimitable nature of our measured, encircled

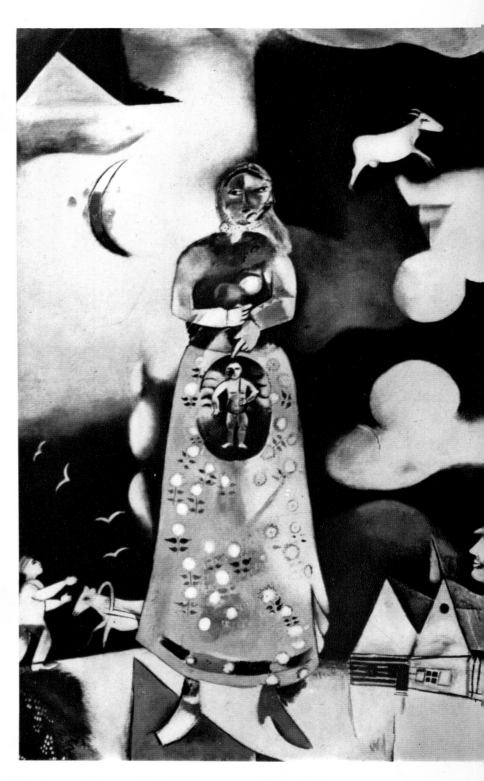

The Pregnant Woman. 1912/13. Oil on canvas. $76^3/_8$"×$45^1/_4$". Stedelijk Museum, Amsterdam.

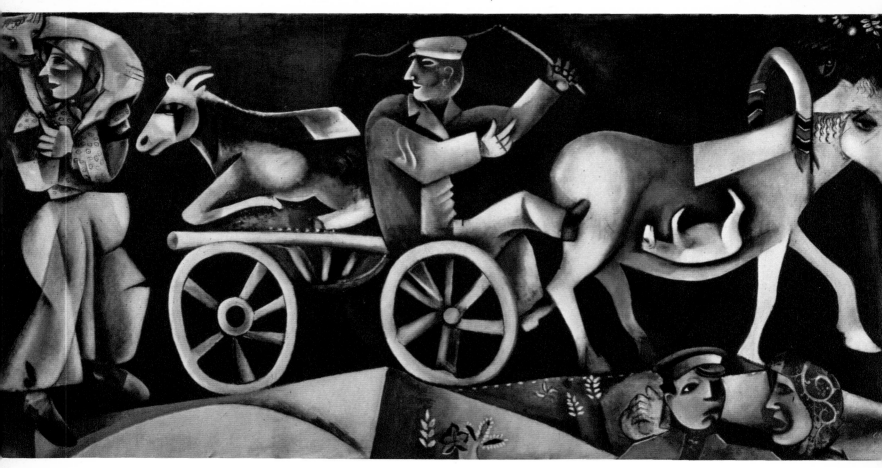

The Cattle Dealer. 1912. Oil on canvas. 38"×80". Kuntsmuseum, Basel.

spaces hedged in by political and economic powers. They do not pierce the walls in an illusory way but initiate, on the level of feeling, a dialectical struggle between the recognition of limits and the desire for the unlimited, between gravity endured and gravity conquered. But their critical force, far from restricting them to a purely negative function, to a reticent analysis of how things are, has its origin in a wild affirmation, in a joy that sweeps everything along with it.

Victorious over time, the radiant hermaphrodite in *Homage to Apollinaire* floats on the strange face of a clock. The prosaic details, the oneiric plants and the transparency (making it possible to see the foal turned upside down in the belly of the mare) make *The Cattle Dealer* an instrument of disorientation. In the *Double Portrait with Wineglass* (1917), a man is perched on the shoulders of his beloved, but he is weightless, his love and intoxication cause him to float and the couple becomes a bridge, a sort of rainbow between earth and sky: the erotic as a means of marrying the terrestrial and the divine. The acrobat in the *Blue Circus* (1950-1952) scarcely makes any use of his trapeze but swims in the air accompanied by a fish whose hand is extended by a bouquet. In the Chagallian universe there is no dependence on nor possession of anything; free of any support, things float, travel and exert force; flowers become

extensions of hands (as in *The Dance*, 1950-1952); the moon may fraternize with a violin and there is no stability. On the wall (which a large canvas makes transparent and opens onto something other than everyday banality), *The Pregnant Woman* (1912-1913), who is enormous, points to her belly, which is also transparent, while a goat leaps from cloud to cloud and the roof of a house becomes the shoulder for a head that extends it.

Neither purely negative criticism of constraints nor total obliviousness to limits, the large paintings of Chagall introduce the spectator inside a circus universe, an obvious theatrical set. The sheer size of the canvases, the phenomena of transparency, the disturbance of physical laws, the abolition of gravity and the geometry that makes love with a cow or the moon, all contribute to create the madness of the theater, or the theater of madness. In the *Prose of the Transsiberian* Cendrars exclaims: "Like my friend, Chagall, I could make a series of crazy pictures." There is no reason then to be surprised at the fascination the theater exerted on Chagall after the Revolution; in this issue of *XXᵉ siècle*, Alain Jouffroy's analyses of the painter's theatrical work are pertinent. For Chagall, the truth of the theater lies in its unreality. The set is a picture that envelops the characters in order to free them. In a sketch for the set for Gogol's *The Revizor* (1920) everything floats: a ladder,

4

To my Fiancée. 1911.
Oil on canvas.
84"×52" with frame;
77¹/₈"×45¹/₈" without frame.
Museum of Fine Arts, Bern.
(Photo Gerhard Howald).

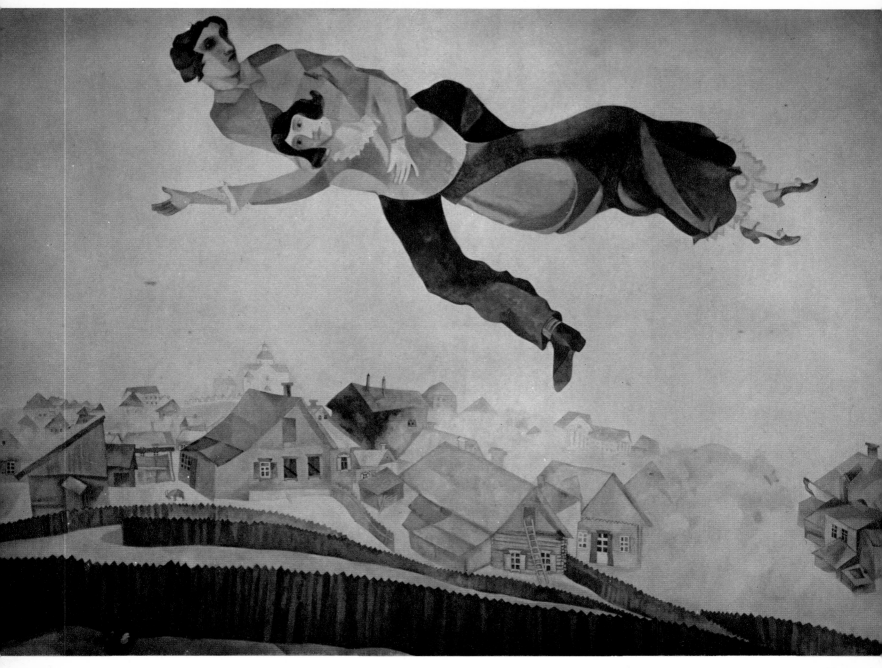

Lovers Over the Town. 1917. Oil on canvas. 61¹/₂″×83⁵/₈″. State Tretiakov Gallery, Moscow.

geometrical forms, an enormous carriage pulled by a locomotive-ant.... A new world is produced in which the impossible becomes the rule, where dream and reality, joy and sadness celebrate a marriage festival, as in Sholem Aleichem's stories and plays (for which Chagall designed many sets).

But now we must insist again on the scale of the works and show why the monumentality of certain pictures is lost on us (a fortunate loss). From this point of view, Chagall's large paintings constitute the exact antithesis of the famous lace collar in the portrait by Clouet—that collar painted in *trompe-l'œil* and smaller than life-size which Claude Levi-Strauss refers to in *La pensée sauvage* (p. 33). In relation to it, Levi-Strauss analyzes the strange charm of small-scale models; the reduction of size leads man to believe, correctly or not, that he dominates the object in its entirety more easily; he thinks he has a more direct, immediate knowledge of it:

When we seek to know the real object in its entirety, we always have a tendency to begin from its parts. We surmount the resistance we encounter in the object by dividing it. The reduction of scale reverses this situation: smaller, the totality of the object appears less frightening; because it has been quantitatively diminished, it seems qualitatively simplified to us. More precisely, this quantitative transposition increases and diversifies our power over a homologue of the thing; through it, the latter can be seized, weighed in the hand, apprehended in a single glance.

6

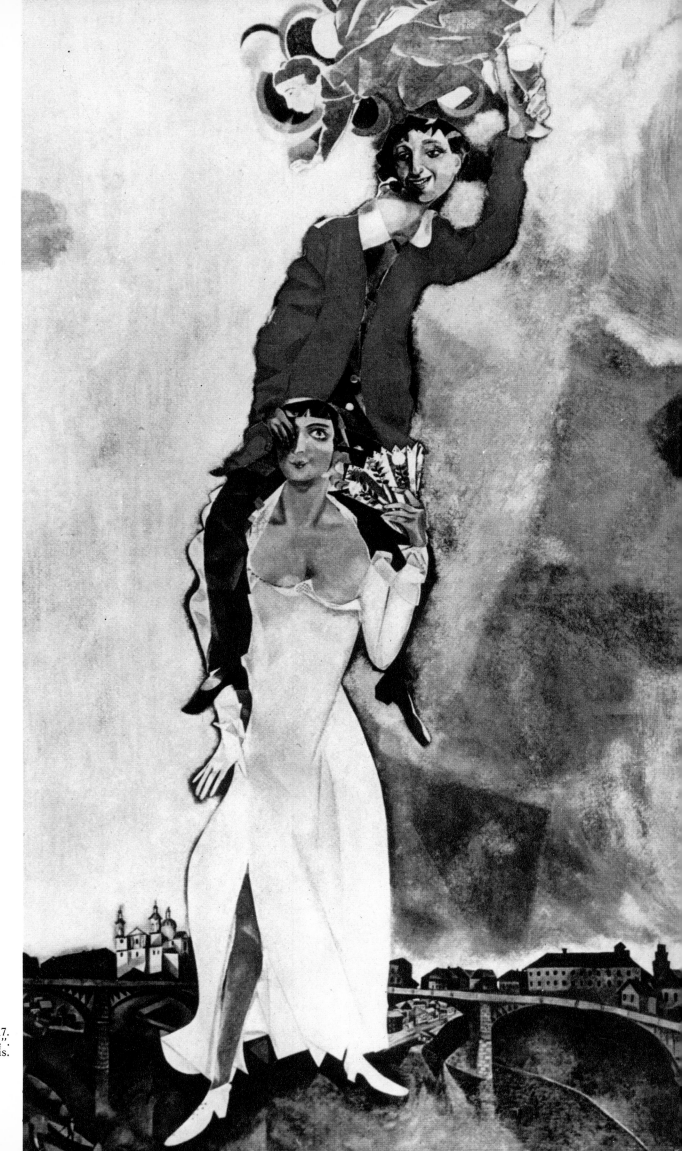

Double Portrait with Wineglass. 1917.
Oil on canvas. 92³/₄″×53¹/₂″.
National Museum of Modern Art, Paris.

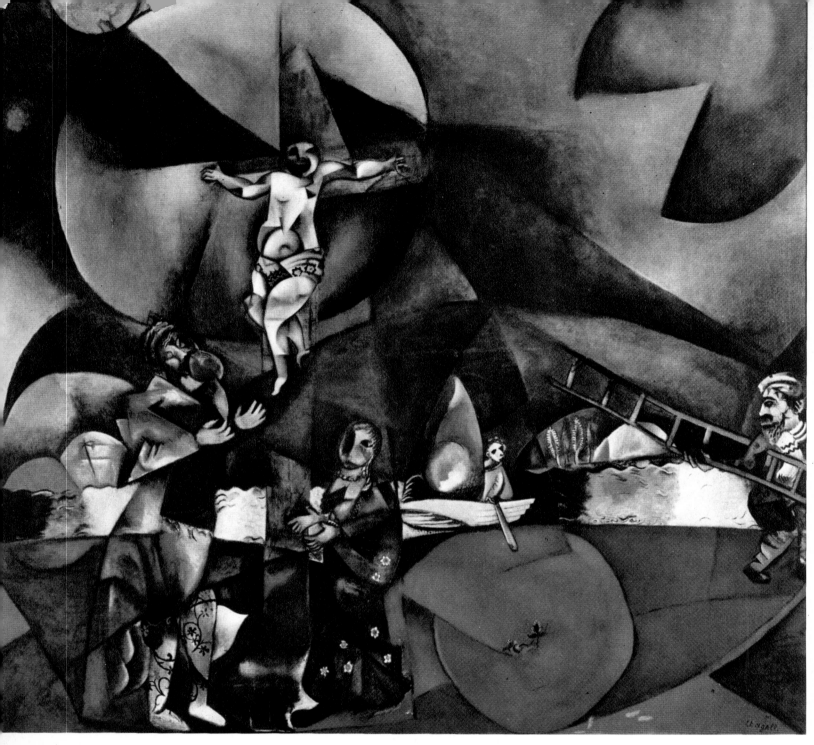

Golgotha. 1912. Oil on canvas. 68¹/₂"×75¹/₂". Museum of Modern Art, New York.

Chagall's works never allow us to take posses-
sion of them, master and know them in this way.
The larger the picture, the more our lack of power
becomes evident and the more the mystery of the
visible endures. Chagall's world cannot be divided,
put into compartments, broken down into com-
ponents; on the other hand, it cannot be dominated
as a coherent whole, weighed and measured. The
grandeur, the monumental quality of certain can-
vases is thus one of the means Chagall uses to
flout any attempt at structuring them and to lead
us astray, away from any path or ownership and
into the chaotic and joyous field of personal
freedom. The *Homage to Apollinaire* remains
(*partly* because of its enormous size) one of the
least comprehensible, and most fascinating and
secret pictures of the twentieth century. Even

Chagall's hand in front of "The Red Horse." ▷
Vence, 1962. *(Photo Daniel Frasnay).*

8

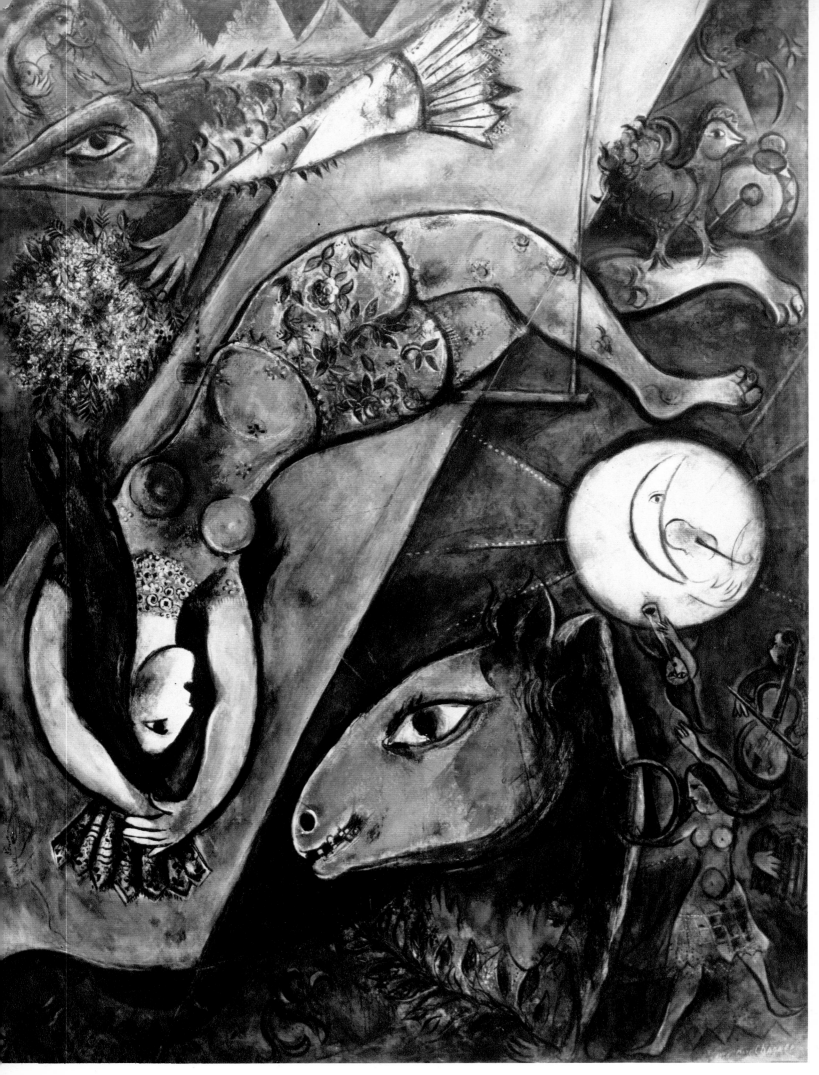

The Blue Circus. 1950. Oil on canvas. 91$\frac{1}{2}$"×68$\frac{7}{8}$". Property of the artist. *(Photo Peter Willi)*.

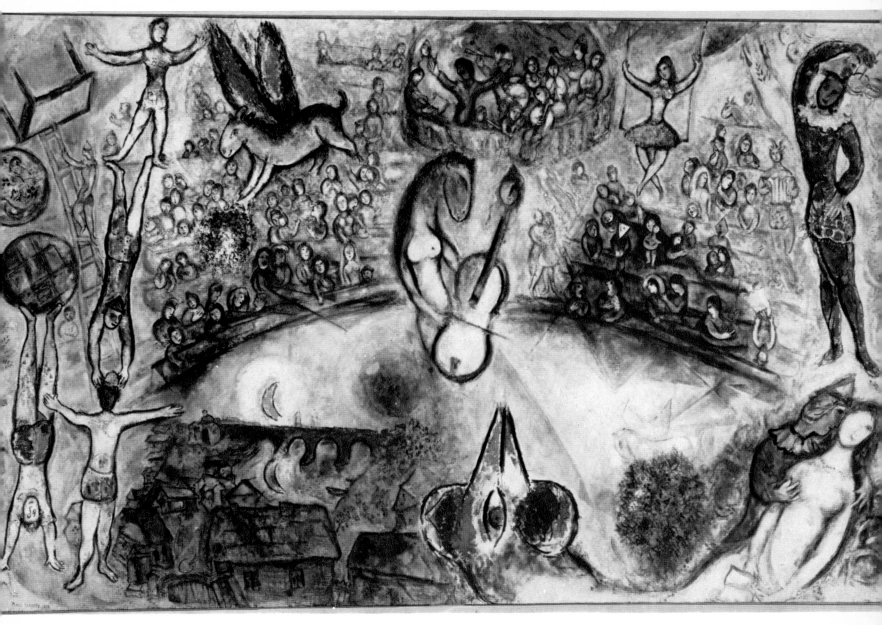

Commedia dell'Arte. 1959. Mural painting of the foyer of the Theater of Frankfurt. Oil on canvas. 99⁷/₈"×157¹/₂". *(Photo Seitz-Gray)*.

when he does smaller works, Chagall never uses the reduction of scale in order to imprison a world, know and control it.

For that matter, Chagall never has recourse to "objects" (to borrow another term from the *Pensée sauvage*). Chagall's painting is not abstract; it rejects every kind of "formalism," but it takes no interest in objects, desires no knowledge of nor power over things. A pictorial storyteller, Chagall likes the narrative form; he moves not among things but among stories.

The Hasidic tradition has often been pointed out as one of Chagall's formative influences. In Vitebsk, where Chagall was born, a Hasidic community had existed for a long time and, according to Franz Meyer, the painter's parents were Hasidim. Meyer also mentions that the disciples of Abraham Kalisker (a Hasid) made, in the course of certain preaching activities, "dangerous leaps

in the street and on the public squares" and lost themselves in "farces." They were, in a way, clowns and acrobats intoxicated by God, and Meyer relates them to the clowns and acrobats of Chagall.

Hasidism probably had more of a profound and less of an immediately observable influence on Chagall. It taught him to love stories, to see in narration not a simple means of distraction but a way of *waking* people up. The Hasidic tradition is made up of countless anecdotes, short stories and fables, which it prefers to reasoned arguments. As Rabbi Nahman of Bratislava states: "Most people believe that stories are made to put you to sleep; me, I tell them to wake people up." In this universe the narrations have a life that precedes their expression; they are much stronger than the person who tells them. As Rabbi Bounam puts it: "One day there was a story that wanted to be told."

The rabbis and the profane storytellers accept

11

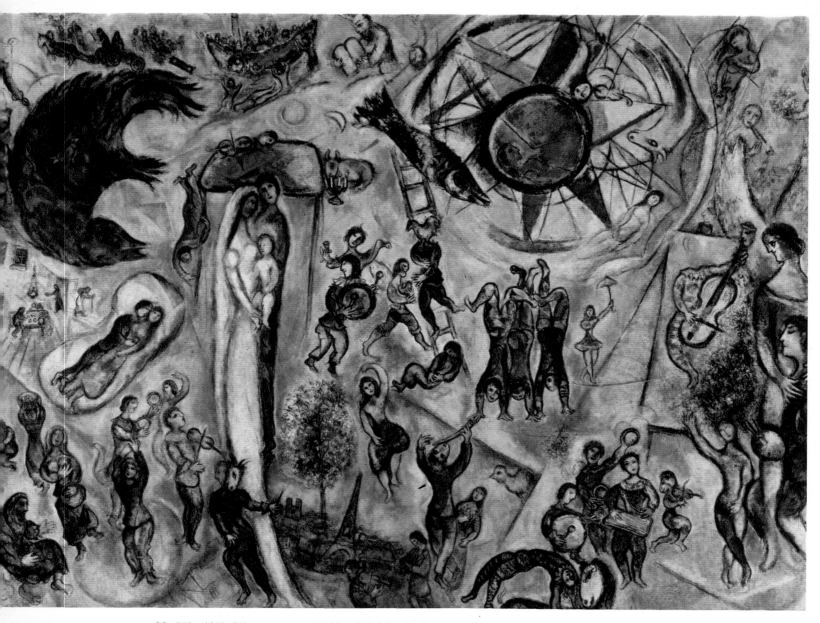

My Life. 1964. Oil on canvas. 116$\frac{1}{2}$"×160". Maeght Foundation, Saint-Paul-de-Vence. *(Photo Maeght Gallery).*

the disconnected, broken structure of these stories, the holes, gaps, sudden transitions and omitted explanations. One need only read *The Magic Tailor* by Sholem Aleichem to see how difficult it is to know what the story is talking about, whether it is joyous or sad, and to remain forever in the dark about how the thing reluctantly called a "goat" was bewitched.... Without doubt Rabbi Nahman of Bratislava developed the art of uncontrolled narration the furthest. In his stories Elie Wiesel (*Hasidic Celebration*) writes:

Each fragment contains the whole and threatens it.... The human condition, made up of questions, is translated by its very explosion.... If Rabbi Nahman tightens the episodic events and lets the narrative float, it is because he prefers the infinitely small to the infinite, a life with leaps and starts to a life without surprises.

Chagall has the same preferences. In particular, the changes in scale and the absence of supporting points on the large canvases disorient us; there is no concern for the habitual rules of composition: figures are massed together in certain areas of the picture, whereas other areas remain empty; we never receive a message, but the existence of an enigma is imposed upon us. Chagall multiplies the signs but provides us with no key. Why, in the *Homage to Apollinaire*, did the painter inscribe his name twice near the upper edge, once in the normal way and the second time without the vowels? Why did he write his first name nearby, half in Roman characters, half in Hebraic letters? How is this repetition of the name, this fragmentation of the first name, related to the bisexual being figured in the work and to the four names inscribed at the bottom of the picture?

12

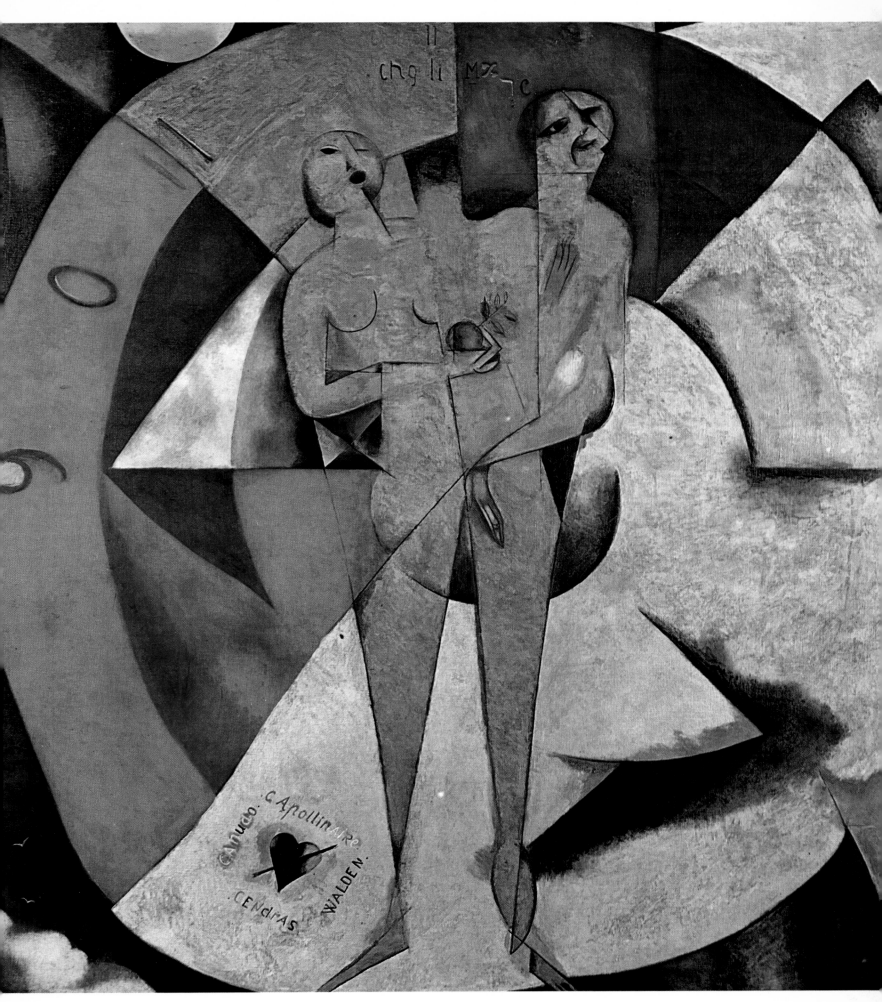

Homage to Apollinaire. 1911/12. Oil on canvas. $82^{1}/_{4}''\times78''$. Stedelijk Van Abbe Museum, Eindhoven.

Theater and

In August, 1918, Chagall was appointed Commissar of Fine Arts in the old "government" of Vitebsk.... The October Revolution was not yet a year old. Chagall immediately prepared to celebrate the anniversary in his hometown. Lounatcharsky, whom he had met in 1912 during his first trip to Paris, had himself been appointed Commissar of Popular Education and Culture at the end of 1917. He protected Chagall until the latter left Russia, procuring a passport for him so that he could depart in 1922 via Kaunas. This same

Lounatcharsky approved, in April, 1918, the founding of the Vitebsk academy. The internal disagreements that stirred the academy, specifically those in which Malevich came into confrontation with Chagall, underline some of the major characteristics of the work of the master of the imaginary: indomitable individualism, antidogmatism and aloofness. Chagall's association with the academy he founded lasted eighteen months and can help us both understand his ideology and conception of painting and analyze the relation-

Introduction to the Jewish Theater. 1919. Sketch of the monumental picture executed in 1921 for the left wall of the Moscow Jewish Theater

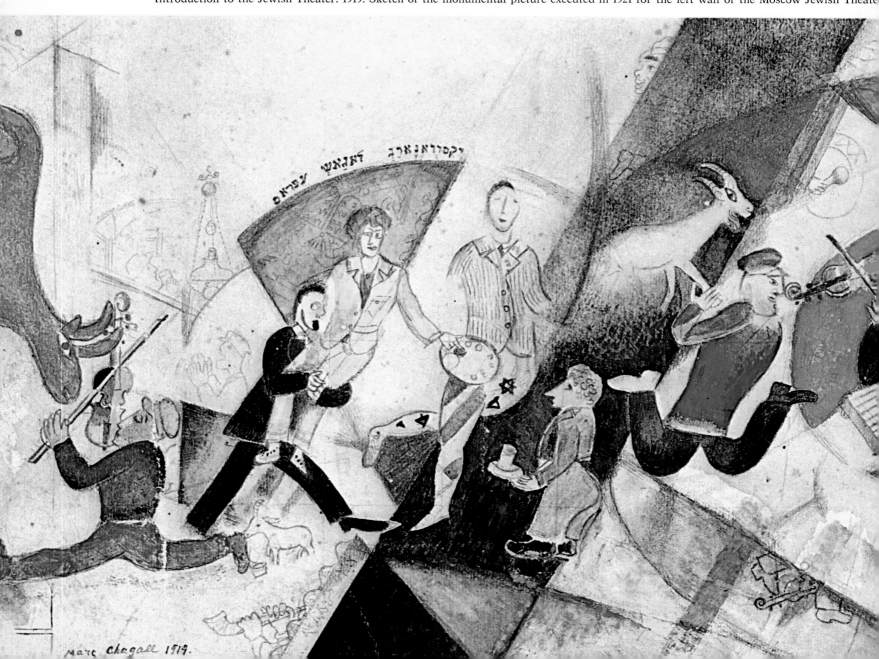

Revolution

<p style="text-align:right">by Alain Jouffroy</p>

ships of the first avant-garde Soviet artists with their own revolution. These eighteen months plus the last episode marking Chagall's stay in his revolutionary country—he taught war orphans for four and a half years, notably at the "Malakhovka" settlement—enable us, better than any other period in Chagall's life, to decipher his work in the light of his convictions, his reveries, his most personal needs. His friendship with Lounatcharsky, who also defended Meyerhold, was a decisive factor in Chagall's participation in the Russian Revolution between 1917 and 1922.

This is not the place to give in to our feelings about the differences and similarities between revolutionary *political* work and revolutionary *artistic* work, and we should avoid taking a particular intellectual position vis-à-vis the problem, no matter what. Whatever our own position on this subject may be, the facts are there, cataloged. They speak, and we must try to understand, to receive what they are conveying to us from faraway, across time. This is not the place, either, to decide if

0"). Property of the artist. *(Photo Jean Dubout).*

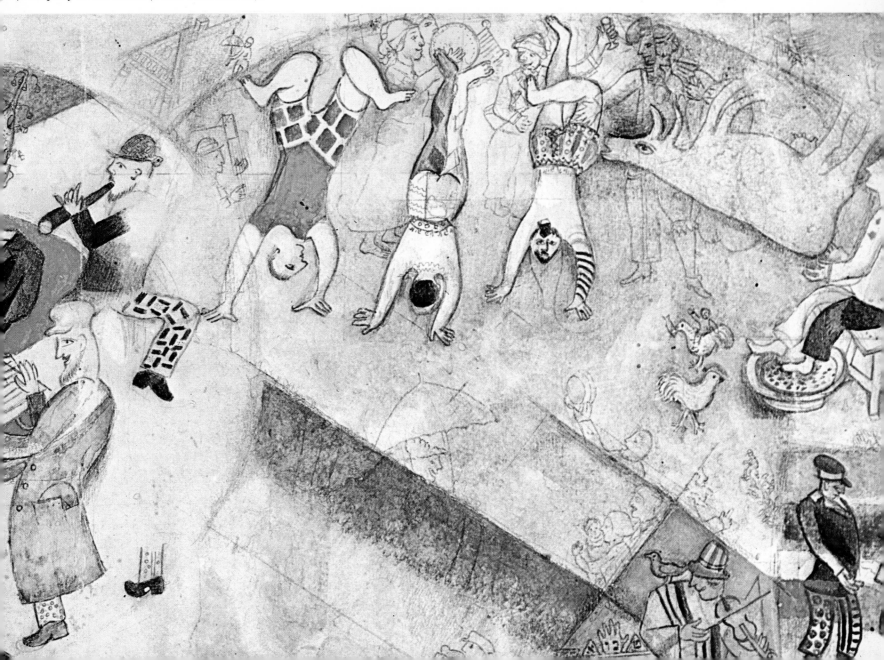

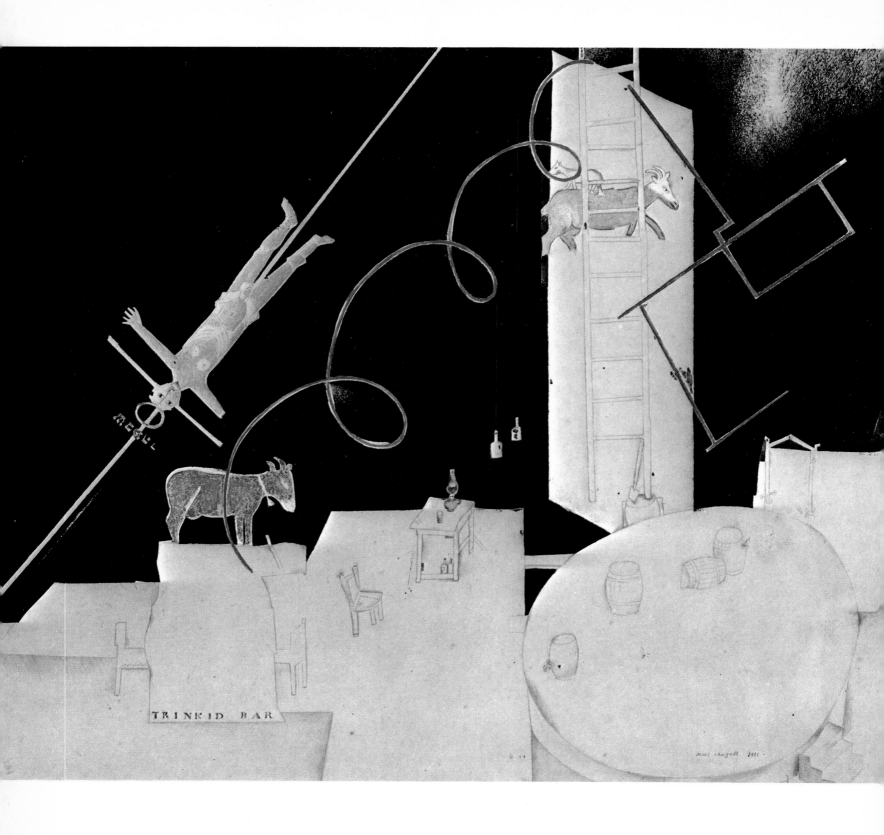

Sketch of the set for "The Playboy of the Western World" by Synge. 1921. Property of the artist. *(Photo Jean Dubout).*

Chagall was right, in what concerns his work and himself, to act as he did during those four years, or to determine what influence his extraordinary destiny might have had on the history of ideas and forms. But we can underline, to start with, this *monumental* fact: an individualistic painter was confronted with a collective revolution, and he effectively participated, as a painter, in this revolution.

Chagall, doubtless on the advice of Bella (they were married in July, 1915), refused to participate in the so-called "Department of Culture" which, in the aftermath of October, was bandied about a bit and would have been made up then of Mayakovsky for poetry, Meyerhold for theater and Chagall for the fine arts. But this refusal, which perhaps took him away from Petrograd, where he lived at Perekoupnoï Pereoulok, not only brought him closer to his hometown but also developed a sense of public responsibility in him: first he organized celebrations for the first anniversary, then he founded the academy. Hence, skirting the Department of Culture (which incidentally never took shape), he became involved in an even more generous social and cultural experience: the teaching of avant-garde painting in a country where everything was in the process of changing; the

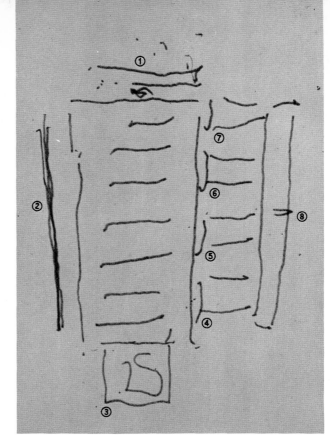

Sketch of Chagall showing the locations of the paintings that he executed for the Moscow Jewish Theater in 1920/21: 1 - Drop Curtain; 2 - Introduction to the Jewish Theater; 3 - Love on the Stage; 4 - Literature; 5 - Theater; 6 - Dance; 7 - Music; 8 - The Marriage Table.

Sketch for the curtain of the Moscow Jewish Theater. 1918.

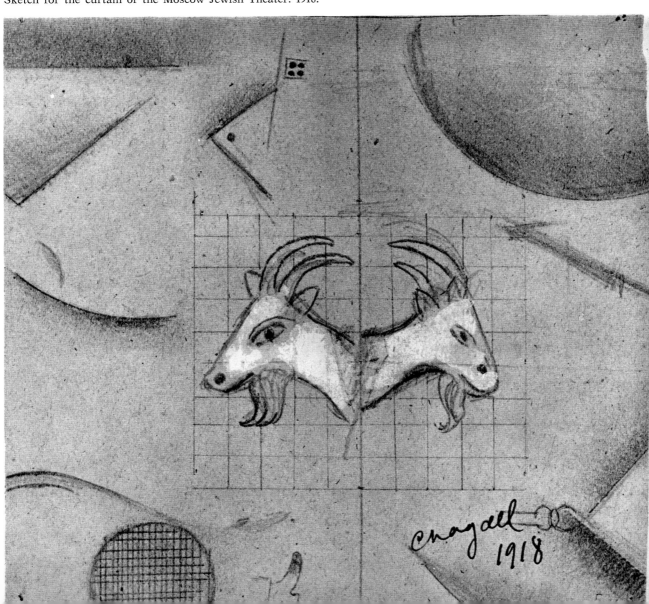

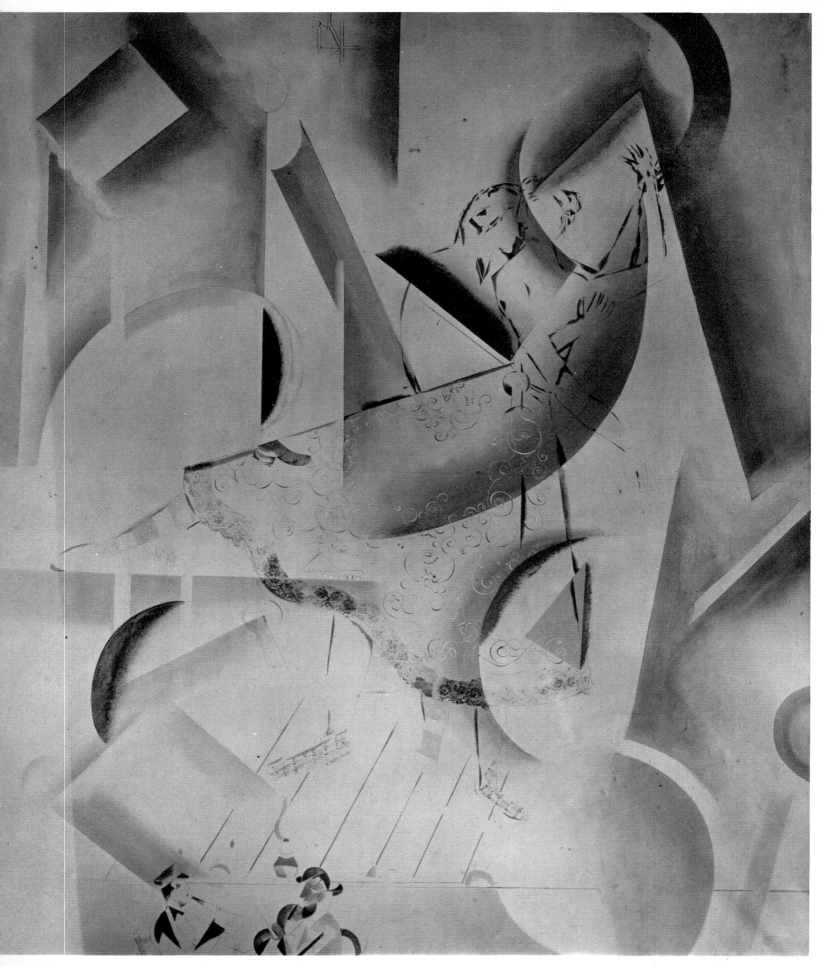

Love on the Stage. 1920/21. Tempera and gouache on canvas. 110$^{1}/_{4}$"×96$^{1}/_{2}$". Mural for the back wall of the Moscow Jewish Theater. State Tretiakov Gallery, Moscow. *(Photo Ida Meyer-Chagall)*.

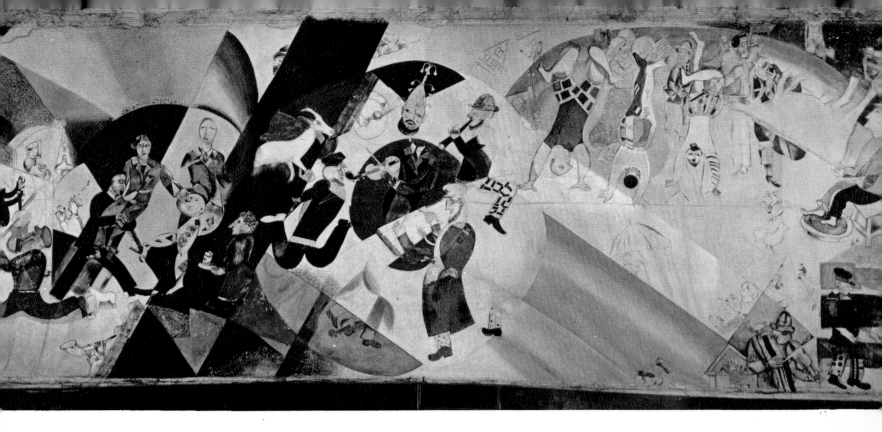

Introduction to the Jewish Theater. 1920/21. Tempera and gouache on canvas. 9'3"×25'10". State Tretiakov Gallery, Moscow. Below, detail. *(Photos State Tretiakov Gallery)*.

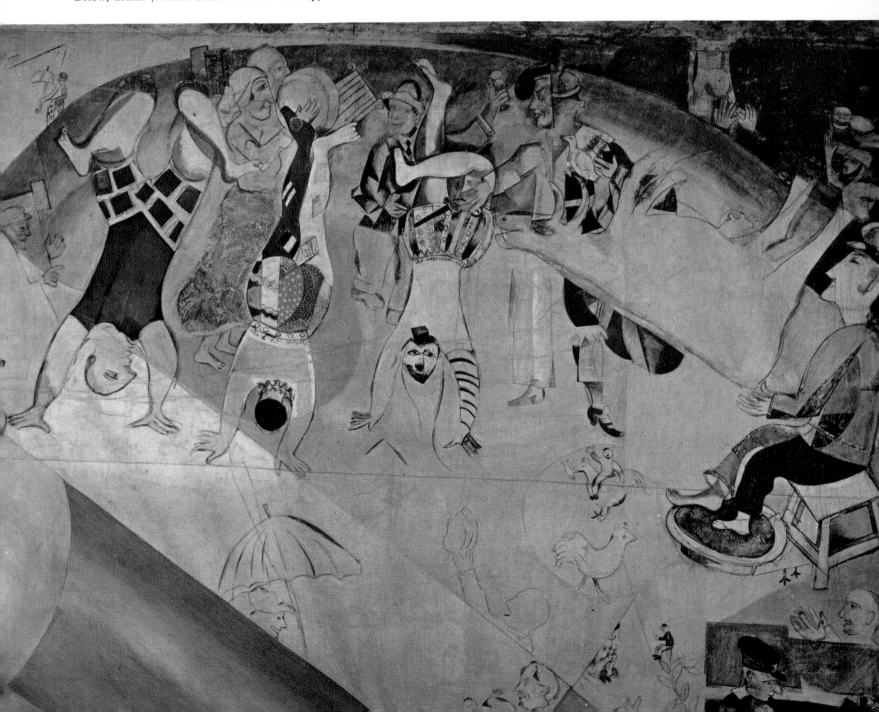

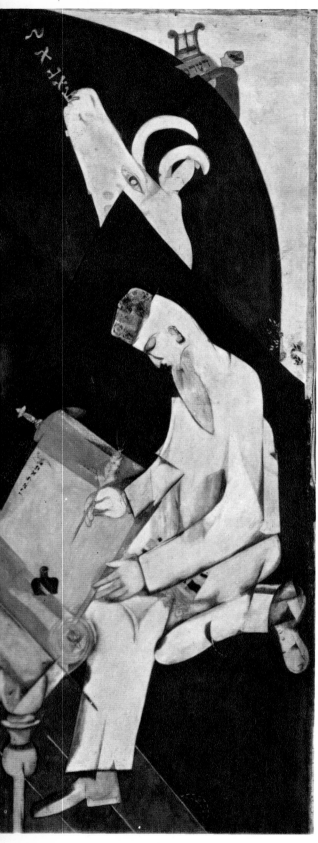

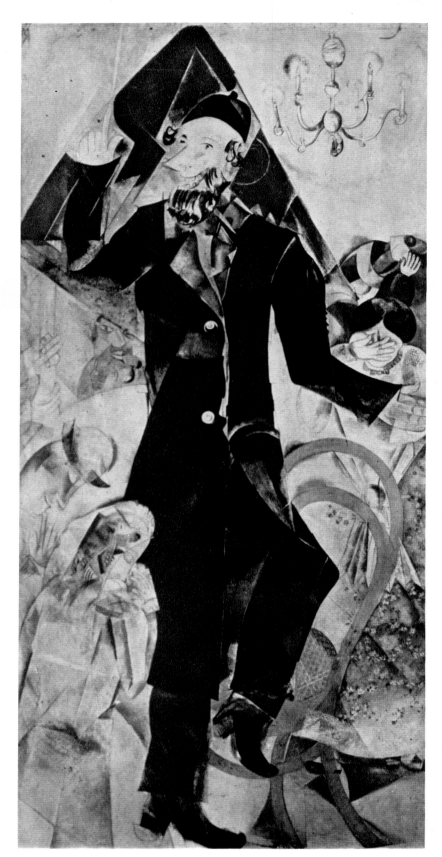

Literature. 83⅝″×31⅛″. Theater. 82⅝″×41¼″.

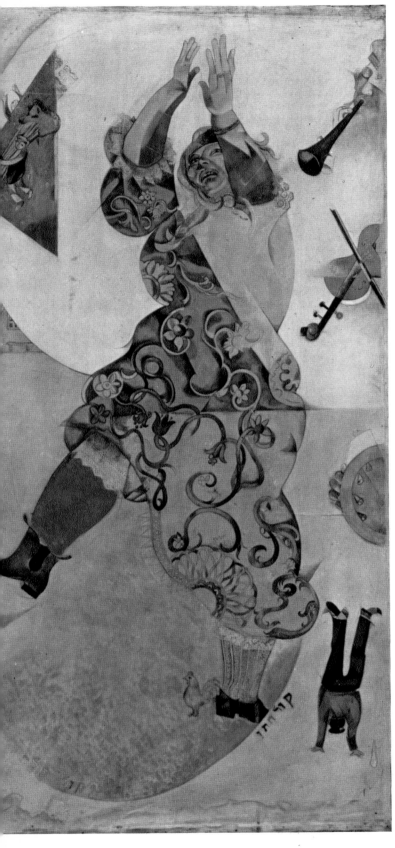

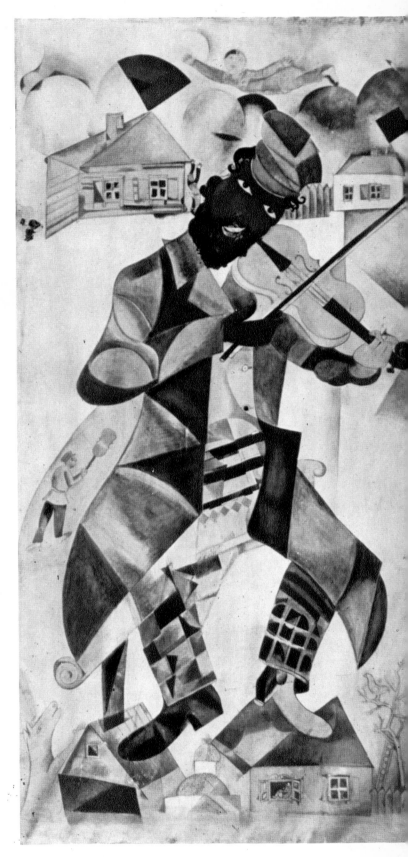

Dance. 82⁵/₈″×41¹/₂″.

Music. 80″×40³/₄″.

Four murals for the right wall of the Moscow Jewish Theater. 1920/21. Tempera and gouache on canvas. State Tretiakov Gallery, Moscow. *(Photos Ida Meyer-Chagall).*

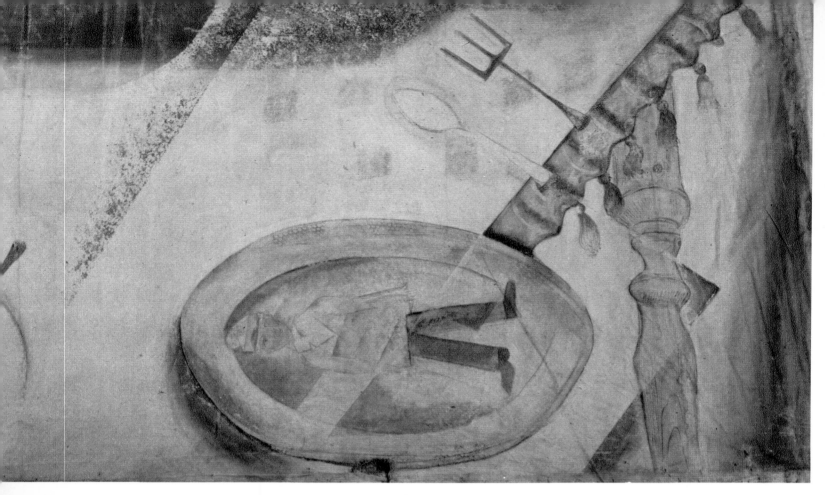

The Marriage Table. Detail. 1920/21. Tempera and gouache on canvas.

The Marriage Table. Detail. 1920/21. Tempera and gouache on canvas.

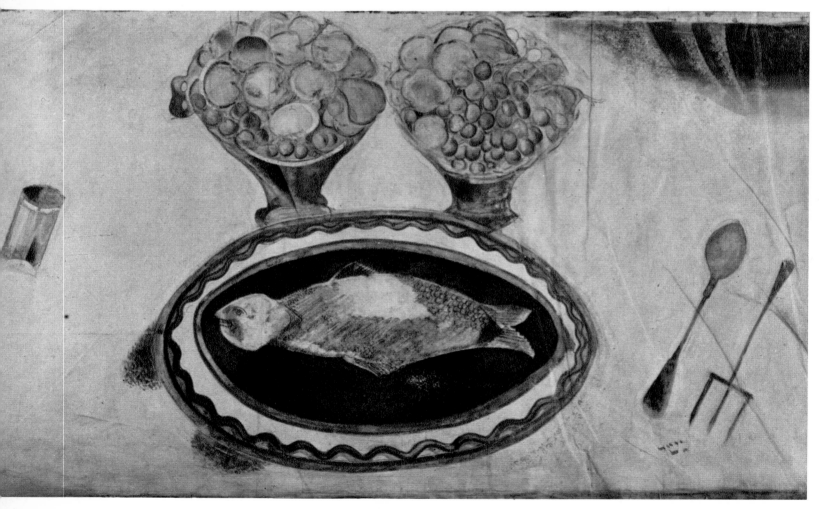

contemporary importance of this should not be underestimated. Personally, I feel that it concerns me, which is why, in this introduction to Chagall's monumental work, I have tried to situate him in his initial historical orbit.

The Flamboyant Individualism of Chagall

The first artists that Chagall invited to come and teach with him were—along with his teacher Pen—the painters Lissitzky and Pougny; shortly afterward, Lissitzky asked him to invite Malevich. Everything opposed Chagall to the latter. Or almost everything. Yet Chagall accepted Lissitzky's proposal, despite his unconcealed hostility, since the advent of Cubism, toward every kind of "realistic" reduction of the image to abstraction. For Chagall, in effect, a triangle, a circle and a square are as much objects as a cross, a metronome or a chair. To the author of *Black Square on a White Background* of 1913, he said, for example: "A square is something I can sit on, you understand: a square is an object." In his interviews, writings, and even more obviously in his painting, he has never stopped evincing his hostility as much toward realism as toward abstraction: he has even completely assimilated one with the other. Which is simply a way of saying how much the presence of Malevich, the suprematist, in the academy he directed must have been unpleasant for him. Nonetheless, to satisfy his friend Lissitzky, who admired Chagall a great deal but soon would yield to Malevich's point of view, Chagall invited him. This is an indication of his freedom, of his independence in regard to himself; he is against every kind of dogmatism, beginning with any that he might be able to draw out of systemizing his own ideas. But in 1919, at a time when Chagall was in Moscow, Malevich took control of the academy and completely transformed it, without the consent of the professors' committee. On the door he even replaced the words "Free Academy" by "Suprematist Academy." Chagall then sent his resignation to Lounatcharsky, but after a few discussions he changed his mind and continued directing the school until 1920.

He had a triumph in April, 1919, in the old Winter Palace, which was changed into the *Palace of the Arts* for the first official exhibition of revolutionary art: the two entrance rooms were devoted to him through June, and the State even purchased a dozen of his works. Immediately after the October Revolution, he had painted a few large autobiographical pictures celebrating his love for Bella: *The Double Portrait with Wineglass, Over the Town, The Apparition* and *Promenade,* in which Bella is painted as his own flag, his emotional oriflamme. Here the flamboyant individualism of Chagall clearly erupts. And yet these same pictures carried Chagall's youthful glory to the center of the palace that had been won by the Bolsheviks. Of

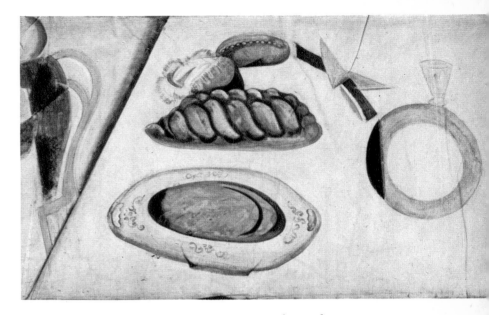

The Marriage Table. Detail. 1920/21. Tempera and gouache on canvas.

The Marriage Table. Detail. 1920/21. Tempera and gouache on canvas.

The Marriage Table. Detail. 1920/21. Tempera and gouache on canvas.
(Photos Ida Meyer-Chagall).

The Marriage Table. Monumental painting for the right wall of the Moscow Jewish Theater. 1920/21. Tempera and gouache on canvas.

course, this didn't happen without jealousy and intrigues: they are inevitable, especially around such a precocious triumph and in a period as electrified as that one.

Chagall, in 1917, was just thirty, and the beauty of the couple he formed with Bella had, it is said, something provocative about it. When he was organizing the celebration of the first anniversary of the revolution in the streets of Vitebsk, an official critic spoke about a "mystical and formalistic Bacchanal," simply because cows were floating with violinists above the roofs. But the identification of revolution with the festival, with individual liberty and love, cannot be doubted: the sketches he made on this theme in 1937 develop, allegorically and retrospectively, this first experience. So we can say that if Chagall participated despite his political unpreparedness in the world's first socialist revolution, it was not through intellectual and political adhesion to the theories of Marx and Lenin, but through a sort of enthusiasm for the physical rotatory movement that in his pictures makes couples revolve and fly above the horizon.

Like the planets around the sun, Chagall incessantly returns, flying and revolving, to his point of departure, and I will not scandalize anyone by affirming, in his place, this totally cosmic conception that he has of revolution. The history of the world, for him, is only constructed of the dream of the individual, who discovers and loses himself in it and rediscovers love. Man only engages in history to recognize, to find all of himself; but if history should dispossess him of the image he has forged of himself, then he ceases being able to participate in it. In fact, it is as if that were what finally convinced Chagall to break away from his country and come back to live in Paris, where another revolution was waiting for him, over whose birth he secretly presided through the intermediary of Apollinaire: Surrealism. Thus, from the red freight cars in which he travelled in Russia with Bella and little Ida to the great intellectual upheaval prepared by Parisian Dadaism, Chagall was one of the first and few to have established the fragile link that binds, in the thoughts of men as in the nerves of poets, the

political avant-garde of the Russian Revolution with the diverse artistic and poetic avant-gardes whose heirs we are today, namely, Futurism, Constructivism, Dadaism and Surrealism. If this link has been dramatically severed, it is not just on account of his leaving Russia: the artistic revolutionaries in power have, in their own way, renewed the classic Platonic exclusion, which consists in chasing the poet out of the city. In 1922, Chagall simply drew this lesson from the experience to which he had given himself wholeheartedly for more than four years with that kind of candor and vertigo inspired by success, friendship and love. He lived with the sacrifice of his own ideas to the point of giving lessons to war orphans and accepting to be treated like a "third-rate artist" by a committee composed of the greatest names of avant-garde Soviet painting. The difference between his personal avant-garde and that of the others perhaps constitutes the invisible key to his departure from Russia. Sectarian intolerance, intellectual fanaticism à la Malevich, perhaps triggered by a ricochet effect, the blind reaction against realism—to which, as we know now, the same Malevich finally yielded—thereby confirming the presentiments and intuition of Chagall, who always identified abstraction with realism and even told Malevich so to his face.

From Theater to Festival via Revolution

Not only does Chagall identify revolution with a festival, but he also associates theater with festival and revolution. This should be clear if we compare the first sketch for the *Introduction to the Jewish Theater* with the 1937 sketches for the *Revolution* itself. He painted the *Introduction* sketch at Vitebsk for the Kamerny Jewish Theater, which in 1920 was installed in a Moscow apartment with a capacity of ninety seats, and where Chagall painted the sets for three plays by Scholem Aleichem: *The Agents*, *Lie*, and *Mazeltov*. The final picture *Introduction* like the sketch, is a fresco over twenty-six feet long and nine feet high, hence the most monumental painted work by Chagall. Today it forms part of the reserves of the Tretiakov Gal-

State Tretiakov Gallery, Moscow. *(Photo State Tretiakov Gallery)*.

lery in Moscow, but like the four pictures *Music, Dance, Drama, Literature* he did for the same Kamerny Theater, the large still-life *The Marriage Table* that faced the *Introduction*, and the background picture entitled *Love on the Stage*, these works are not accessible to the public. We can only wonder in what kind of a state they are today (they were sized) and hope, along with the rest of the world, that they can be restored. Their historical importance, comparable to that of the Cubist pictures on display at the Hermitage in Leningrad, would in itself provide enough justification for this. Yet they were not included in the Chagall exhibition at the Grand Palais in 1969, a fact all his admirers regretted.

It is all the more regrettable because this theater/festival/revolution association I have just mentioned might make it possible to reinterpret Chagall's work in a new perspective and quite another light than hitherto. Chagall did not wait for October '17 to paint theater sets: Nicolas Evreïnov, an old friend of Meyerhold, had asked him to do those for a play he himself wrote (*To Die Happy*), which was to be put on in a sort of cabaret-theater located in a cellar not far from the Winter Palace, a place oddly called the Place de la Concorde, where Mayakovsky came from time to time to *spit* on the public. Thus, even before the Revolution, we can see that this explosive contact was operating—Mayakovsky/Winter Palace/Chagall/theater—in which I see, secretly introduced, the most enigmatic fuse of the bomb. There was enough converging, in any case, so that the painter of the *Decapitated Poet* could enact with that band of itinerant actors, that *prival kommediantov* which included Block, Essenine, Mandelstamm and Mayakovsky, a preview announcing not only the future victory, but the forthcoming diaspora of the revolutionary intelligentsia.

The Enemy of All Systems

Chagall detested the "psychological realism" of Stanislavsky, preferring the novel ideas and explorations of Taïroff and Meyerhold. But his hostility to Stanislavsky's realism led him into dif-

ficulties after the Revolution. Wachtangoff, a well-known student of Stanislavsky and director of another Jewish theater, the "Habima," invited Chagall to collaborate on the set designs for Anski's *Dibbuk*. Chagall was particularly happy about this since Anski, like himself, was from Vitebsk; but when he presented his project, Wachtangoff opposed it: "All your acrobatics and tricks are nothing," he told him, "there's only one path and that's Stanislavsky's." Chagall, who, as we have seen, wouldn't accept any kind of dictatorship, pounded on the table and cried, "You'll end up copying me anyway," and then left. Wachtangoff later tried, in effect, more or less openly to imitate Chagall, whose work and cult were preserved in Russia for a few years after his departure, until the Kamerny Jewish Theater was shut down during the darkest years of Stalinism. But we can see that Chagall's enemy between 1917 and 1922 was less the bureaucratic and authoritarian spirit of the politicians than the sectarianism of the avant-garde artists themselves.

Apollinaire—who had pronounced the word "supernatural" in 1913, in Chagall's studio in Paris, who would later invent the word "surrealism," and to whom Chagall rendered one of his biggest and most beautiful homages, a picture he had begun to paint in 1911—evaluated Chagall correctly when he wrote in the *Intransigeant* (April, 1913) that "Chagall reveals a curious and tormented spirit" and specified in 1914: "He is an extremely varied artist, capable of monumental paintings, and he isn't troubled by any system." It could not be better put, if we recall that it is precisely systems that Chagall has fought most violently his whole life; and nothing sheds more light on his behaviour during the years of the Russian Revolution, both at the Vitebsk Academy and among the theatrical world of Moscow: he fought Malevich who had joined forces with Lissitzky, as well as Wachtangoff and the partisans of Stanislavsky.

Lenin the Acrobat

It was Alexis Granovsky, Director of the Kamerny Jewish Theater, who accorded Chagall the freedom

25

he needed to fulfill his potential. We must compare the large-scale pictures he did for this theater with the *Revolution* sketches of 1937 if we wish to understand the analogies Chagall perceives between the social upheaval of a festival and that of a revolution. An attentive comparison of the actors in the *Introduction to the Jewish Theater* with that picture which Chagall destroyed in the United States after Bella's death during one of the crises of doubt that have occured rather frequently in his life, reveals at once the most glaring fact: Lenin, standing on one hand on the corner of a table, plays the equilibrist just as do the actors of the Kamerny Theater who are portrayed not far from the musicians. This posture of Lenin, contrary to all the iconography that has accumulated around the leader of the Russian Revolution, in a way makes the history of the world dance, literally turns its meaning upside down: people dream on the earth, or play the violin around a sun that has fallen to the earth, while a donkey sits patiently on a chair. The armed masses, gathered under the red flags, look at the spectacle of Lenin the equilibrist as if he were a great actor, I was about to

say the actor Michoëls, the most fervent Chagall enthusiast at the Kamerny Theater. In the two compositions, the oblique space is the same and the figures are placed as though in a parade or anniversary celebration in the street. Chagall perhaps remembered the one he organized himself in 1918 in Vitebsk.

In spite of his success at the Kamerny Theater, Chagall was unable, among the sets and costumes he designed for the theater before leaving Russia, to do those for the *Players*, Gogol's *Marriage*, Synge's *Playboy of the Western World*, and Anski's *Dibbuk*, which Wachtangoff had turned down in '21. Only the sets and costumes for Gogol's *Revizor*, which Razoummy, the director of the "Satirical and Revolutionary Theater," had gone to Vitebsk to ask him about, were completed; Chagall says somewhere that they were very "amusing." A few of his designs have survived however; in particular, the set for *The Playboy of the Western World* in which a silver Christ, hanging upside down from a thread above an immobile golden calf, was to have revolved continuously throughout the play. But this Christ, after fifty years, turns

Chagall in 1921 surrounded by his students in the "Malakhovka" camp for war orphans near Moscow.

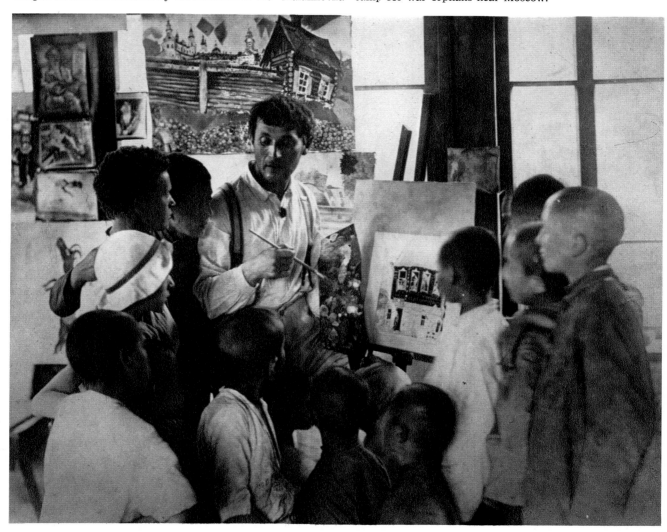

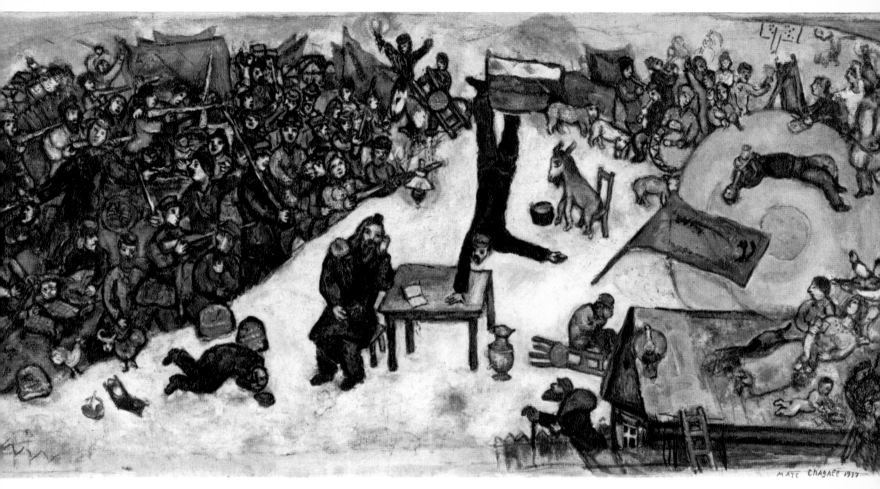

The Revolution. Study for the large picture that was executed in 1937 and later divided into three pieces. Oil on canvas. Property of the artist. *(Photo Jean Dubout)*.

in the same darkness, the same emptiness in 1972, as it did in Moscow in 1920 and '21, exactly as if it had never existed for anyone except historians and Chagall connoisseurs.

The *Introduction to the Jewish Theater* is still the Chagallian archetype of the allegorical representation of the life and role of the creator, artist and poet in society. As one of his exegetists says on this subject: "The circus and art lead to nothing but are everything." Thus *The Big Circus* of 1936 picks up the themes of the picture of 1920-1921 in which the strolling acrobats extended an invitation to the festival by standing the world on its head. In the *Introduction*, it is the head of the central violinist that flies away; in *Absinthe* (1913) it is that of the poet; and in *The Big Circus*, it is that of the orchestra conductor. As to the figure walking on his hands at the right of the *Introduction*, he can be seen as following the acrobatic troop of the Jewish Theater; it is as if Lenin, in the *Revolution* of 1937, were only one of the travestied acrobats from the Jewish Theater or the circus, a reinventor of the world, a clown of history. The world, for Chagall as for Jarry, is nothing but its own parody, its mask, its double, but at the same

time this double, this travesty, unveils its truth. The game creates the beauty, and if the game should stop, death alone would triumph.

The continuity we can decipher in the *Introduction to the Jewish Theater*, *The Big Circus* and the *Revolution*, defines the omnipotence of the Chagallian dream, which refuses to barricade the frontiers between domains that everyone separates: love, reality, society, poetry, revolution, the circus. In any case, painting enables him to unify, to reconcile what daily life everywhere fragments and opposes. Painting saved Chagall from misery and the unhappiness of living, but above all it permitted him, as at the time of the first anniversary of the Revolution when he dreamed "of transforming ordinary houses into museums and the vulgar inhabitant into a creator,"[1] to connect painting to the history of the world rather than to the history of forms. Certainly, the circus, the theater, revolution "are not life," but precisely what makes it possible to act out, illumine and change life. For Chagall, painting was only the instrument of this transformation: treating one or the other subject, he recaptured all his dreams. That is why the *monumental paintings* that Apollinaire felt Chagall "ca-

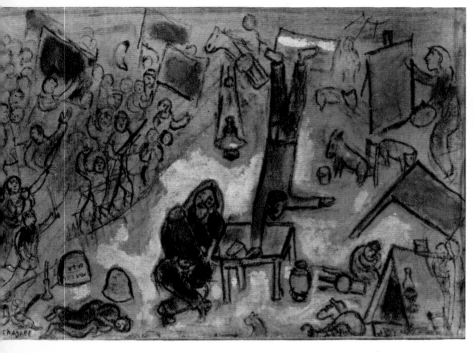

Study for the central panel of "The Revolution." 1937.
Property of the artist.

pable of" in 1914 principally deal with the major, constant theme of this identification of painting with mental revolution and theatrical play, and of this play with life. The pictures of the Kamerny Theater make it possible to establish historically this general interpretation of Chagall's entire work. Their remoteness is therefore all the more meaningful.

Perhaps we should take the fact that most of the sets Chagall designed in Russia are still buried in boxes or cellars, if they have not simply disappeared, as a sign. The picture of the *Revolution*, which Chagall exhibited at Zervos's, then at the Pierre Matisse Gallery in New York before tearing it up into three pieces, also indicates, by its symptomatic presence/absence, the drama that binds, releases and then connects Chagall anew to the history of this country and the revolution he began by applauding. Like his works, the private storms of his life coincide with those that have for the longest time shaken artists and poets throughout the world. The work and life of Chagall can be

Study for the left panel of "The Revolution." 1937. Property of the artist.

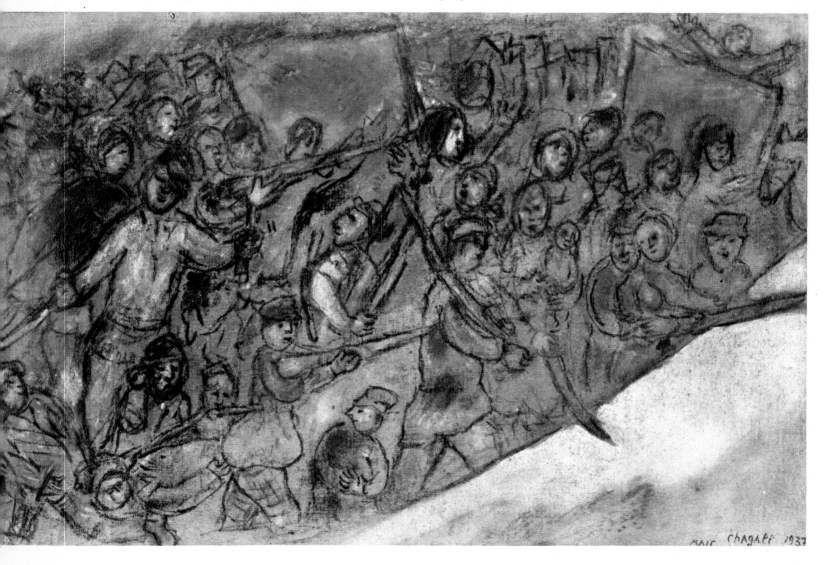

thought of as a parabolic mirror of the intellectual history of the twentieth century whose principal events he has lived through, endured and surmounted. With this mirror, he has erected one of the most enigmatic monuments to freedom and the imagination.

Today, Chagall is as old as Juan Gris would have been. In one breath, so it seems, he has responded to Mayakovsky's wish that he keep on "chagalling like Chagall"; he has stridden across the twentieth century.[2]

The point of all this is simply that the theater represented for Chagall the most direct intermediary between himself, the world and history. His painting inaugurated a revolution that encountered and intersected the start of a social revolution but that could never identify itself with the State the revolution gave birth to. And yet power fascinates Chagall insofar as it is related to the secret disturbance of his work. Painting allows him to see the world as *a stage* on which, as in the circus, the collective forces are travestied. In the center of

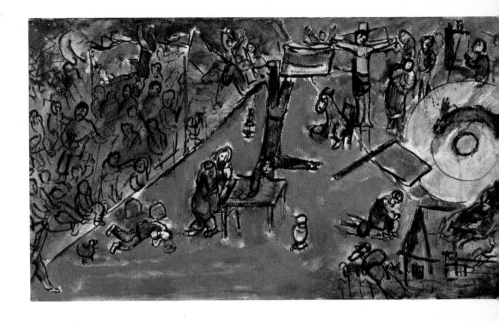

Study for "The Revolution." 1937. Property of the artist.

Study for "The Revolution." 1937. Property of the artist. *(Photos Jean Dubout).*

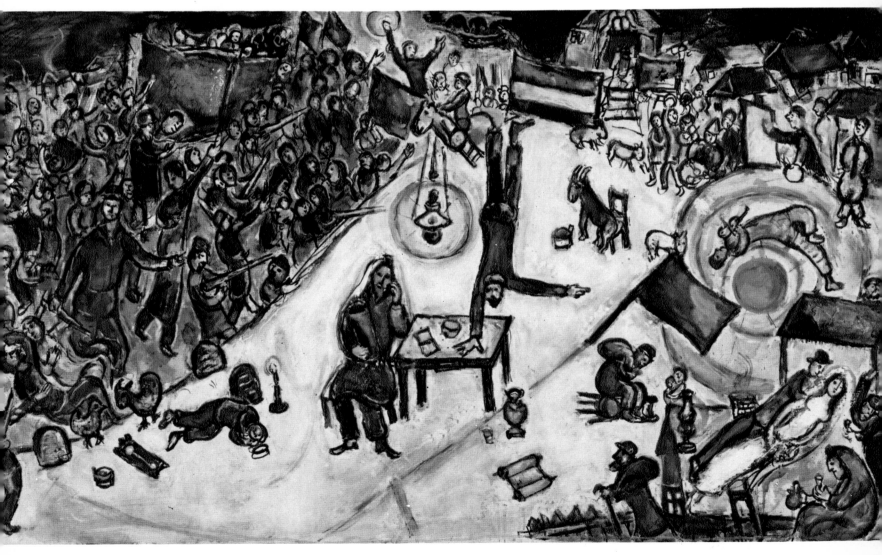

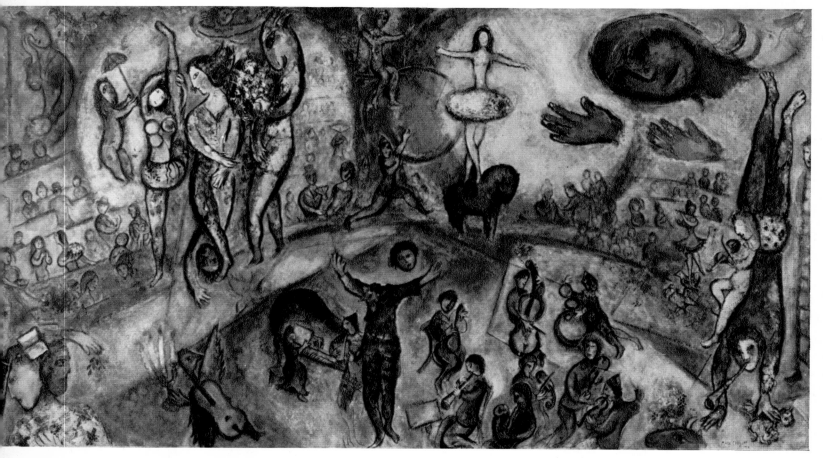

The Big Circus. 1956. Oil on canvas. 59"×12⁷/₈". Gustav Stern Foundation, New York.

Absinthe. 1913. Gouache on cardboard. 17³/₄"×20¹/₂". Private Coll.

this whirlwind he sees himself as the poet *who has lost his head*. There is no authority in the world capable of convincing him that he could not lose it, as the exuberant fantasies of his pictures prove.[3]

Postscript

"I am always crazy," Chagall said to the Soviet Minister of Culture, Mrs. Furtevsa, during his trip to the Soviet Union last June. It was his first visit to the country of his birth since 1922. The occasion for the trip was an exhibition of sixty-four lithographs and five paintings by Chagall that were shown at the Tretiakov Gallery in Moscow, but the Soviet press buried any mention of this event in the back pages of the Pravda and Izvestia. There was, however one surprise: he was allowed to see the paintings that he did for the Jewish Theater. Yet one can only regret that Chagall's "craziness," which testifies in every respect to a certain quality of experience and knowledge, failed to inspire some Soviet acknowledgement of the necessity of an individual madness in the increasingly stifled sphere of "culture."

[1] *My Life*, by Chagall.
[2] "Chagall," in Russian, means "to take long strides."
[3] Cf. *Théâtre et révolution*, by A. V. Lounatcharsky (Paris: Editions Maspero, 1971).

30

Opera and Ballet
Chagall in Full Flight

by Guy Weelen

André Malraux was the one who asked Chagall to create a new ceiling for the Paris Opera. It seems that the idea came to him when, during a gala evening, he attentively examined the work of Lenepveu and definitely received no response.

There is no need to make it a secret: the Paris Opera is a pompous, overdone monument. Even if it today forms a part of the glorious image of Paris, it is none the less monstrous because of its overabundant ornamentation, its veritable redundancy, although the architecture on the inside is,

so it seems, perfectly adapted to its intended purpose. In his study of Marc Chagall's ceiling Jacques Lassaigne has written:

The Paris Opera is striking on account of its architecture and because it bears the mark of a powerful temperament, that of Charles Garnier, whom we want to see as representative of a definite period although he surpassed and in many ways differed from it. He created an atmosphere, a very personal style, and he was successively praised and violently criticized until finally he imposed

Ceiling of the Paris Opera. Detail. 1964. *(Photo Jean Dubout).*

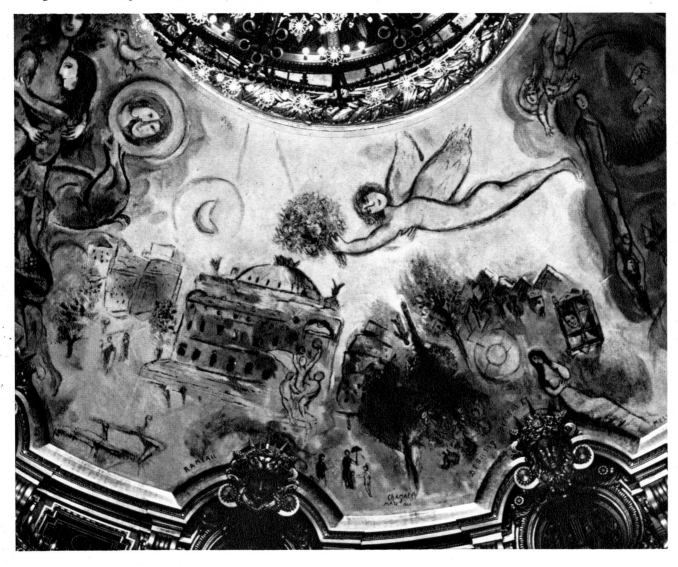

himself by his very excesses, his ornateness grafted on a functional and rigid framework.

If we must be grateful to Garnier for having invited Carpeaux to execute *The Dance*, the only group in the mediocre collection of scuptures that merits some esteem, we should be aware that Garnier was not so fortunate with respect to painting. How could he be? The painters that he might have called upon either did not suit his temperament or did not figure on the list of officially accepted painters.

In that enormous edifice dedicated to music and movement, where the line is often displaced, even destroyed, the ceiling had to be like a call, a summons, amid the radiance of the purples and golds.

The dome had to have a presence, an ampleness so that in the general tumult it could make its voice heard without becoming imposing or creating a harshness. In a few words this underlines the scope and complexity of the problem with which André Malraux's proposal confronted Chagall. We can understand why, to use his own words, he was "troubled, touched and deeply moved." His uneasiness lasted for a long time, but the offer seemed so interesting and tempting that he slowly began to compose circular sketches, taking into account the particular constraints imposed on him by the general character of the architecture and especially the fourteen gilt heads jutting out from the edges of the ceiling. To someone else these

Ceiling of the Paris Opera. Detail. 1964.

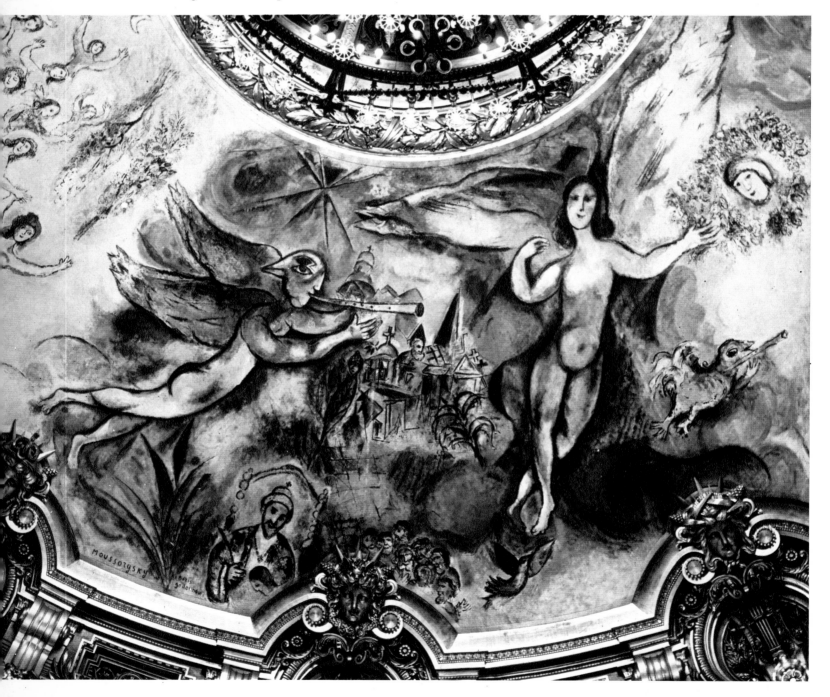

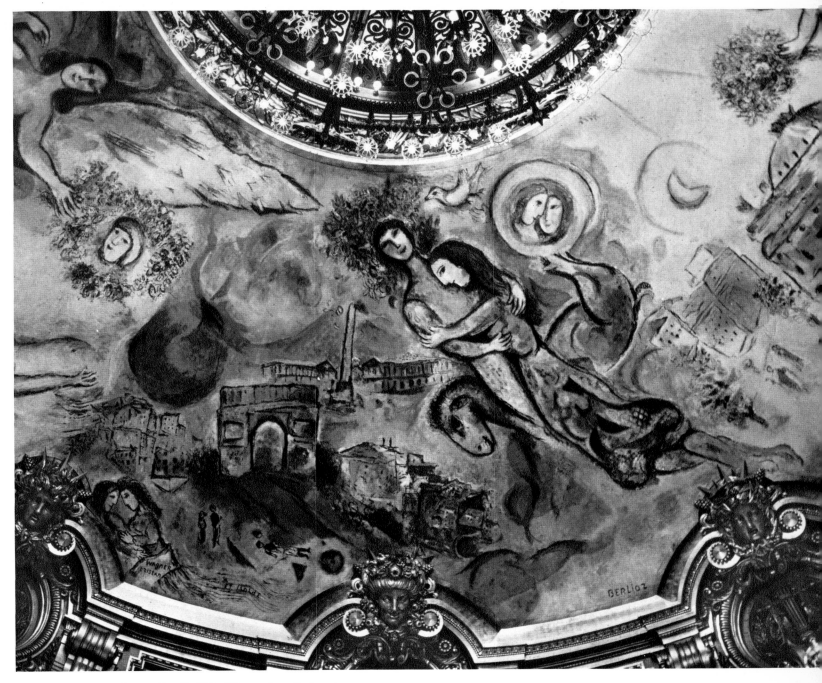

Ceiling of the Paris Opera. Detail. 1964. *(Photos Jean Dubout)*.

constraints might have seemed burdensome, but I believe they stimulated Chagall's imagination, offering a resistance that triggered both his curiosity and his desire to execute a difficult work.

The numerous sketches and studies Chagall made show the care he took first in determining the areas of color and then in choosing the elements to be distributed over the surface of the dome; these elements, in turn, were meant to be absorbed by the color or to come and float on the surface in order to form a large fluid ring marked by alternating rhythms. As a result, the evocations were selected gradually and, under his hand, they became responsible for singing in their own way the music and the musicians who haunt his spirit. Jacques

Lassaigne has observed to what degree the first sketches "reveal two principal lines of research: the installation of great masses of color and a thematic development going as far as an extreme precision of detail." In short, the ceiling was to be divided in five colored areas, each with its dominant color to celebrate the artists Chagall chose to honor. Blue for Moussorgsky and Mozart, green for Wagner and Berlioz, white set off by yellow for Rameau and Debussy, red for Ravel and Stravinsky, yellow for Tchaikovsky and Adam. In these two last parts Chagall pays tribute to the ballet by evoking *Daphnis and Chloe*, *The Firebird*, *Swan Lake* and *Giselle*, but this basically traditional organization, with dominant warm and

33

The Cock. Costume for "Aleko." 1942.

cool colors sustained by complementary colors or intensified by the mixing of colors, cannot contend with the centrifugal force that imparts a remarkable unity to the composition. The transition between the different zones is no less important than the harmony which is created inside each between the two adjacent walls. There are areas of influence and approach, and the unity is accentuated by three major axes that carefully balance each other, each of which functions like the backbone of the composition: a perpendicular Eiffel Tower answered by the diagonal of Berlioz' lovers and the subtle alliance of the two great angels of Moussorgsky and Mozart.

Chagall invoked Moussorgsky as the father of Russian music, and he has focused on Boris Godunov. If the father is the cruel killer of his son, he also contributes in the drama to the birth of a nation. The tsar is shown on his throne under an array of cupolas and steeples. The geometrical accents of 1917-1919 are visible, and the figures are half personages, half houses. The great angels with their beating wings punctuate the composition. A double-faced red-winged angel for Boris, is contrasted with the smile and inner tenderness of the angel who spreads his wings in Mozart's orb. Here we notice blue palms, stars with crisscross shafts that extend the adornments of the gilt heads of Garnier's border.

For Chagall, Berlioz symbolizes French romanticism, and Wagner transposed into music the most moving pair of lovers to bear the weight of destiny: Tristan and Isolde, who soar in an enormous green expanse along with Romeo and Juliette entwined and carried away on a huge horse. Isolde's gown is transformed into a river, and Juliette's is spangled with stars and crescent moons. She extends diagonally across the whole composition. In these figures Chagall recaptures the tenderness of the lovers with bouquets he did in the 1930 s. The landscape that accompanies them renews the theme already dealt with in the *Lover of the Eiffel Tower*. The Place de la Concorde is evoked by the dawn, and the Arc de Triomphe bursts out with the flaming red of passion. For the artist this series of images incessantly renews the themes of eternal love.

A large, clear expanse scattered with red and gold and a few patches of intense blue opens up to show the continuity of French music. In it the Garnier palace explodes like a red fanfare, and Carpeaux's dance flashes with gold. The trees, blue like reflections, are mirrored in this vast river of music. Not far away, behind the foliage, rises the misty palace of Mélisande, and the princess herself, combing her hair, bends forward at the edge of the ceiling. Suddenly we see, isolated from time and torn away from space, the blue window of an isba in which Pelleas' face appears. The artist has given the face Malraux's features, just as painters did in the past when they wished to honor their patron.

It was by designing the sets for the ballet of

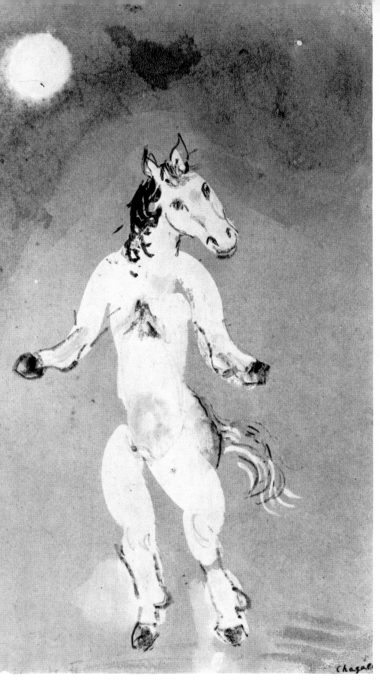

in a little meadow where a poet reposes, violins that play by themselves, lovers under a marriage canopy.

To represent Russian folklore, Chagall chose Stravinsky, but gave him a relatively small part. By doing so Chagall demonstrated his international sense of art, implicitly answering those critics who thought he would be incapable of forgetting his origins and would only invoke his personal mythology to praise music. Stravinsky could have provided the pretext for the expression of violent contrasts. Instead, Chagall chose a glittering yellow for him in which he makes light, airy dancers whirl. Thus he glorifies ballet, depicting movement free of anecdote and even scenery. *Swan Lake* is represented by a beautiful blue figure carrying a bouquet and reclining on the coiled neck of a

The Fortune-teller. Costume for "Aleko." 1942.

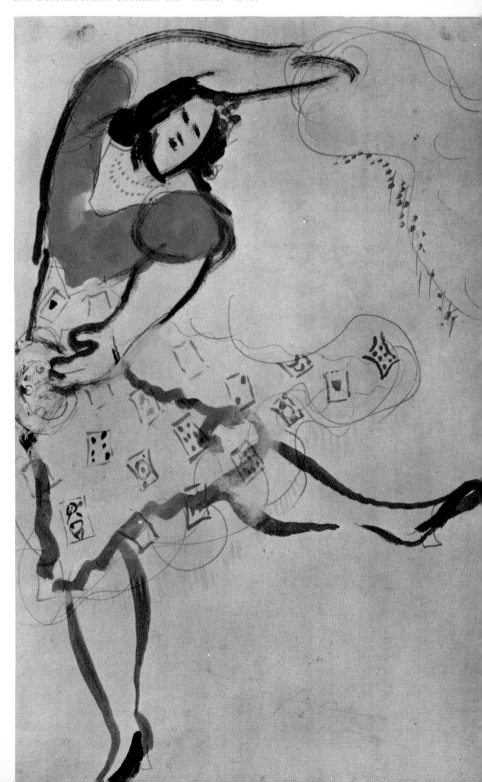

A Horse. Costume for "Aleko." 1942. 13³/₈"×8¹/₂".

Daphnis and Chloe that Chagall, so to speak, "entered" the Opera. He chose to honor Maurice Ravel and especially this work. Rather paradoxically perhaps, the painter selected red to signify both, but this violent color can be explained by the passionate nature of the ballet. The grazing sheep, the sea and the sails, as well as that double-enlaced body—like an arrow shooting through the composition—bathe in this fused matter. At the bottom of the group a bacchanal unfolds and starts to beat like a wave breaking against the circumference of the ceiling. All at once, like a rock, a huge Eiffel Tower rises; it is simultaneously a steel framework and a sparkling Christmas tree. This big vertical does not cause a break; rather, it unites the revery of childhood and the world chosen by the artist. The painter leans against it, holding his palette and contemplating the universe he has created. We recognize his fabulous imagery: the crowned cock strutting above roofs and domes, strolling musicians, bearers of offerings, fir trees

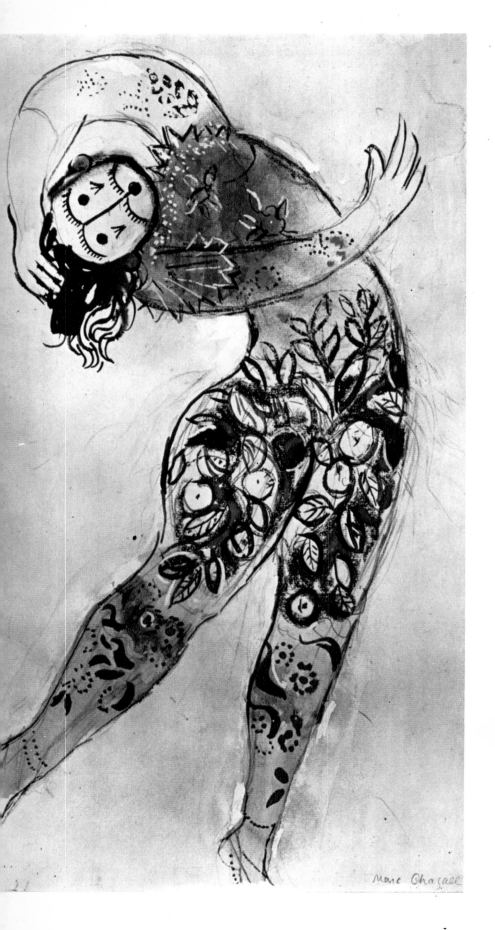

Monster. Costume for "The Firebird." 1945.

swan. Here we can clearly see Chagall's capacity for wonder, his sense of beauty independent of any geography or country. Hadn't he already in his illustrations been able to appropriate the myths of Gogol in whose humor he discovered his own expression? Hadn't he, illustrating La Fontaine, renewed his technique and his themes? Hadn't he felt like a Greek among the Greeks of antiquity? And to narrate the Bible hadn't he found images that provided the legend and the story with significant additions?

Inside the vast dome of the Opera there is another circle that the branches of the huge chandelier make it difficult to see. Four groups form a homage to Gluck, Beethoven, Verdi and Bizet. Chagall conceived this unit as a separate composition with its own rhythm, as an accompaniment to the general composition.

The extreme care that went into the work on the ceiling is comparable to that of an easel painting; every detail was thought, felt and carried out according to what Chagall had desired. Offering this work to France, his adopted country, he declared:

I wished to reflect, as though in a mirror high above, in a bouquet of dreams, the creations of actors, of composers; to recall the colorful movement of the audience below. To sing like a bird, without theory or method. To render homage to the great composers of opera and ballet.

If I have insisted on first describing the ceiling of the Opera, it is because this vast, superb composition stands like a fixed point in time in relation to Chagall's work with the dance, music and the theater. A set for a ballet or an opera, even if it is used repeatedly, is ephemeral, and the ephemeral is perhaps one of the secret pivots, perhaps the most touching, of Chagall's work. This is why it is important to follow the artist's long association with the world of the theater. It began in his childhood and has a guiding thread that has become more and more apparent over the years: imagination.

In his youth Chagall worked with Bakst, but too many differences put him in confrontation with his elder and with the group to which he belonged along with Benois, Roerich, Golovine and Bilibine. Influenced by the Munich style, these artists created historical reconstructions based on research and documentation of the past. Chagall had other aims, which is probably why he preferred not to respond to the invitation of the Russian Ballet to participate in making collective sets. The work he did between 1919 and 1921 for the renovation of the Jewish theater had helped Chagall discern his path. In 1917 he worked with Evreinov, a friend of Meyerhold, who also sought to liberate the imagination of the spectator. His most fruitful collaboration was with the actor Michöels, whose very acting style was changed. In effect, *Chagall imposes on the characters a new structure that introduces into*

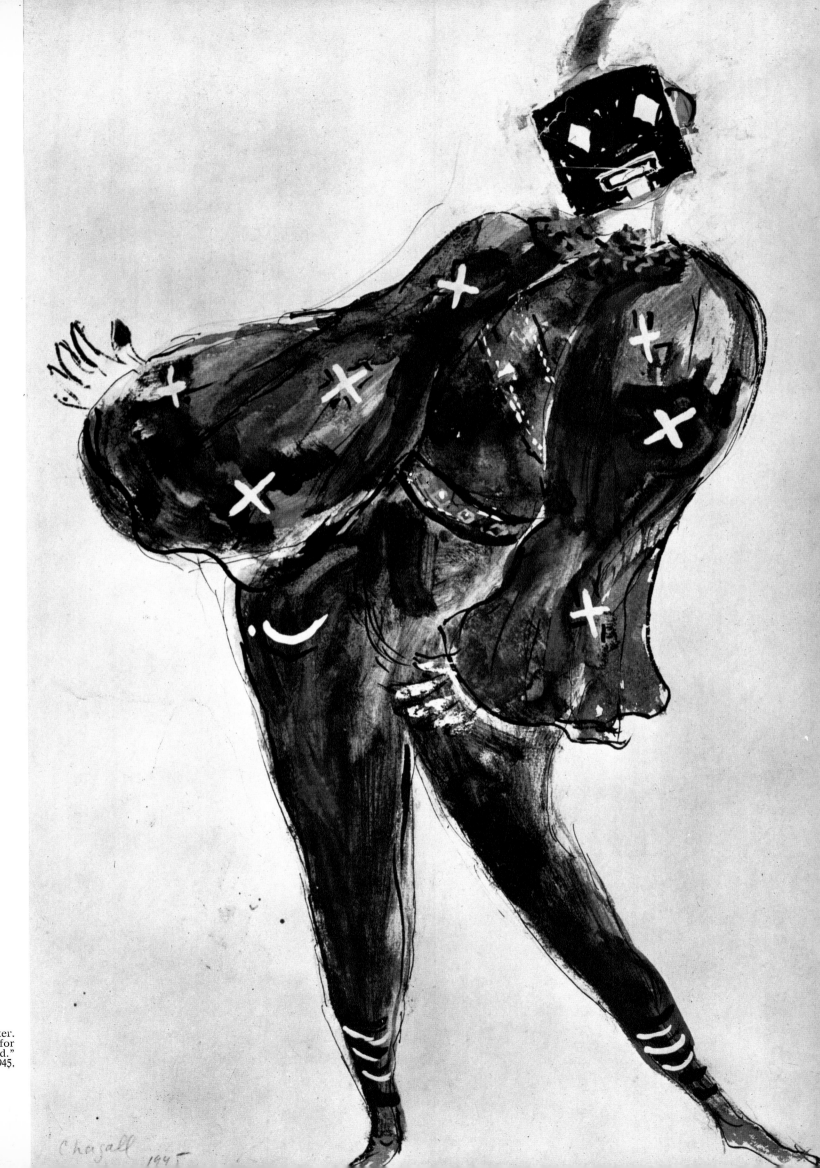

Monster.
Costume for
"The Firebird."
1945.

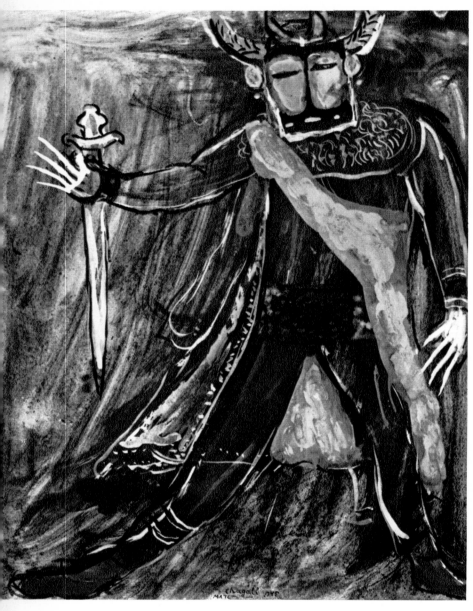

Katchaï the Sorcerer. Costume for "The Firebird." 1945.

their portrayal, in addition to their character traits, a veritable prefiguration of the action that will sweep them away.... For him, the final spectacle should function as a complete unit in which sets, costumes and lighting as well as the performance of the actors translate the bursting forth and the development of the idea....

In other words, he does not limit himself to being at the disposal of the work but wants to assimilate all the elements in order to cast them in a single, perfectly homogeneous, plastic expression which envelops and represents the work from then on, and corresponds precisely to his intentions. Chagall dreams of a total spectacle, and no part of it should be isolated; the sounds and the forms should echo each other, lines and movement should harmonize, interlock, and every aspect penetrate every other aspect in order to attain unity.

Hence, scorning the relationships of everyday logic, Chagall invents in order to make us lost,

mixes everything up in order to disorient us, because his objective is to break the ties that bind the imagination in order to liberate it; he wants to create a state of wonder which we can share. Thus he was able to say to Jacques Lassaigne: *I wanted to penetrate the spirit of* The Firebird *and* Aleko *without illustrating them, without copying anything. I don't want to represent anything. I want color to play and speak alone. There is no way of equating the world we live in with the world we enter in such a way.*

The plot of the ballet *Aleko* is based on the very beautiful poem *The Tziganes* by Pushkin. It is a tragic love story in which a fantastic delirium takes possession of the young poet-assassin. Tchaikovsky illustrated it in his *Trio in A Minor* for piano, violin and cello; he himself considers that "the general tone of the work is gloomy" (letter of January 12, 1882). The sets and costumes for the ballet *Aleko* were commissioned from Chagall at the end of 1941 by Lucia Chase and Sol Hurok for the New York Ballet Theater company. Chagall, always meticulous about details, worked for months in New York with Leonid Massine, the choreographer, steeping himself in the music, listening over and over again to Pushkin's beautiful verses read to him by his wife. For various reasons the ballet was never performed in New York but in Mexico, and it was thus on the spot that he size-painted the four big canvases for the set. Despite their imposing dimensions, they are still intimate as well as evocative; they resemble enormous reveries that are more impregnated with the atmosphere of the ballet than they are with references to the actual vicissitudes of the plot.

In the first set, a pair of lovers surges up in a cloudy tempest, a pale moon pierces the mist through which, like a clap of thunder, a red patch in the form of a cock suddenly busts. These four elements are quite separate from one another, yet the eye is irresistibly attracted by the spots of color on the young girl's dress and is drawn along a path from the white expanse to the white halo.

The second set depicts an immense green and violet bouquet stamped with black and suspended above a red bear brandishing a violin. In the upper left are two very freely placed blues; then, under a delicate pink mixed with yellow, the horizon curves, and we discern the faint outline of a village.

On the yellow background of the third set, a huge sun with diffused rays and an enormous red, white and yellow target appear and form a cosmic whirling above a river bordered by high grass; a blue boat floats indolently on the river and out of it suddenly rises a large scythe, the apparition of death. This scenery instantly recalls and underlines the circles and rhythms which occured in Chagall's pictures around 1911.

The fourth curtain is certainly the most intense and the most moving. Above a red line, monuments rise up evoking Saint-Petersburg. Blocked off by the green mass of a cemetery hill, the entire com-

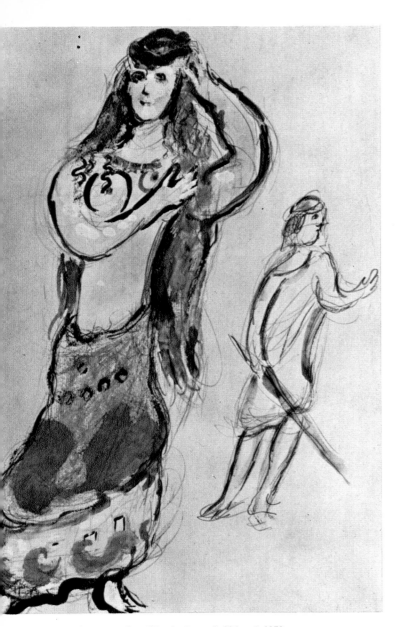

Costume for "Daphnis and Chloe." 1958.

July 20, 1950. Chagall began working on it in 1945, after the terrible period that followed the death of his wife, Bella. Assisted by his daughter, who helped him mainly with the costumes, Chagall painted, once again by himself, the enormous curtain and the three sets for the ballet. This legend of triumphant love reached deep into Chagall's soul, and he passionately threw himself into this new undertaking, giving free rein to his familiar fantastic ideas.

On the opening curtain *The Firebird* appears shrouded in midnight-blue above an uncertain horizon line, with its great wings spread wide bearing a woman, her head thrown back, who represents a homage to Bella. On the ground a horseman gallops; an angel hovers above the domes, a monster stretches his limbs and the

Shepherd. Costume for "Daphnis and Chloe." 1958.

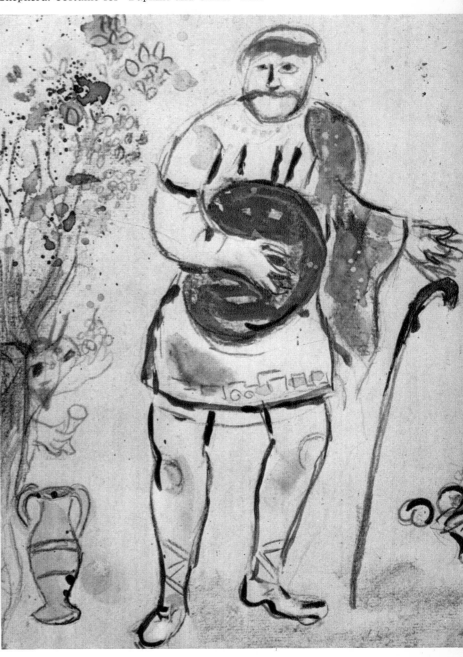

position is barred by a broken-down white horse pulling a cart. An illumined chandelier is poised in a golden orb.

All these canvases evince Chagall's concern with the idea of building up pictures by juxtaposing and distributing clear and dark masses on a surface. The idea of fluidity constantly haunts him, and he is careful not to dam it up by using forms that would be too evident or imperative. Under the brilliant beams of the spotlights Chagall wanted his work to manifest a radiance of colors and to conserve a character of passionate effusion.

The Firebird, for which Stravinsky composed his explosive music in the first decade of this century, is based on an old Russian fairy tale. The Russian Ballet Company performed it for the first time in 1910. The new version, performed by the New York City Ballet was directed by Balanchine and had its world premiere in Covent Garden in London on

The Fight. Costumes for "Daphnis and Chloe." 1958.

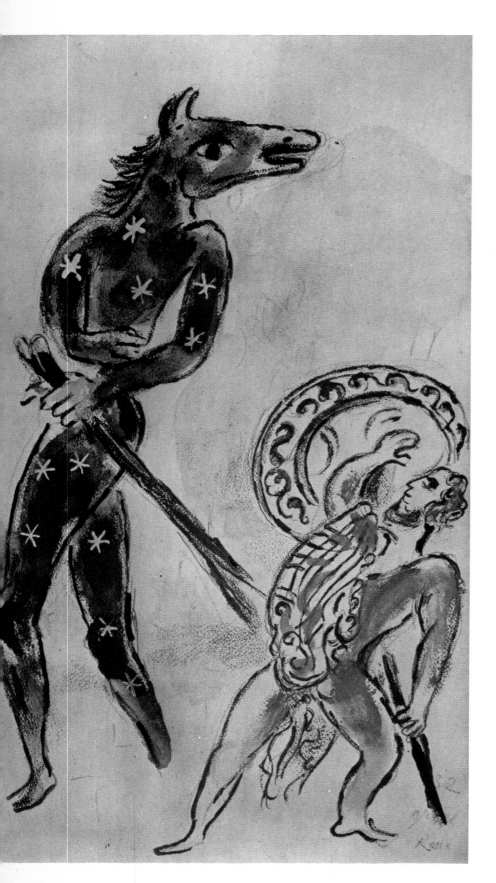

dampness of the earth contrasts with the freshness of the sky.

The first backdrop is a forest so enchanted that it is repeated twice, as if it were looking at itself in a mirror. Winged animals, lost birds, wakeful griffins are huddled under the foliage, and the forest is full of mysterious paths that go nowhere, like a lot of traps meant to lead one's footsteps astray. A vast blue zone in the middle seems to be at once a river and a sky in which the moon and the sun are simultaneously reflected. The composition of the second backdrop has great suppleness. We see the explosion of a bouquet of flowers bursting out from a forest where lions prowl, and this is balanced by a fantastic animal, a mixture of feathers and scales, whose flank bears the castle of the Sleeping Beauty. Between the two extends a large pale pink space in which a young girl climbs a ladder leading to the palace. The whole curtain is endowed with extreme lightness. We understand what Chagall expects from color: power and surprises. The third backdrop is organized around a harmonious interplay of reds and whites. It consists of sweeping, dynamic circular forms out of which emerge angelic musicians, blue cows carrying torches and bells whose sound is lost in the wind. Triumphant love shines and blends with the sunlight. Like an arrow, the young girl, freed at last, and the prince spring toward another world.

With great lightness Chagall reinvented the circular forms that structured the space in his large compositions of 1911-1912 and which he resumed in 1933, 1949 and 1953. His sets, although related to the past, are the manifestation of new concepts. Chagall assigns to color the role of organizing space. The scattering of objects and figures creates systems of tension in which the solids have the importance of the voids. Thanks to them the scattering technique becomes a prelude to fluidity; it is a stratagem in the rules of the game perfected by the artist.

For a long time Tériade, the noted publisher, had cherished the idea of having Chagall illustrate the pastoral romance attributed to Longus, *Daphnis and Chloe.* Before undertaking this delicate work, Chagall felt he had to go to Greece, which he visited twice, in 1952 and 1954. These voyages made very deep impressions on him, revealing to him the Mediterranean miracle. He had already started work on the illustrations when, in 1958, he received a commission for the sets and costumes of a ballet for the Paris Opéra based on the symphonic suite, *Daphnis and Chloe,* by Ravel. Chagall, who greatly admired the composer, was delighted by this proposition and saw in it a chance to break the chain of unfortunate events that until then had always seemed to obstruct the attempts to bring this work to the stage. The ballet had been performed by the Russian Ballet at the Chatelet Theater in 1912 with costumes and sets by Leon Bakst and choreography by Fokine, which at

40

Costume for
Daphnis and Chloe." 1958.
(Photo Delagénière).

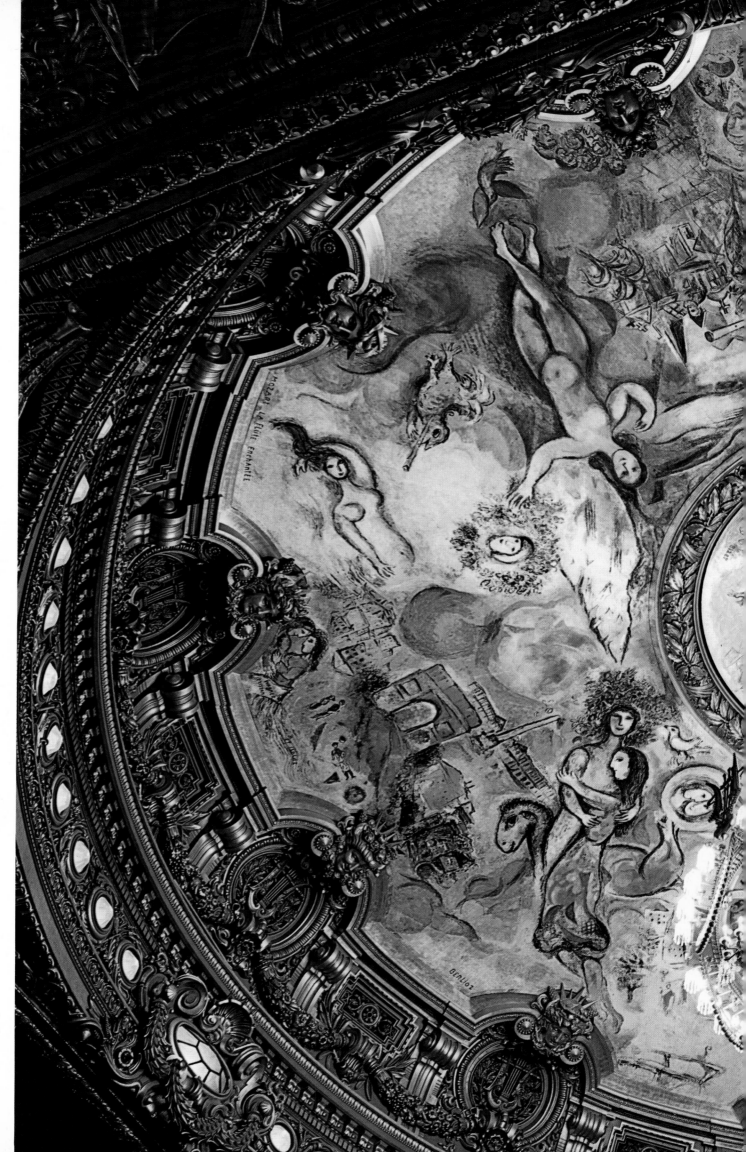

Ceiling of
the Paris Opera. 1964.
(Photo Jean Dubout).

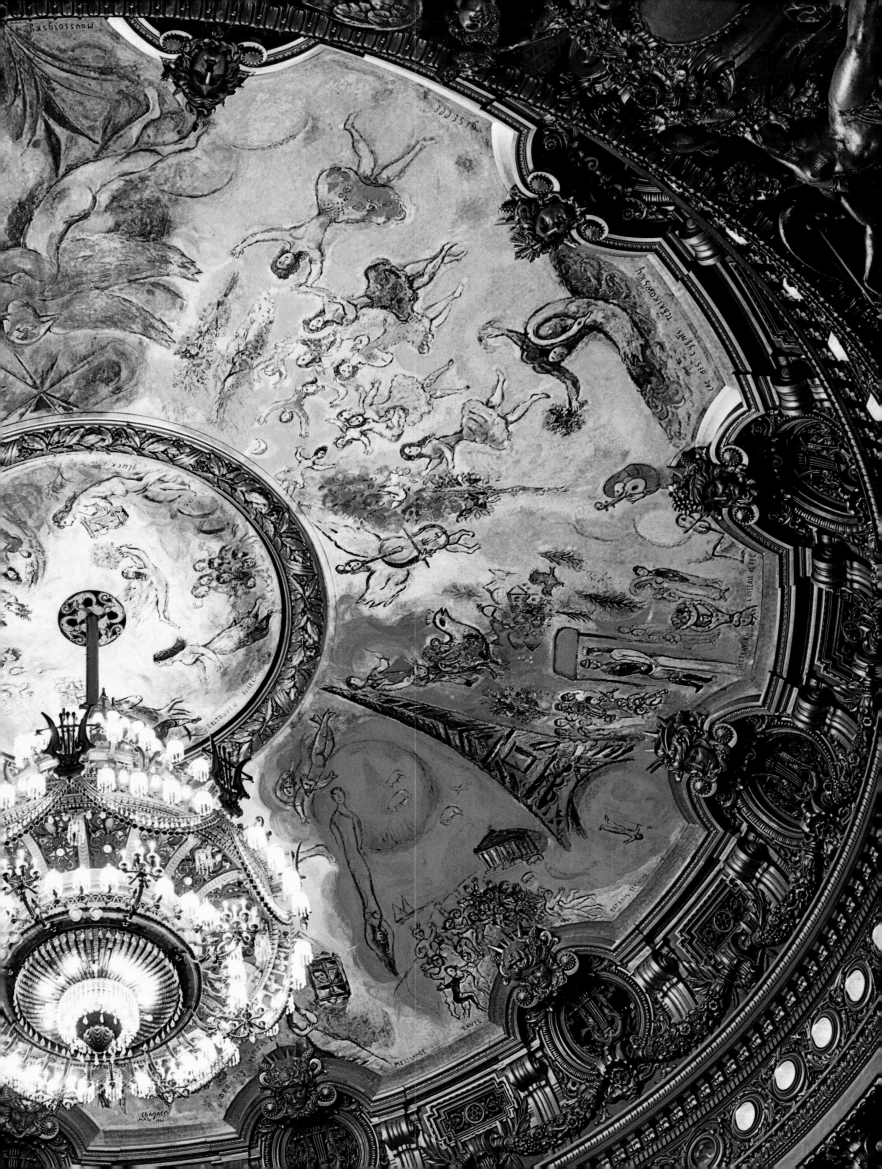

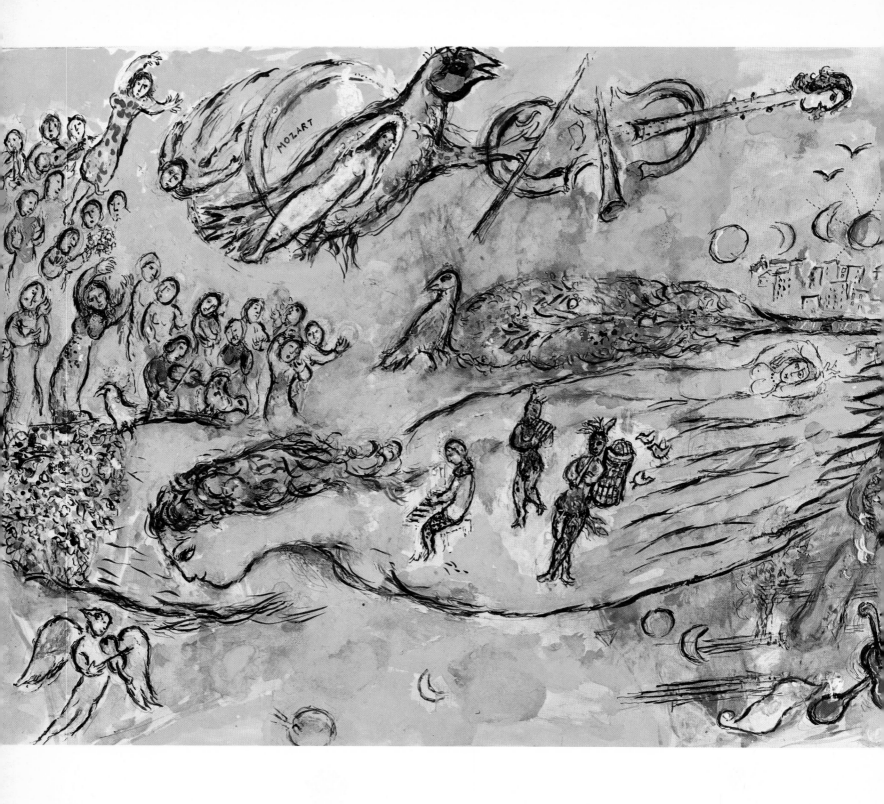

Homage to Mozart. Opening curtain for "The Magic Flute." 1967. *(Photo Jean Dubout)*.

the time was sharply criticized; but, times having changed, it nonetheless was used by George Skibine as the basis for this new homage to Ravel. The musical work is delicate and complex, balancing impetuous vitality with almost static moments. Aside from the kidnapping of Chloe by pirates, it contains few dramatic elements; it is above all a mood work in which Ravel exalts youth and the lyrical emotions of the young lovers. This impressionistic poem loans itself to the subjective vision of each listener, and how to clothe it seemed to be a sort of wager which, however, did not frighten Chagall.

Rather than trying to provide a description, Chagall decided to create an unsubjugated, independent work, and with this in mind his primary recourse was to use color and intensity. The richness is excessive but fully satisfying for the spectator who, once swept away by the sounds and the color, surrenders totally to it. Chagall here used light, mottled paint which the luminous effects support, giving it an almost phosphorescent sparkle. The costumes have no precise character; elements from the forest, flowers or vegetation, they blend in the general fairy-like atmosphere. Color then becomes a sort of prolonged vibration of the music. Yellow and blue predominate in the first curtain; dark blue spangled with a few reds, yellow and white in the second; glittering yellow in the last. Chagall created a magic space, favorable to passion, where the spirit of Greece seems present and that was ideal for the incarnation of the fable. Just as the midday heat makes a landscape shimmer, so all the forms lose their contours in the trembling radiance of the colors.

Once again, the precise outlines of the composition must not be defined by geometry but by other criteria. The figures, temples, fish, gods and goddesses are dispersed around the circumference of a huge oval where, as in the *Nympheas*, fragrant groves are reflected. We lose all consciousness of a fixed place, of the idea of above and below. On the contrary, the second curtain opposes the flashing mass of the waters to the distant line of the islands, which takes on the look of a gigantic fish. A red moon explodes like the clash of cymbals. Pursuing his idea to its limit, Chagall created for the third scene the equivalent of the lofty exaltation of a shimmering light. We can barely discern the line of a road with temples alongside or that of the crest of the hills; in its illumined outburst, the color becomes like the stridulous flute of a young shepherd in the beatitude of noon.

Here, as in no other ballet perhaps, Chagall has attained the high point of the incandescence of color, the fluidity of the great works of Monet, the secret tension of Mallarmé. It was difficult to do, but he did it. In its very structure, the decor exaltedly depicts the first innocence of a world where love was pure.

Chagall was offered yet another opportunity to execute a total spectacle in which sounds and

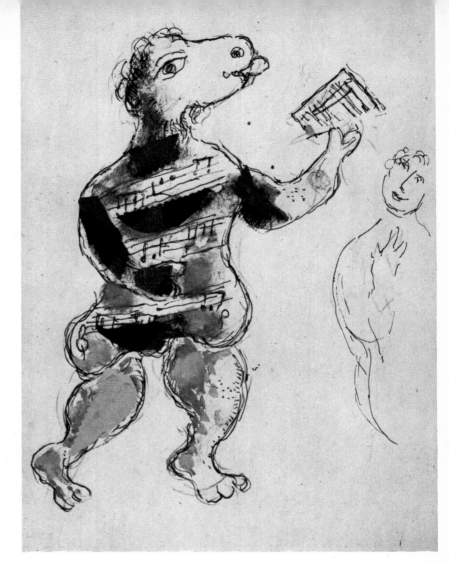

Animal. Costume for "The Magic Flute." 1967.

Demon. Costume for "The Magic Flute." 1967. *(Photos Jean Dubout).*

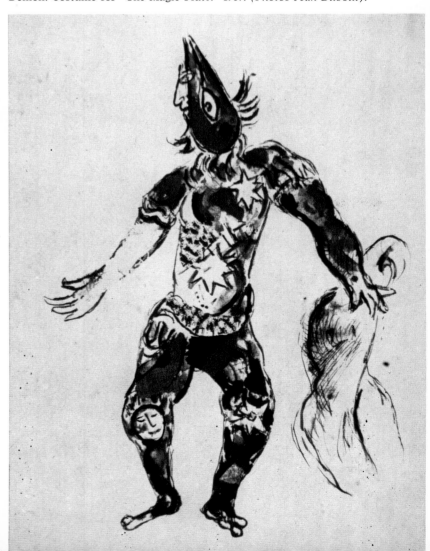

colors, intermingled, would seem to have the same essence, the same origin. He undertook the sets and the costumes for Mozart's *The Magic Flute* which was to be performed by the Metropolitan Opera of New York in 1967. Chagall has a predilection for Mozart and especially for that hermetic and fantastic work:

I adore Mozart, I couldn't refuse. He's a god, and The Magic Flute is divine, the greatest of all operas. No, I don't know why. It's impossible to say why a god is divine.... I got as close as I could to Mozart, who is so witty, so spiritual, so religious.

This project was the result of a meeting in 1964 between Gunther Rennert, a producer from Munich, Rudolf Bing, director of the Metropolitan Opera, and the artist. Chagall threw himself into this delicate and difficult undertaking with his usual ardor. During three years he composed no less than thirteen great curtains (54'×33'), twenty-six smaller canvases and almost one hundred and twenty-one costumes and masks. After having studied the staging and untiringly nourished himself on that music, Chagall gave his sets and models to the theatrical workshops who would execute them.

Chagall's anxiety was such that he came to New York a month before the scheduled date of the first performance. He then discovered that the sets, costumes and masks were nothing more than starting points and that he had to rethink them and take them up again. Feverishly, he painted an im-

"The Magic Flute." 1967. Curtain for the first act, scenes 1 and 3.

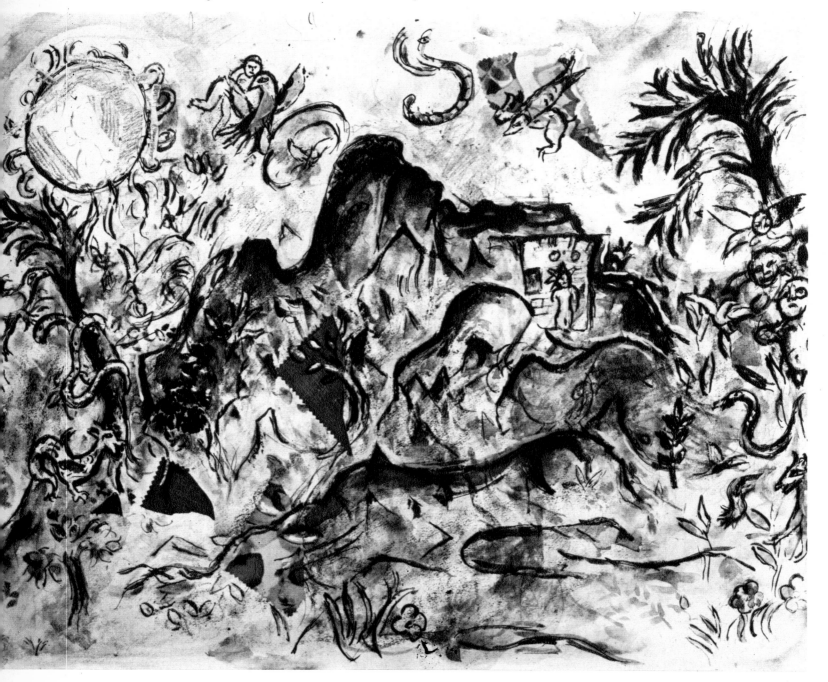

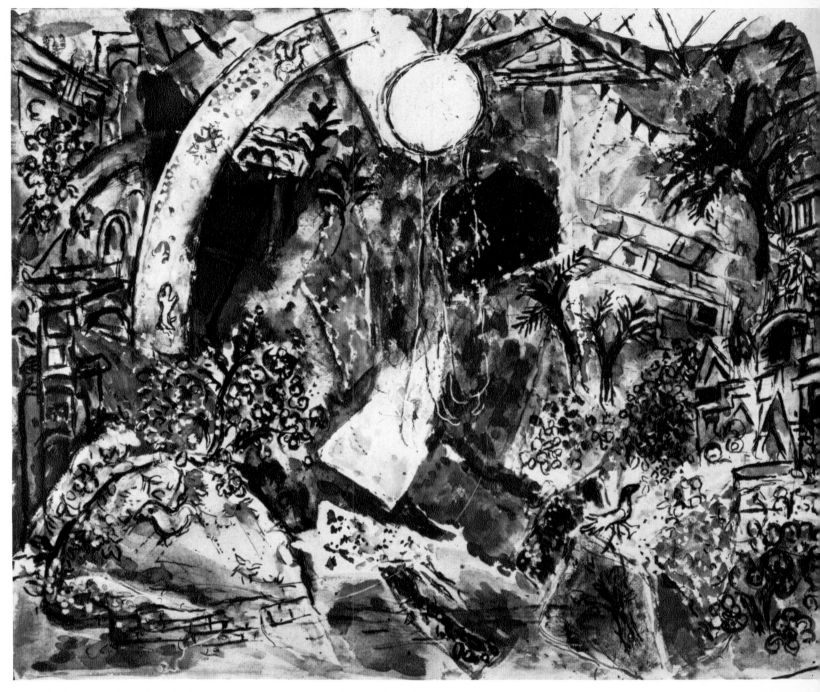

"The Magic Flute." 1967. Curtain for the second act, scene 3. *(Photos Jean Dubout)*.

mense homage to Mozart for the opening curtain. To give more density to his costumes, he changed the shapes, redid the colors and used different materials in order to accentuate the textures. He let his imagination go, gave himself up to bursts of inventiveness and pushed the expression of form to the limit. He sought out the superimpositions and transparencies that would be best adapted to the vicissitudes of the action, the lighting that would convey the work's unreal atmosphere, and the successive iridescences that would metamorphose the forms. However, all his effects definitely did not transform the original work and should rather be thought of as a pursuit of density. His

love of Mozart's music impelled him to discover a specific tonality that would imbue the work and become consubstantial with it.

For many, the monumental is expressed through the imperatives of geometry, but Chagall has a different idea. For him, it represents the history of the long development of his inner world. Great audacity was required to renounce precision and trust color alone, trust its power and intensity, to attain fluidity. Yet that is precisely the measure of Chagall's undertaking and what he accomplished. It enabled him to obtain that dazzling fusion of sounds, forms and colors so often sought by other means and so rarely achieved.

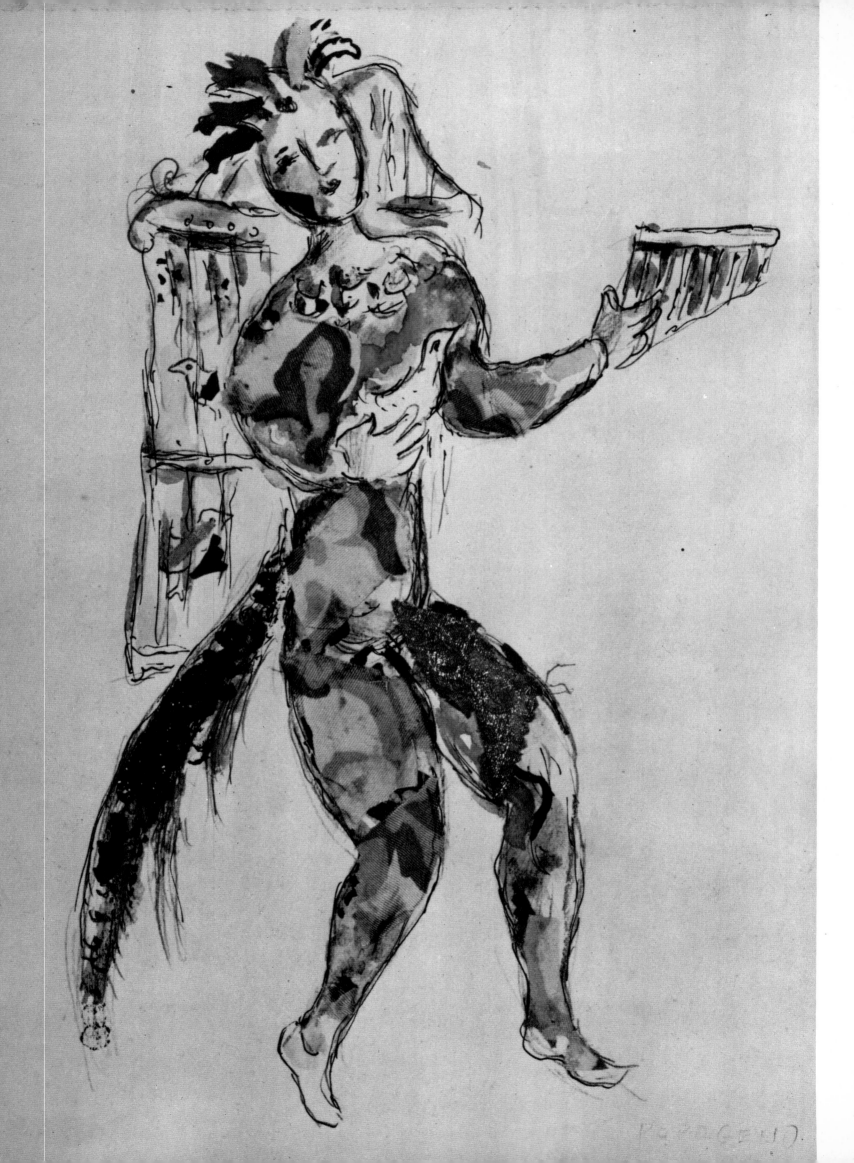

Papageno.

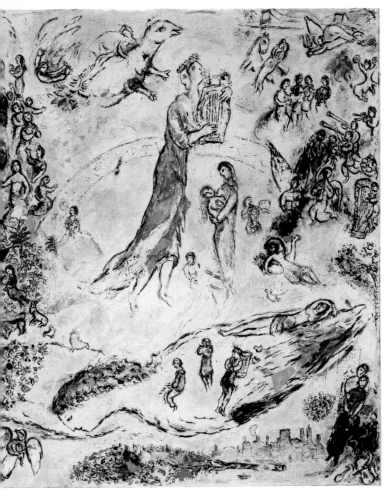

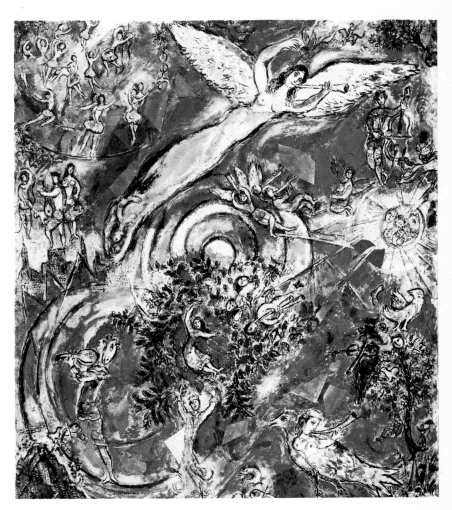

The Sources of Music. 1966. Final sketch. Metropolitan Opera, New York.

The Triumph of Music. 1966. Final sketch. Metropolitan Opera, New York. *(Photos Jean Dubout)*.

THE MURAL PAINTINGS OF THE METROPOLITAN OPERA

The two mural paintings that Chagall executed for the north and south façades of the Metropolitan Opera in New York face Philarmonic Hall and the New York State Theater. Their imposing size (36¹/₄'×29¹/₂'), their chromatic intensity and theme make them flamboyant oriflammes of the music. In Chagall at the "Met"....[1] *Mrs. Emily Genauer has underlined their importance by first comparing the architecture in which they are integrated with Saint Mark's Place in Venice.*

The Sources of Music *and* The Triumph of Music, *on account of their position in this architectural unit and the distance from which we regard them, lead us, as Emily Genauer writes, into "torrents of color richer and more vibrant than appear in any other Chagall work." The rhythm of the compositions and the waves they spread heighten the effect so that it is in accord with the proportions of the place. Mrs. Genauer goes on to point out:*

In The Sources of Music *the color is predominantly yellow, drenching the composition in ambient golden light, transforming it into a paradisiac dream-world in which, illogically but delightfully, there are glimpses of the here and now in New York.*

In The Triumph of Music, *predominantly red, color doesn't float but swirl, in great circles moving out from its central core to a separate golden sun at the extreme right whose center fairly radiates energy, to a series of looser, wider-flowing circles at the lower left.*

There is ceaseless compositional movement in both murals. In The Sources *the rhythm is gentler and slower, as each passage slips softly into the next; bird becomes nude, or river becomes tree, the whole thing undulating in an easy, even languid circuit. In* The Triumph *the flow becomes a torrent, carryng with it everything movable and in Chagall everything is always movable. Dancers are caught in the air. Musicians blow wildly on their trumpets as, their feet flying in all directions, they too are swept along. A violin without player bobs about. Even tall buildings careen with the current.*

Emily Genauer concludes:

It is triumphant in more than one sense of the word.

A. B.

[1] *Chagall at the "Met,"* by Emily Genauer (New York: Metropolitan Opera Association / Tudor, 1971).

Papageno. Costume for "The Magic Flute." 1967 *(Photo Jean Dubout)*.

The Biblical Message in Nice

Eternity Recaptured

by André Verdet

On Friday morning, January 12, 1973, Marc Chagall was at the work-site on the Cimiez hill in Nice where the Biblical Message Foundation was in the process of being built. He visited the various rooms that, since his gift was dedicated in July, 1973, have received his works. He spent a particularly long time in the music and conference room in front of the three stained-glass windows constituting *The Creation of the World* and on the patio in

front of the large mosaic, whose image will be reflected in the water of one of the pools. The stained-glass windows and the mosaic had been completed. Their setting is an integral part of the architectural scheme, which was carefully planned and took into consideration their long-range destiny and the spiritual light that emanates from them.

In an article published in the December, 1971

The Biblical Message in Nice under construction.

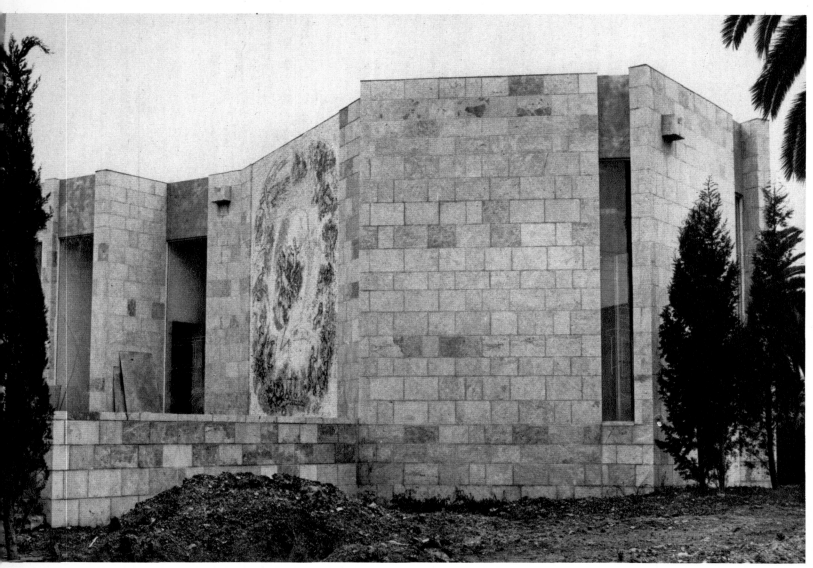

Marc Chagall in front of the Biblical Message in Nice, France. *(Photos André Villers).*

issue of *XXe siècle* (No. 37), the material, moral and artistic characteristics of the building specially designed for the *Biblical Message* were discussed in detail, providing a preview of the now-completed building.

It seems germane to recall here that in the mind of the great Chagall this project can in no way be likened to a "museum," as one usually conceives of such an edifice today. Rather, it is a "sensitive, spiritual place" open to winged meditation and subtle revery, "a place," Marc Chagall would say, "where a certain presence imposes respect."

The Biblical Message building allies structural

rigor, aesthetic function and high material quality. It has a clarity and a resoluteness of harmonious lines. The diversity of its lines makes for peaceful interplay between the rectangular spaces and the more inventive lozenge-shaped ones. The rooms inside are adapted to the terraces, pools and shaded gardens outside.

The stone, extracted from the neighboring mountains, reflects the bright sun and has a hard, clean look; it constitutes the principal element of the masonry, streamlining it in a way. Other metallic materials — alloys of aluminum and silicon — are used in conjunction with the noble stone.

Artificial light is combined with natural light in such a way that the lighting from all directions is optically unified in a tranquil flow, a peaceful radiance. The problem insofar as the inside galleries were concerned was how to temper the great, voracious luminosity of Provençal sky. This light is extremely intense because of the reflections of the sun on the sea a short distance beyond the spacious terrace that is on a level equal with the gallery-foyer of the Biblical Message. The precise problem was how to respect, to the letter, the safety regulations imposed by the Directorate of the National Museums and ensure the preservation of the works, the danger being that overexposure to light would fade the paper, ink, gouaches, etc.

I would also like to point out the use of tinted glass for the glass walls in certain parts of the building; this was done to prevent people's eyes from being dazzled by the very brilliant sun when looking out at the gardens.

The constant concern that guided André Hermant, the architect, was to serve to the best of his ability the cosmogonic thought of Marc Chagall, his lofty inspiration, the plain song of the pure legend. The studies for, and the execution of the work on the superb site provided by the city of Nice were carried out over a period of a few years under the joint supervision of the Directorate of the Museums of France and the officials of Nice. The painter of the *Biblical Message* made his first donation to France in July, 1966. The Louvre Museum (Mollien Gallery), for a memorable exhibition in 1967, accepted the large paintings done after 1955 as well as several important gouaches and watercolors dating from 1930 and 1931. The exhibition enabled the public to understand with what fervor, awareness and insight Marc Chagall had prepared the development of the majestic pictures whose rich lyricism towers above and crowns all the studies he did for so many long years. The second donation, like the first, was made by Marc Chagall and his wife Vava.

The true spiritual starting point of the *Message* goes far back in time, no doubt to Marc Chagall's stay in Palestine from February to April, 1931. Ambroise Vollard had commissioned him to do some etchings for a Bible. The artist had just illustrated Gogol and La Fontaine. He departed for Palestine because, as he said, "I wasn't seeing the Bible, I was dreaming it." Contact with the landscape of the Holy Land, with that sort of luminous and fluid streaming of the legendary centuries, gave him both a revelatory shock and the dazzling confirmation of the meaning of his preceding works related to biblical motifs. Here, under the lovely Palestinian sky, he discovered the poetic and at the same time the spiritual element of those works in which nostalgia for the fabled land soared toward mystical regions.

He had seen the trace and heard the echo in his past works.... And here he was face to face with a land in which history continued to live and be incarnated, from a distance certainly but still present through its myths, among the most ancient of human civilization.

When Chagall returned to Paris from Palestine, he painted for himself a series of gouaches which today form part of the *Biblical Message* in Nice. In the same burst of inspiration, he set to work on the etchings intended for Vollard. From 1931 until Vollard's death before the war, more than sixty plates were made. But it was not until 1952, after Chagall had come back from his exile in the United States where he had fled from Nazism, that the painter resumed this work; completed in 1956, it was taken over and published by Tériade in 1957.

When Marc was a child in Vitebsk, his birthplace, the reading of the sacred book had rung in his ears like the sound of golden music. Throughout his adolescence it provided him with a sort of poetic sustenance with the flavor of a charm whose essence was expressed by the philter of time and past centuries—that same flavor and essence that we can find in many pictures by Chagall. Not only the Old but the New Testament inspired him when his talents as a painter began to be affirmed. In 1910 he painted a *Holy Family* and drew a *Christ on the Cross*. A gouache of 1911 depicted the figures of Cain and Abel. His affection for the Bible grew as can be seen by, among others, three *Golgothas* (1911 and 1913), *Susannah Bathing*, and two *Resurrections of Lazarus* (1912 and 1913). For the next fifteen years, until 1930, when Chagall met Ambroise Vollard, his inspiration moved away from the sacred book.

Then the biblical theme came back powerfully with pictures that we can classify among the most charged with lyricism and drama in all of Chagall's painted work. Thus we have *Solitude* (1933) with its intense emotional force, *Angel with Red Wings* (1936), *Fall of the Angel* (1937), etc. Later on, the mystical inspiration shifts from the Old to the New Testament, and there are an abundance of Christs: *White Crucifixion* (1938), *The Painter and Christ* (1938-1940), *Yellow Christ*, *Descent from the Cross*, *Persecution*, *Christ with Candles* and *Mexican Crucifixion*, (canvases executed between 1941 and 1944).

After the dramatic flowering that continued through 1951, the Old Testament once again became the focus of Chagall's inspiration; *Abraham and the Three Angels* marks the beginning of a series of large canvases: *David, The Crossing of the Red Sea, Moses Receiving the Tables of the Law, Moses Breaking the Tables of the Law*.

In 1955 the painter settled in Vence. Near his house there was a Way of the Cross with a large chapel flanked by a sacristy and smaller votive chapels strung out like so many stations of the cross. These buildings had been deconsecrated. The village officials thought it might be possible to have the chapels decorated by the painter. Chagall welcomed the idea. He planned to begin with the large chapel, which because of its size and structure best lent itself to his purposes.

The Prophet Elijah. 1970. Mosaic. 23'6⁷/₈''×20'11¹/₂''.
Biblical Message, Nice.
(Photo Jean Dubout).

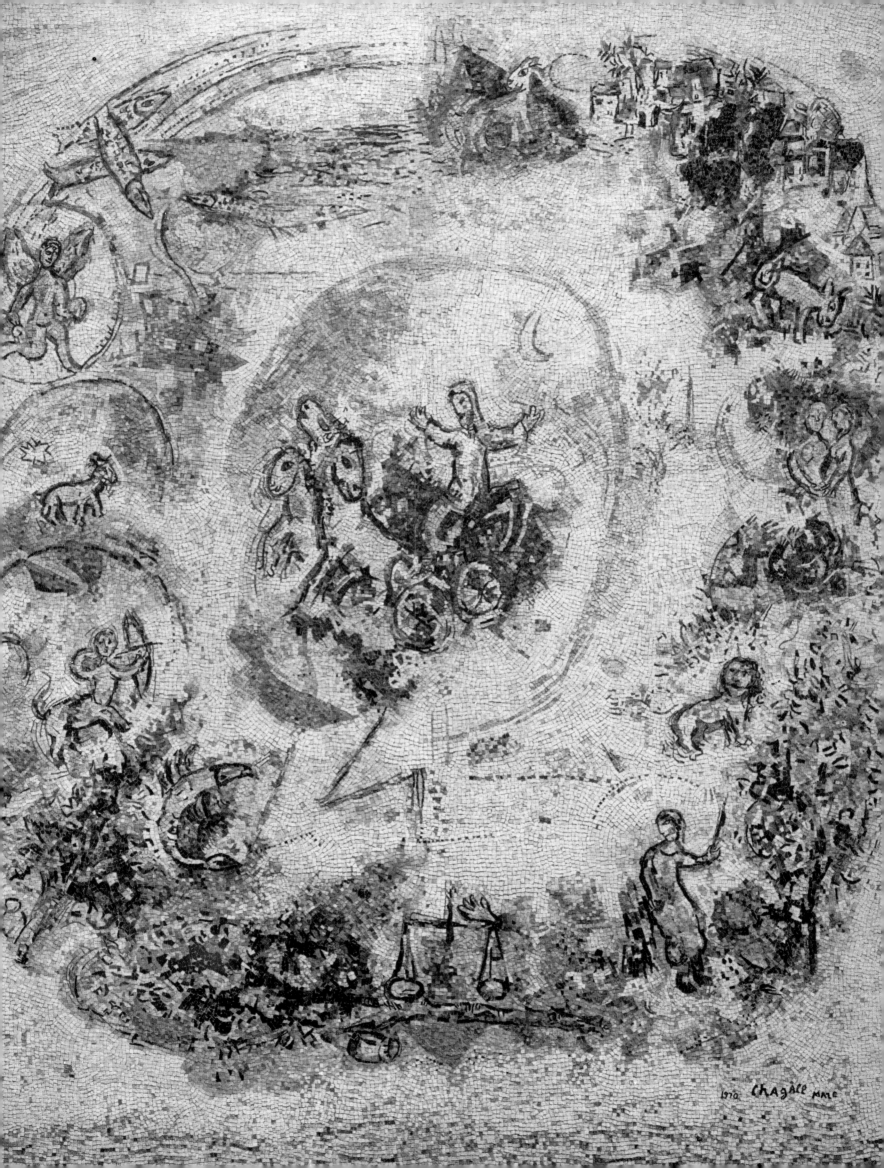

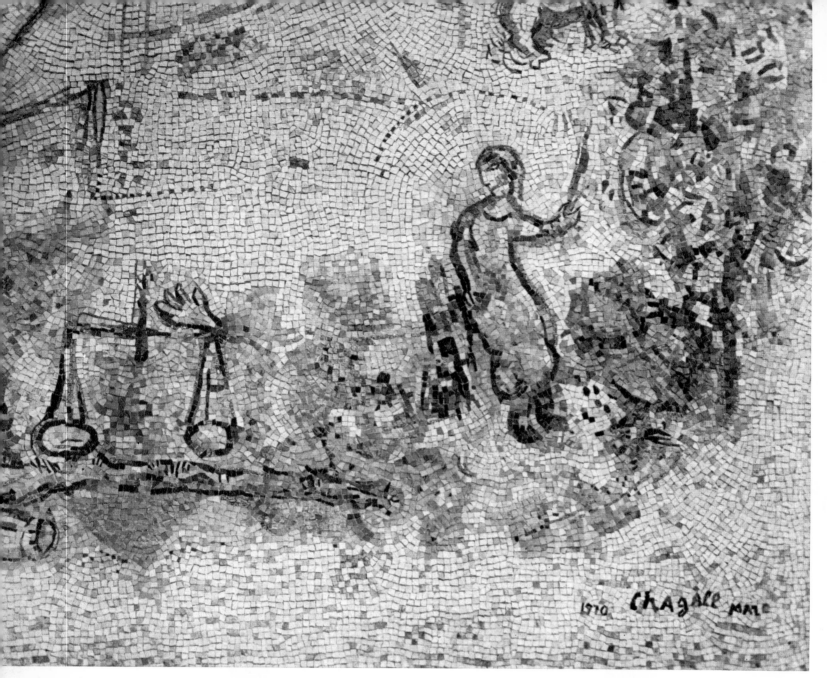

The Prophet Elijah. Detail. 1970. Mosaic. 23'6⁷/₈''×20'11¹/₂''. Biblical Message, Nice. *(Photos André Villers).*

For a long time the artist meditated before the white spaces. He measured each wall. Mentally, he prepared the installation of the canvases and their subjects. As he stood alone in the silence of the rooms, the images that rose in his imagination were gradually suffused with the enchanted fervor to which he has remained faithful ever since his young hand seized pencil and brush to try and set on canvas or paper that world of supernatural legends told to him from the Open Book, that world of mystery, wonder and terror encrusted like an immense sign from an immemorial time. The young Marc also found its echo and coloring in the smoke-blackened icons of old Russia.

In Vence, Marc Chagall plunged into the work, exalted by the project for the chapels of the Way of the Cross. Once the measurements and the locations in the large chapel had been determined, he began painting large canvases scaled to the architecture of the walls. He had decided to use

Genesis, Exodus and the Song of Songs as motifs. Thus he painted for the back of the apse a *Creation of Man*, flanked on the right and the left by an *Earthly Paradise*, an *Adam and Eve Driven Out of Paradise*, a *Jacob's Dream*, and a *Jacob Wrestling with the Angel*. For the right transept Marc Chagall had visualized a *Sacrifice of Abraham* and a *Smiting the Rock*, and for the left transept a *Moses Receiving the Tables of the Law* and a *Noah's Ark*. For the nave a *Burning Bush*, *Abraham Entertaining the Three Angels* and *Covenant of the Lord with Noah*.

Starting in 1955, then, seventeen canvases were born in silent enthusiasm. But the Vence project couldn't be realized. The canvases created for the Vence project are among the works that can be contemplated on the Cimiez hill in Nice. Twelve of them fill the large Genesis and Exodus Room. The five others adorn the Room of Songs.

The seventeen paintings have been placed in

The Prophet Elijah. Detail. 1970.
Mosaic. 23'6⁷/₈''×20'11¹/₂''.
Biblical Message, Nice.

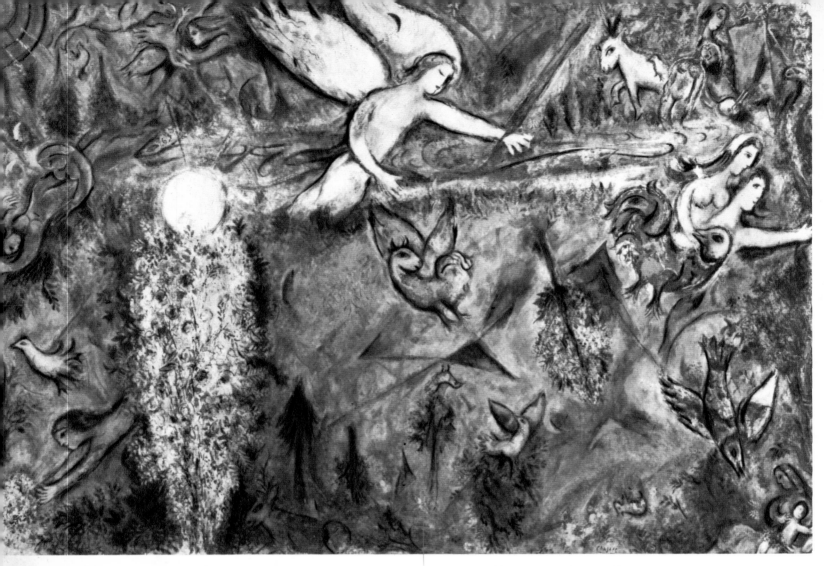

Adam and Eve Driven Out of Paradise. Oil on canvas. 74³/₄"×111". Biblical Message, Nice.

rooms whose measurements, volume and style of architecture were designed to be in accord with that of the Vence chapel.

The other rooms hold an important collection of studies, gouaches, watercolors and copperplates, a perfect introduction to the large central compositions; regardless of whether one considers the latter to be pictorial or monumental, the additional presence of the former causes the Biblical Message Foundation to truly take on the air of a Spiritual Place. It is personalized and raised to the level of a cosmic symbol by the demiurgic genius of a visionary painter who was able to reinvent—so that today's crowds can better perceive its astonishing poetic content—the images of one of humanity's oldest sacred texts, a text considered to be one of the major and most probing parts of the Enigma: that original, incessant dialogue, now terrible, now appeasing, between God and his creatures.

The biblical stories are integrated in the historical process of the Afro-Mediterranean civilizations. They profoundly nourished Chagall, who has furnished us with a plastic version that is only related to his visionary art. He interprets, makes them his, while respecting the spirit, the law I might say, of the Scriptures. Having forgotten the pictorial tradition that was connected with them,

rejected conventional iconography and the irritating anecdotal aspect, he imparts to them youth and freshness, charm and a new force and does so in such a way that contemporary man, touched in his heart and soul, becomes attentive to their ontological meaning, their moral resonance on the plane of the complexity of human destinies.

The Word is painted. Painted, it attains an epic grandeur, often verging on the sublime, but at the same time it remains familiar, grazed by fantasy and winged grace. Its severity is full of touching details and, like a stubborn and tenacious flower, a bit of dawn always pierces the heart of the tragic. The drama in it is accompanied by humor and candor. The appeasing starry idyll appears in a vast, prophetic, eternally blue night. What is described here is precisely the ineluctable confrontation between God and man (I was about to write between God and his gods and men, or between God and Nature raised in front of him).

The Creation consists of three stained-glass windows: *The Elements* is devoted to the first four days, *The Species* to the two following and *The Lord's Rest* to the seventh day. *The Elements* (15'3¹/₂"×13') is adorned with a vast, dominating ultramarine blue in the center of which oranges, rubies, pinks, greens and yellows spring up, blossom, flash or shimmer, grow lighter or deeper or

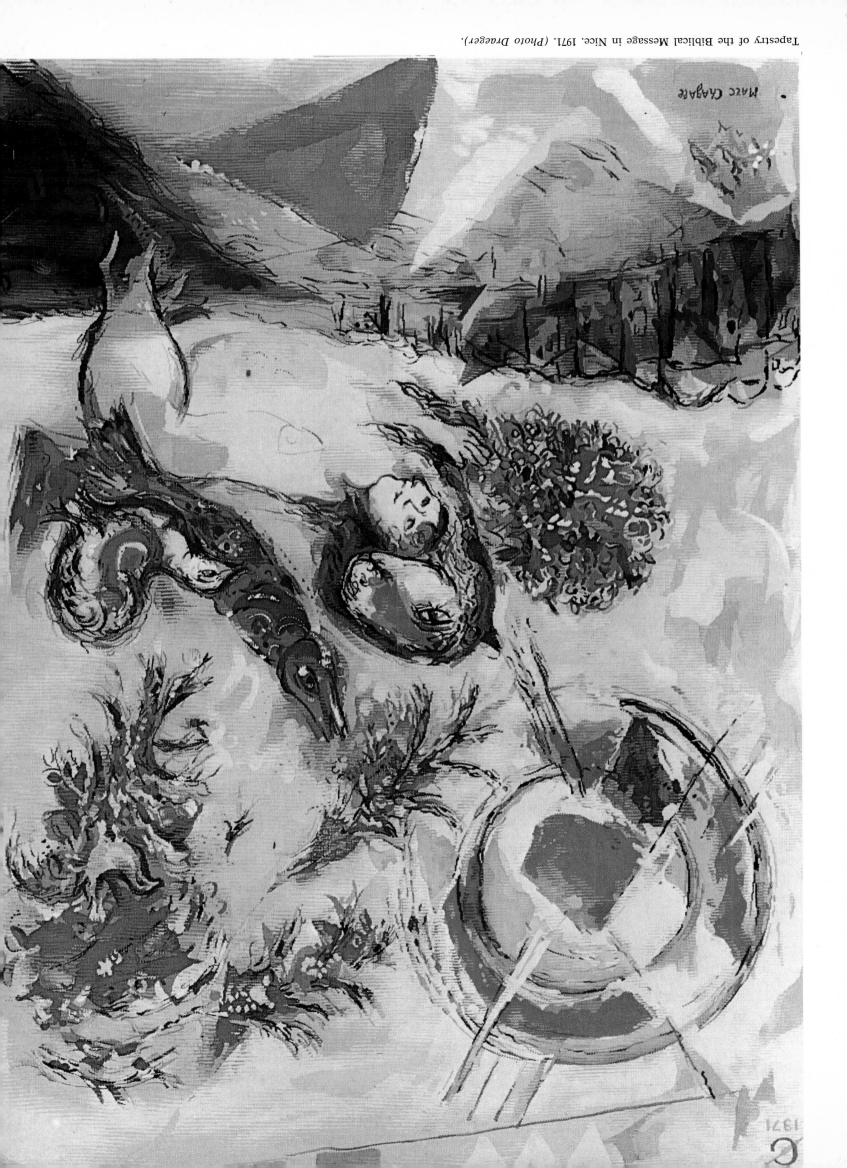

The Creation. Stained-glass windows of the Biblical Message in Nice. 1971/72.
From right to left:
The Elements, 15'3½"×13'. (Photo Jean Dubout).
The Species, 15'3½"×8'9". (Photo Jean Dubout).
The Lord's Rest, 15'3½"×4'2⅜". (Photo André Villers).

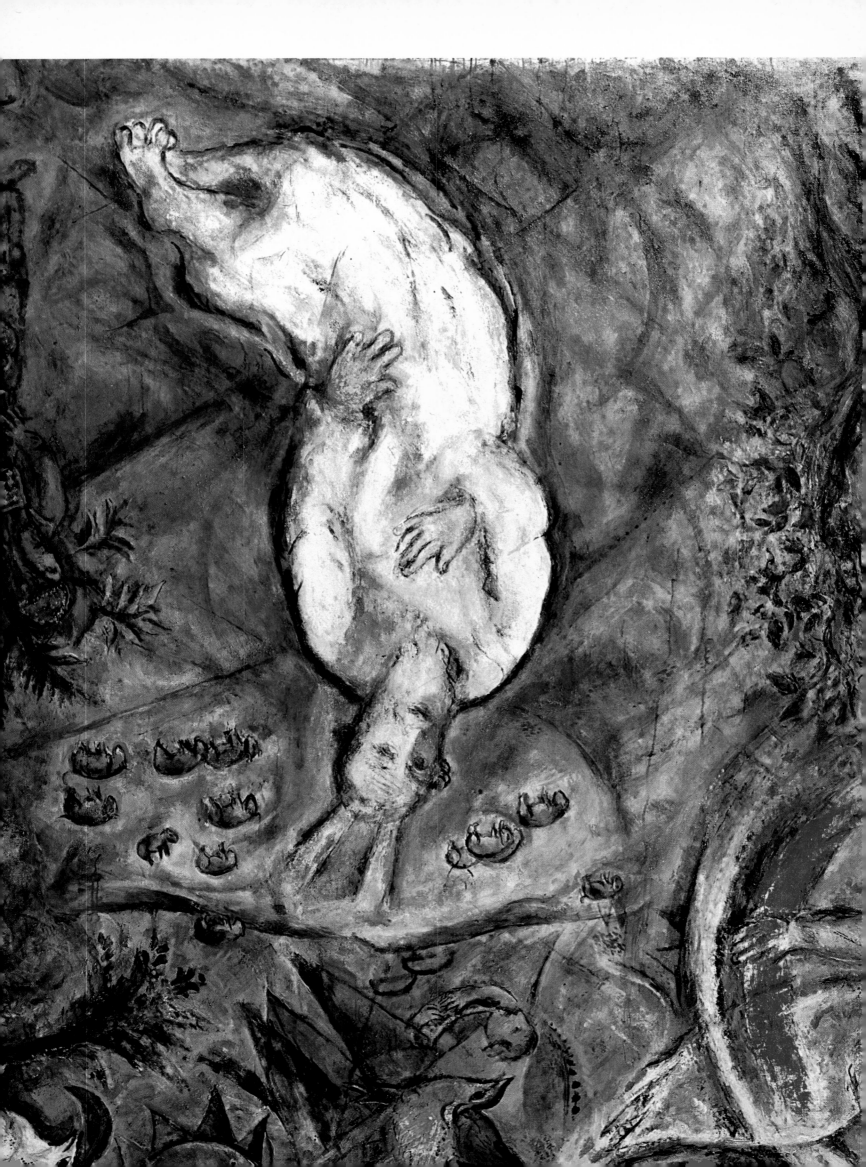

Moses Faces the Burning Bush. Oil on canvas. 76³/₄″×122⁷/₈″. Biblical Message, Nice.

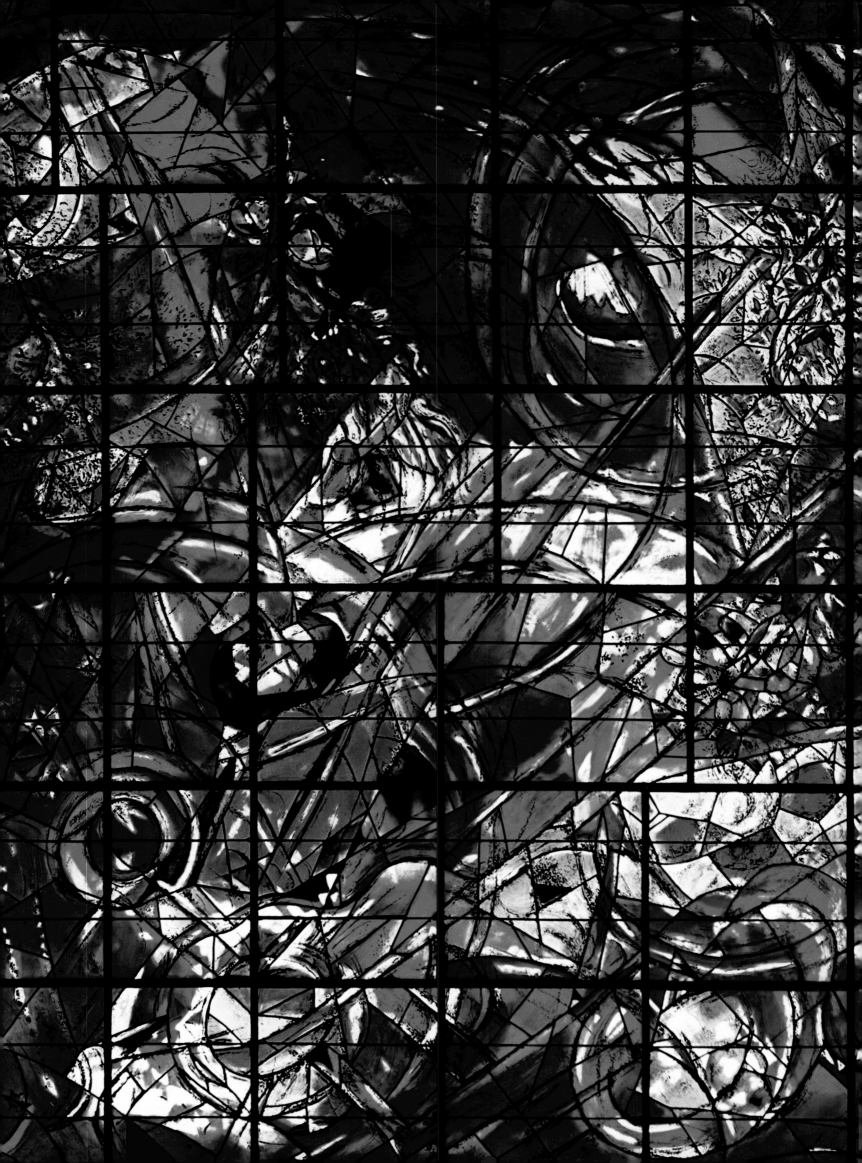

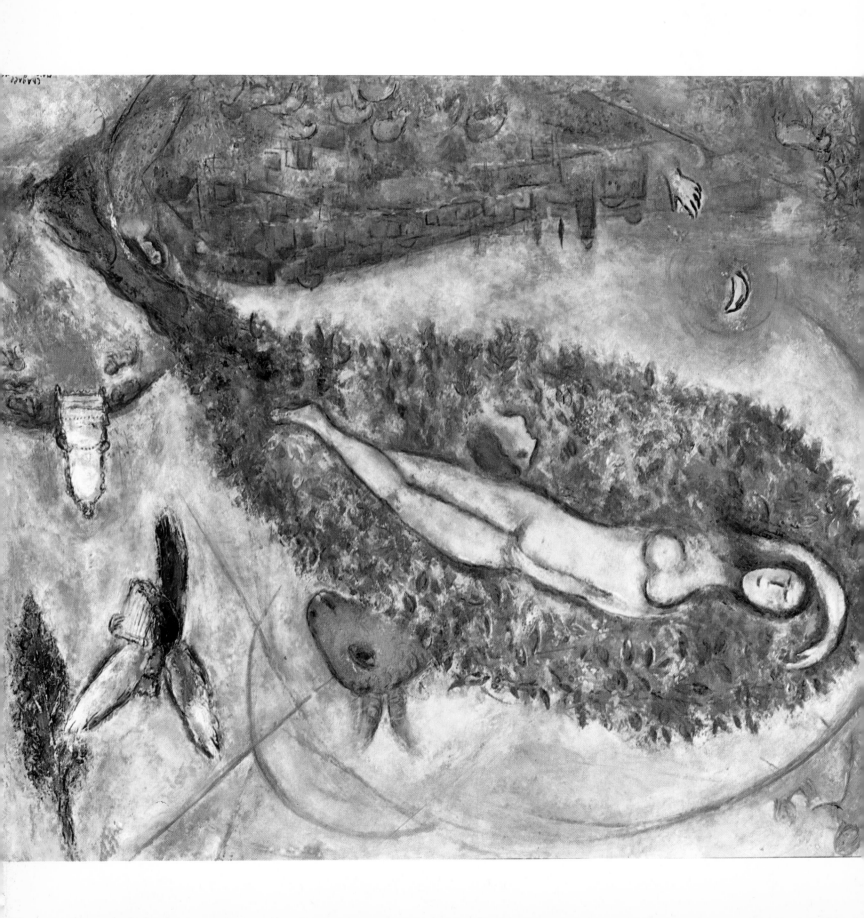

The Song of Songs. 1957. Oil on canvas. 55⁷/₈"×64¹/₂". Biblical Message, Nice.

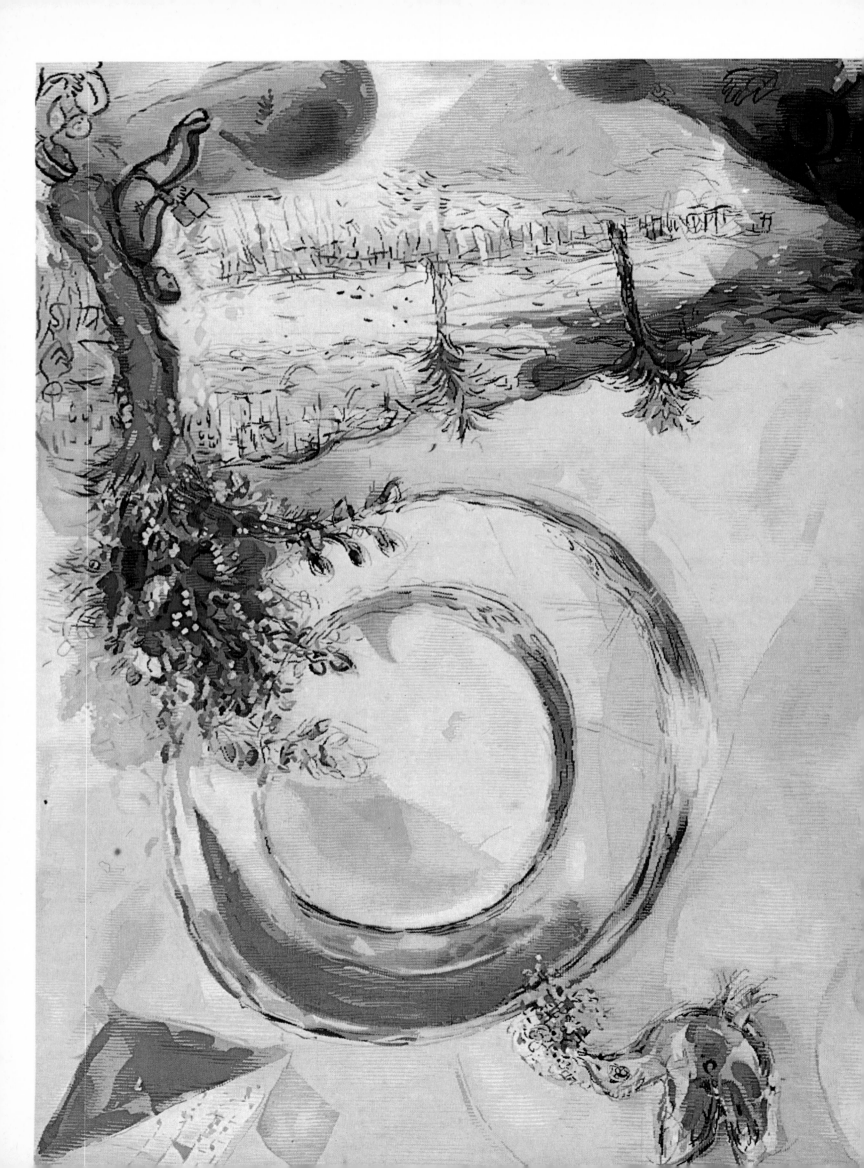

recede, depending on the time of day and the changing availability of light. At dusk a violet abyss little by little extends its solemn empire under a nocturnal velvet wherein a few astral forms still continue to flicker and burn out in the darkness of Genesis.

There is a dynamic conception behind this stained-glass window. The abstraction of the forms thrust into space and clothed with a creative light hides a powerful concentration of forces, forces drawn out of chaos, orchestrated, integrated into an already cosmic rhythm. Structural lines, struggling against each other, establish points of tension, relations between movement and speed: circles and diagonals in full trajectory, some fuse-shaped, some orbicular. We are confronted with the dynamism of the light and the celestial mechanisms: suns and planets.

Cobalt blue is dominant in the stained-glass window of *The Species* (15'3¹/₂"×8'9"), that of the Creation of Man, the Animals and the Plants. Here are Adam and Eve, the Serpent, the Goat and the Birds, the whole fauna familiar to Chagall, the creatures of his countless fables.

Triumphant angels cover the space of the third stained-glass window, that of the seventh day, *The Lord's Rest* (15'3¹/₂"×4'2³/₈"). Here again the forms emerge from the controlled yet powerful dynamics; faceted prismatic forms, a little like stones mounted in space, with developing chromatic vibrations, are metamorphosed according to the position of the sun, changing with the morning, noon and early evening light. As in the two other stained-glass windows, we find the same lines of inner tension, feel the "electricity" that runs through them.

As usual Marc Chagall worked in the Simon workshop in Rheims in close collaboration with Charles Marq, the master glassmaker who always assists him and whose sensitivity, creative craftsmanship and intuitive gifts for transposing the work are highly appreciated by Chagall.

Standing before the stained-glass windows of Marc Chagall, we perceive the work for the first time: the light absorbing, dissolving the mechanical lead framework. The technical skill of Charles Marq was put at the service of the painter's inspiration, became one with it, as it were. Hence, when the jointly carried out work was complete, the effort was invisible in the face of the work it helped to create.

Marc Chagall supplied the master glassmaker with a model scaled to a tenth of the size of the final window. Charles Marq studied it for a long time, bent on discovering its "insides"—what was hidden and existed within it. He tried to capture its main intentions. Then he transposed the pictorial language of the model into the masses of basic colors and the leads.

One of the major triumphs of the master glassmaker consists in his ability to underline the principal movements of the composition by the placement of the leading. The initial lead frame-

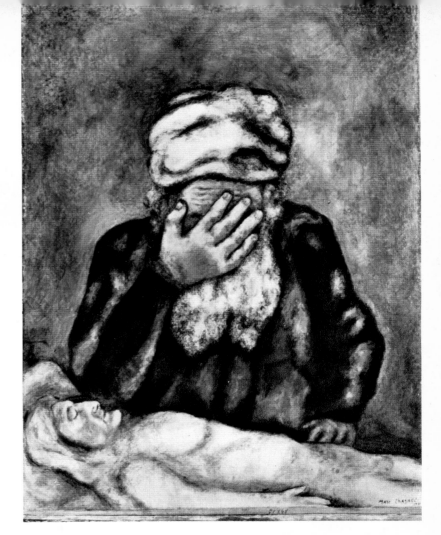

Abraham Mourning Sarah. 1931. Gouache. 24⁵/₈"×19¹/₂". Biblical Message, Nice.

Noah Releasing the Dove. 1931. Oil and gouache. 25"×18⁷/₈". Biblical Message, Nice.

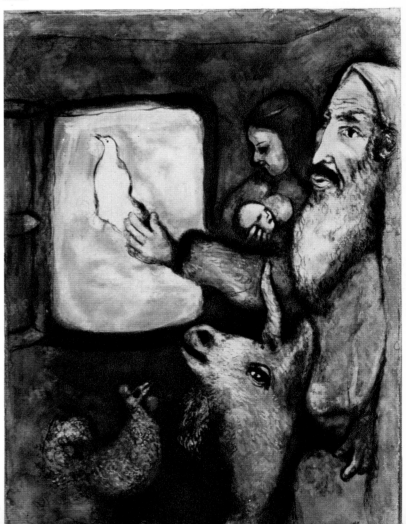

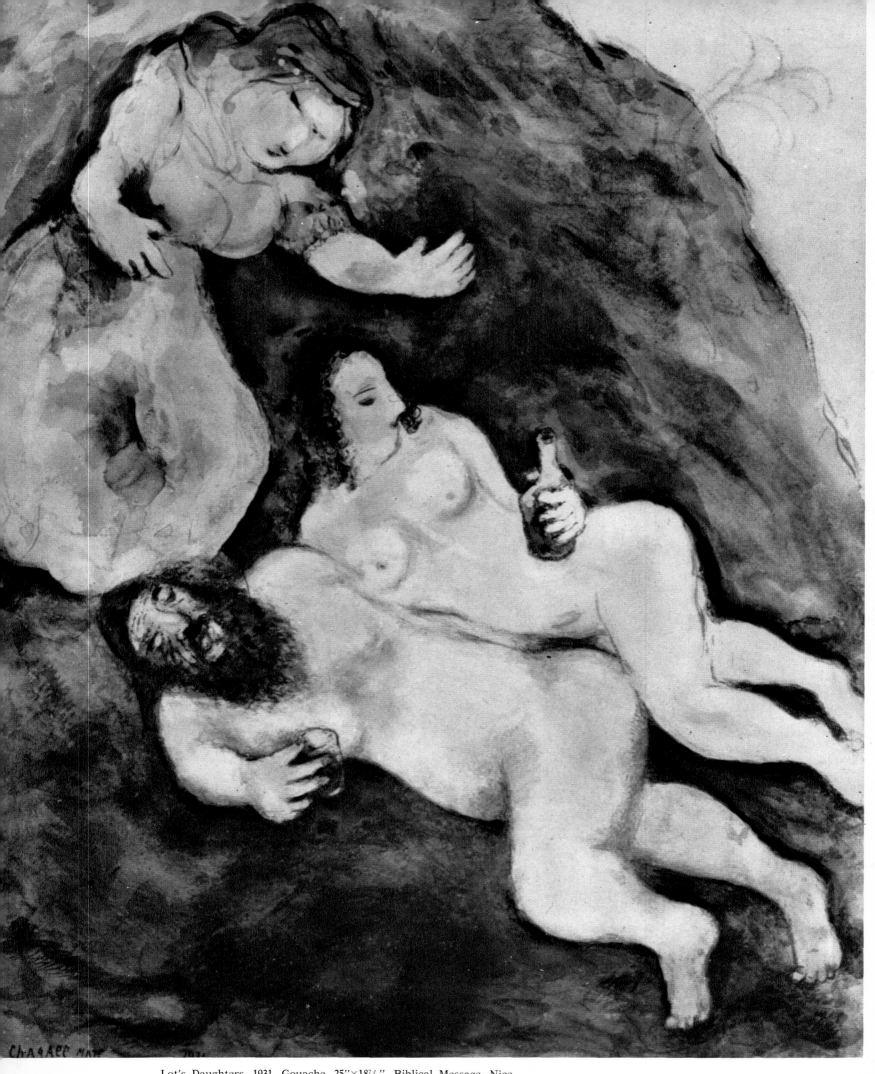

Lot's Daughters. 1931. Gouache. 25″×18⁷/₈″. Biblical Message, Nice.

The Israelites Eating the Paschal Lamb. 1931.
Gouache. 24⁵/₈″×19¹/₄″. Biblical Message, Nice.

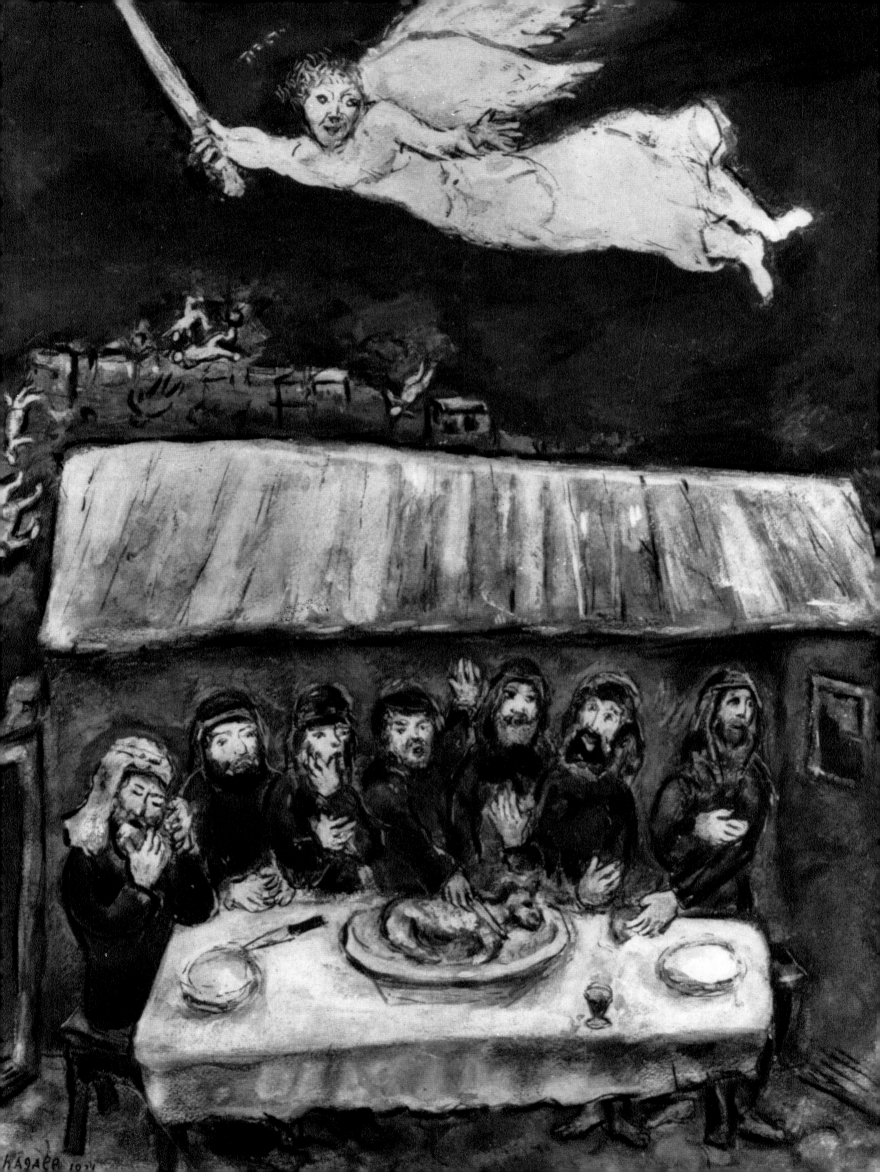

work is basically graphic, contributing to the expressiveness of the drawing and the color. The second is purely mechanical, contributing to the maintenance of the work's structural soundness and the physical strength of its armature. The master glassmaker must avoid monotony in the windows by breaking the lines; a systematic geometrical checkered system would be fatal to the work.

The artist can, if he judges it necessary and after consulting with his assistant, rectify, add or substract certain lines from the leading of the first framework.

Marc Chagall's work consisted in painting directly on the surface of the colored glass, adding to the masses of basic color. In technical terms this is called "applying the grisaille." The structure of the composition is worked out after the principal forms and details have been decided upon. Such and such a design is emphasized by a harder or softer contour. The work requires constant vigilance, since the physical nature of a pane of glass and the specific use to which a stained-glass window is put necessitate following other rules than those that govern an oil painting. In the end Chagall had to integrate into his design, without any break, the various leadings required by the master glassmaker. In order to sensitize the background matter, in this case the colored glass, the artist employed scratchings, or what he calls "peckings." Soon the surface was sprinkled and tattooed with traces, imprints, figures similar to those in engravings found in ancient caves, polymorphic enigmas.... Eventually, these "peckings" are transformed into *signs*. When the stained-glass window is illumined, they are drowned in the triumphant light, in the sacred apotheosis of the colors. Nonetheless, they live in the incessant metamorphosis like imperceptible particles of swarming life, buried in the splendor, robust fossils of space and the air.

The monumental mosaic on the patio, *The Prophet Elijah*, rises on one of the side walls of the Foundation above a pool whose water will reach the level of a watermark on the mosaic which is one of the linear plastic elements of the work. Elijah, upright on his fiery horse-drawn chariot, in the shape of a prow, constitutes the central figure. He surges up like an apparition. A sort of astral line envelops, encircles him like an aureole, outlines his beige-colored form, reminding one of a planetary crust, a planet from which the words of the Prophet Elijah will soon thunder forth.

The space around Elijah and his chariot is filled with the symbols of human destiny which appear to move around him in a clockwise direction; we clearly feel the turning of the stars and the constellations, each of which is itself carried away by the revolving motion suggested by a subtly sketched circle. The duration of motion and the rhythm of time are thus fixed in space. The interpretation is miraculously fresh: an aerial vision that resembles the pictures in children's storybooks. The whole

King David. Rogne stone stele. 30¹/₄"×16¹/₂"×7¹/₂". Biblical Message, Nice.

work sings like a pure poem of love. The figures seem to escape from a dazzling dream, to be made iridescent by a thin cloud that becomes more and more blurred, impalpable celestial smoke.

It is like a rich field sown with graduated hues and washed out colors, with bursts of flowers and subtle blossoms in pale colors. The forms bathe in pools of tenderness. They are often outlined by a supple, nervous line that accentuates the astral rhythm of the composition.

The discreetly emotional sensitivity of the matter, impregnated with memory, charged with meaning, is adapted to the medium of the stained-glass window or of the oil paintings: it resembles a fluid in which can be discerned the constantly enriched chemistry of Marc Chagall.

A barely perceptible spinning motion was imparted to the whole set of stones, glass marbles, etc. whose arrangement on a concrete wall ends up by forming a gigantic palette in which the general background greys are, I believe, the source of the chromatic iridescence of the composition, the basis of the accord between all the different tones.

The reds that dominate the upper right-hand section are those of the Sign of the Bull. They contrast with the other colors, initiate a dynamism, set the eye in motion and lead it to the right in order to bring it toward the blues and then into the rotation of the Zodiac, of which Elijah the Prophet seems the guide and master.

Lino Melano, the ceramist, one of the most sensitive specialists in Europe and who for many years has been assisting well-known artists, collaborated with Chagall on this composition (23'6$^7/_8$"×20'11$^1/_2$") and helped him to successfully produce a mosaic that I believe is one of the painter's most outstanding monumental works.

The two curators, Charles Marq and Pierre Provoyeur, are delighted when Marc Chagall pays them an occasional visit. Their conversation about the *Biblical Message* sometimes turns into a spiritual exchange as they walk through the beautiful rooms, still deserted and open to the wind, or under the numerous olive trees that make the gardens peaceful. The two curators know that the *Biblical Message*, of which they are the trustees and which they guard, will give to men in search of culture and knowledge not only a part of the innumerable and often enigmatic riches of the Scriptures, but will affirm the most meaningful presence, that of the painter-poet illumined within by the Obscure Word of the Origins and Destinies.

A haven for meditation offering the public a spiritual sense of grave joy and of the pathetic grandeur of existence, the *Biblical Message* will be endowed with four sculptures and a tapestry woven at the Gobelins, in addition to the paintings and mosaics.

Moses. Rogne stone stele. 20$^7/_8$"×8$^5/_8$"×3$^1/_2$". Biblical Message, Nice.

The Stained-Glass Windows of Chagall

The Alchemy of Light

by Robert Marteau

Angel. Stained-glass window for the baptistery of the church at the Plateau d'Assy, France. 1957.

The art of "the window" sounds so simple: the materials, the light. For a cathedral or a synagogue it is the same phenomenon: a mystical thing that passes through the window. However, I was as frightened as one is on his first date. The theory, the technique, what are they? But the materials, the light, now that is creation!

MARC CHAGALL

When Chagall was introduced to the space of the stained-glass window, he was given the privilege of being more transparent, lighter, because of the very gravity of the song. He was being chosen; he himself did not choose. His subject matter was his whole life, since early childhood. To borrow an image dear to Cendrars, the poet closest to Chagall's heart, the window of the temple was to become the necessary membrane for osmosis between the heart of man and the heart of the world. What did the undertaking demand? That he illuminate the Book that had illuminated him. A humble task, as well as an immeasurable one, in which humility alone would be powerful enough for him to be received in the anonymous communion of the Chartres and the Bourges craftsmen. This Chagall had been aware of even before he started, had always been aware of it. And he is seized with enthusiasm because he clearly realizes that this is an opportunity for him to offer sincere thanks for the gift he has received. The artist frees himself, just as he knows he is made free, by a compact which vindicates what centuries and millenia have proclaimed, namely that the work of art, long ignored as such, never grows or expands if it is not grounded in the spiritual.

What Chagall also knows is that the stained-glass window is ruled by a destiny entirely different from that of the painting: first on account of the place, which is neither the collector's gallery nor the museum. Also on account of the eyes that will look at it, which are not art-lovers' eyes but worshippers' eyes. He will let others discuss the techniques; his job is to impart the urge to pray to the onlookers, the eye giving precedence to the heart as a mode of perception. What Chagall wishes is that his work should be assimilated by the architecture of the place as well as by those

gathered by the same faith. He wants not to impose his imprint but to mingle his own music with the song that everyone secretly whispers. And when his window is seen inserted in the stone for which it was destined, our first emotion is born from that sudden evidence that Chagall has exalted his gifts only to give them away. And in this submission he reveals to us and makes us see what the blinkers of custom had gradually obscured. For it is true that Chagall is a man who awakens. His vision cannot flourish in lethargy. Ceaselessly nourished by his sensibility and his feelings, it animates the whole space where it takes shape and vibrates into the hearts of his fellow creatures. And it is clear that it is not out of carelessness or indifference that he by-passed fashion but out of an irresistible necessity, a compulsion to obey the commands of his blood, the deep music whose perception he was blessed to find within himself.

In this way his whole work acquires a particularly clear meaning in his windows; it seems to me that all the intuitive experience of Chagall is there brought into focus, that in them are fused together the finding and the spelling out of tradition and intuition. Not having to bother with invention and its undercurrent of cerebral activity, he discovers in his net of images the living verve that permanence constantly needs in order to perpetuate itself, whose truth is called life and movement. The discoveries of the heart, that is what Chagall offers us, and such is the offering that he provides between earth and heaven for the sun to diffuse its beams.

Need we add that Chagall has the great merit of having relied on the most secure traditions of the craft without renouncing a whit of his freedom and personal vision? From the outset he recognizes the art of the stained-glass window as autonomous. With him it is not a matter of transposing painting to the medium of painted glass, but a meditation at work within a specific medium. What we find here and there simultaneously are the gestures, the emotions and the unalterable unity of his nature. Not unlike the old masters, Chagall knows that the subject matter of the stained-glass window fundamentally lies in the interplay of the glass and the light. But, like them, he also knows that it is necessary to do extra teaching and moving, so as to go beyond mere virtuosity for virtuosity's sake and beyond the risk of shutting oneself off in decorative sterility. Accordingly, it seems to me natural at this point to pay homage to those who served this design when transcribing the incantation that Chagall ceaselessly renews at its fountainhead. I have in mind Brigitte and Charles Marq. The inheritors of the finest tradition, they translate into action their sensibility, their science and their technique in their workshop at Rheims. They set about their task with the gravity required by passion. They are the attentive curators of song, around which they know how to weave a latticework which will heighten it, rather than imprison it.

Angel. Stained-glass window for the baptistery of the church at the Plateau d'Assy. 1957. *(Photos Jean Dubout).*

Notre Dame de Toute Grace Church, Plateau d'Assy

The two windows placed in the baptistery of the church of the Plateau d'Assy are born out of the white glass where some flickers of red and blue still burn occasionally while the silvery yellow underlines the general grayness. Two angels combine their trajectories so that the fire of the Spirit may be united with the water of grace. It is an image of baptism, the perpetual act of life, which is death and resurrection. On one side, the holy vase holding the primary and regenerating waters;

on the other, the candlestick with six branches equally distributed right and left:

Three bowls made like unto almonds; with a knop and a flower in one branch; and three bowls made like almonds in the other branch, with a knop and a flower; so in the six branches that come out of the candlestick. And in the candlestick shall be four bowls made like unto almonds, with their knops and their flowers.... And thou shalt make the seven lamps....

Exodus XXV, 33-37

Chagall does not illustrate, does not describe, he only suggests. But what? Well, this impenetrable mystery in which we are steeped and which constitutes us. Look at the sphere which blooms here in the hands of the celestial messenger, it is our earth undoubtedly, and each flame around the sun is certainly a planet poised in the sky, and, furthermore, the luminaries shedding light on the twenty-two revealed letters are at once the mothers and the daughters of John's Word:

All things were made by him; and without him was not any thing made that was made. In him was life; and the life as the light of men. And the light shineth in darkness; and the darkness comprehended it not.

John I, 3-5

It is also the dove:

I saw the Spirit descending from heaven like a dove, and it abode upon him. And I knew him not: but he that sent me to baptize with water, the same said unto me, Upon whom thou shalt see the Spirit descending, and remaining on him, the same is he which baptizeth with the Holy Ghost.

John I, 32-33

It is also the darkness changed into light and at Cana, the water changed into wine:

the governor of the feast called the bridegroom, and saith unto him, Everyman at the beginning doth set forth good wine; and when men have well drunk, then that which is worse: but thou hast kept the good wine until now.

John II, 9-10

The two windows are a hymn to the light that will be overcome by darkness, to the knowledge that the carnal creature receives through the Spirit.

Cathedral of Metz

From 1958 to 1968 Chagall works for the Cathedral of Metz. He illuminates three windows and the triforium, setting his most extensive poem into the gothic stone:

The more our time refuses to see the whole face of the world and restricts its gaze to a very small fragment of its skin, the more anguished I grow when considering this face in its eternal rhythms and the more intent I am on fighting against the general trend.

I store away the painter's words as his brush is setting the Sinai aflame. But first:

there was under his feet, as it were a paved work of a sapphire stone, and as it were the body of heaven in his clearness.... And the Lord said unto Moses, Come up to me into the mount, and be there: and I will give thee tables of stone.

Exodus XXIV, 10 & 12

That red up there, that devouring red, is the divine Love as it is perceived by the people down below. Moses alone is allowed into the mystery: sucked upward, he is a flame in the fire, a torch and a twisted fringe. He wears on his forehead the white horns of lightning, a single foot still treading the ground as his whole body is ascending the ladder that the angels are wont to climb. He receives the stone, the *donum Dei* that the alchemists are searching for, materializing the spirit and spiritualizing the matter. And this twofold current, the very principle of life that is symbolized by both the double beat of the heart and the death-resurrection couple, this restless stream which is the vertiginous drift of the Universe, recaptured in the lead network of the stained-glass window, suddenly burns, spreads, casts its gleam upon the crowd in the desert while a solitary witness, Aaron, already fancies himself invested with the priesthood.

David now: godlike virtues, human manifestations, the springtime of the tree of Jesse. What David, the harp-player, receives is the greenness of breath, of the wind (*viento verde* as Lorca would have it), of the sap, of the creation; he is Orpheus, the regulator of chaos, the poet inspired by God, who establishes order and peace through the power of music. Toward him we see Bathsheba coming, the feminine principle of the world awakened by love. To those nuptial festivities are convened the sun, the men, the animals, the entire cosmos given over to dancing and gleefulness.

Fright, cruelty, horror, the crucifixion, the bird of nightmare, the book scoffed at, the inverted city:

He cast down from heaven unto the earth the beauty of Israel

the veiled light, the fall, the return to chaos; stains, bites, soiled colors, splotches as if left by the lees of wine:

His children have been carried away captive before the oppressor

Would that God had ordained that the prophecies should not be accomplished! Jeremiah, so sweet and so loving in heart, why were you chosen even before you were conceived in your mother's womb, you, the oracle of the Lord?
Why were you chosen in times when only woe could be augured? Why did you have to oppose all—kings, priests, false prophets, people of influence and the smaller fry—without being able to open the eyes of anyone, without being able to delay the slow lingering death of the kingdom of Judah?

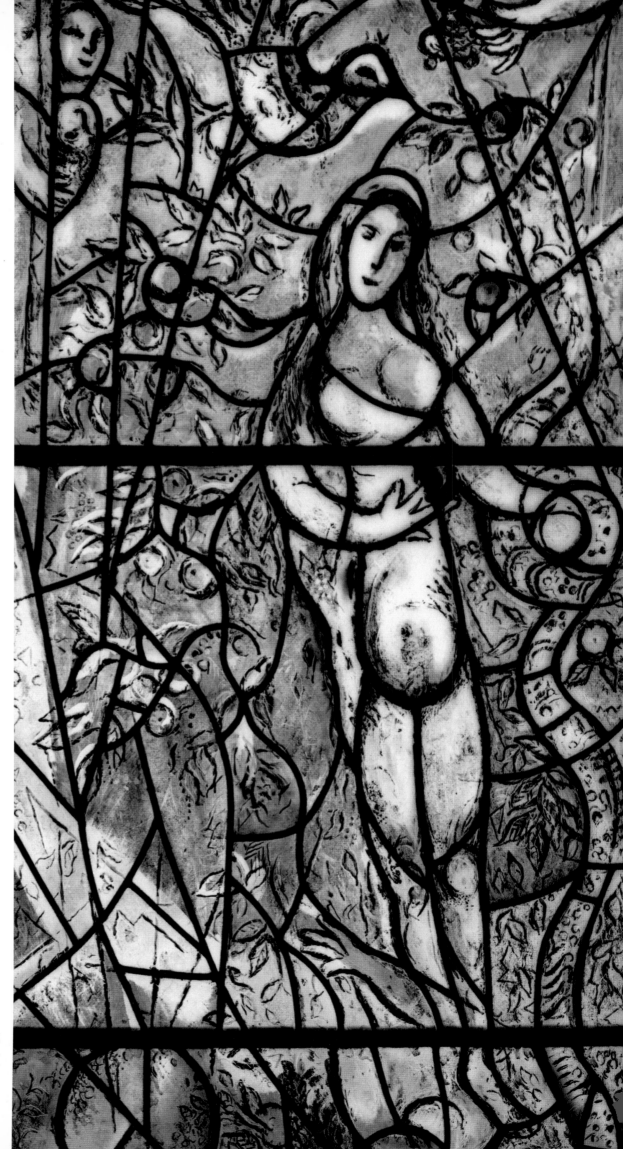

Eve and the Serpent. Detail, 1964.
Third lancet of the north transept window
on the west side of the Metz Cathedral, France.
(Photo Jean Dubout).

The Tribe of Naphtali. 1961. Stained-glass window. 11'1"×
8'2½". Synagogue of the Hebrew University Hadassah
Medical Center, Jerusalem. *Twelve windows, all the same
size, oriented in groups of three on the four cardinal points.*
1960/61. *(Photo Daniel Frasnay).*

What a contrast with the preceding window!
But also what a masterful triptych is composed by
those three works! See how Chagall can tremulous-
ly twang the three taut strings of his instrument,
in a single stroke of his bow revealing the know-
ledge, in which human love is poised between the
two poles of the divine revelation and of the misery
subsequent to the veiling of God.

Higher up, the center of the sphere and of the
rose whose petals he links together, Christ still
crucified over and over, even in heaven, by the
men blind to the reality of the Spirit.

Given the office of the priesthood by Melchize-
dek, who made offerings of bread and wine to the
Almighty, Abraham stands here bathed in the blue
hue diffused by the wisdom made manifest by the
breath of the Creator. No sign of doubt on his
face, marked only by the loftiest obedience; to

Isaac his son he answered: "God will provide
himself a lamb for the burnt offering"; this is the
moment when it is said:

*And they came to the place which God had told him
of; and Abraham built an altar there, and laid the
wood in order, and bound Isaac his son, and laid
him on the altar upon the wood. And Abraham
stretched forth his hand and took the knife to
slay his son. And the angel of the Lord called
unto him out of heaven, and said, Abraham,
Abraham: and he said, here am I. And he said,
Lay not thine hand upon the lad, neither do thou
any thing unto him: for now I know that thou
fearest God, seing thou hast not withheld thy son,
thine only son from me.*

Genesis XXII, 9-10

This, a premonition of crucifixion, the supreme
sacrifice, when God lets himself be the holocaust
in the fire of the cross. Prefiguring Christ, Isaac
enlightens us with his meek and total innocence.

Jacob has crossed over the ford. Can he see the
fiery wings of his opponent?

*Tell me, I pray thee, thy name. And he said,
Wherefore is it that thou dost ask after my name?
And he blessed him there. And Jacob called the
name of the place Peniel: for I have seen God face
to face, and my life is preserved.*

Genesis XXXII, 29-30

Jacob fought: he received unto himself divine,
intemporal power, which is love and light; he sees
and experiences the real nature of the world that is
illustrated on the ladder by the two inverted an-
gels, a double and similar movement of the forces
that only this metaphor can make visible.

Chagall knows that the color of a flame changes
according to the wood that feeds it: the bush in
front of Moses is suffused with a blue tinge without
endangering its tender flower-like hues; on the
contrary, this fire causes the tallest blossoms to
open out, this fire is the fountainhead of the green
water of the saps and the streams.

Darkness has received the light and has given
birth to the world, to the stars, to the sun which
animates all things, the very image of Christ,
ceaselessly crucified and resurrected. The ever-
lasting Virgin is leaning above him, a chalice in
which childhood is restlessly renewed. Red: divine
love in action. Blue: shield of wisdom upon the
face and breast of the Creator. Life pulsating in
the whole cosmos. "And God said, Let us make
man in our image, after our likeness" (Genesis I,
26). "In him was life; and the life was the light of
men" (John I, 4). Having created man, God made
a gift of himself, and to live is to die and be reborn
in every moment to that gift. And every morning
the first rays of the sun on the first lancet of the
transept reread and repeat the first chapter of the
world, as the painter has there brought emergence
and sprightliness to the most peaceful serenity.

74

The Synagogue of the Hadassah-Hebrew University Medical Center, Jerusalem

When I made my etchings for the Bible I went to Israel, where I found both the light and the earth that is the substance. At Metz, for my first windows, there was stone to cope with. In Jerusalem everything is new, but here I have my talisman. When you are twenty you don't bother about substance. To do so you must have gone through suffering, or have grown old. Sometimes I am told: "But, Chagall, you are unsubstantial" and I answer: "You have to be unsubstantial to understand what substance has to say."

So Chagall speaks, and he goes on, still referring to the windows destined for the synagogue of the Hadassah Medical Center: "When they are assembled, they will form a kind of crown. Each color must be an enticement to pray...." adding: "I cannot pray myself, I can only work."

It is said (Numbers IX, 15-16):

And on the day that the tabernacle was reared up, the cloud covered the tabernacle, namely, the tent of the testimony; and at even there was upon the tabernacle as it were the appearance of fire, until the morning. So it was always; the cloud covered by day and the appearance of fire by night.

The tabernacle, which is the tent of the testimony, is now the synagogue, and the cloud that crowns it with the appearance of fire is the celestial ring or the migrating sun. The celestial crown is, in effect, the twelve glass houses that Chagall built beneath the Judean sky, so that the sun could pull them each morning from the night, visit them each day, and bless them with its rays, a daily reminder of the gesture of Jacob, the father of the twelve tribes through his sons Reuben, Simeon, Levi, Judah, Zebulin, Issachar, Dan, Gad, Asher, Naphtali, Joseph, and Benjamin, whom he blessed before going to join his fathers "in the cave that is in the field of Ephron the Hittite. In the cave that is before Mamre in the land of Canaan. [There they burried Abraham and Sarah his wife; there they buried Isaac and Rebekah.]" (Genesis XLIX, 29-31).

This is a reminder that the synagogue, like all temples, is an earthly reflection of the cosmos, and the tabernacle is a reflection of the Lord, just as every man is himself a microcosm and a temple where God dwells in the form of the source of light. Just as the sky was divided into twelve parts by the zodiac, so the land of Canaan a truly celestial land as much as the other, was divided among the twelve tribes. It is the act of the universe that Chagall brings back to us by coloring the twelve units of glass, by coloring the white light of Judea, by working with red, blue, yellow, green, by drawing and by using black as a filter. It is a lattice-work, a locked cage that imprisons neither the wing nor the song, a cage to extoll effusion, to make the visible transparent, to color

the wave and the vibration, a cage whose squirrel is the sun of the nativity, Jacob, who gives birth and who gives names.

Union Church of Pocantico Hills

On that Good Friday of 1970 spring was already in the air. For half an hour the train clattered across the huge wasteland outside New York amid automobile cemeteries, heaps of scrap-iron, bricks and discarded tires.

The Reverend Marshall L. Smith met us with his car at Tarrytown, and drove us to his church in Pocantico Hills.

The Hudson River flows at the bottom of the

The Good Samaritan. 1964. Stained-glass window. 14'7²/₃"× 9'1¹/₄". Chapel of Pocantico Hills, New York. *This chapel comprises eight other windows, all the same size: 4'10¹/₄"× 3'10¹/₂", and the same year: 1966. (Photo Jean Dubout).*

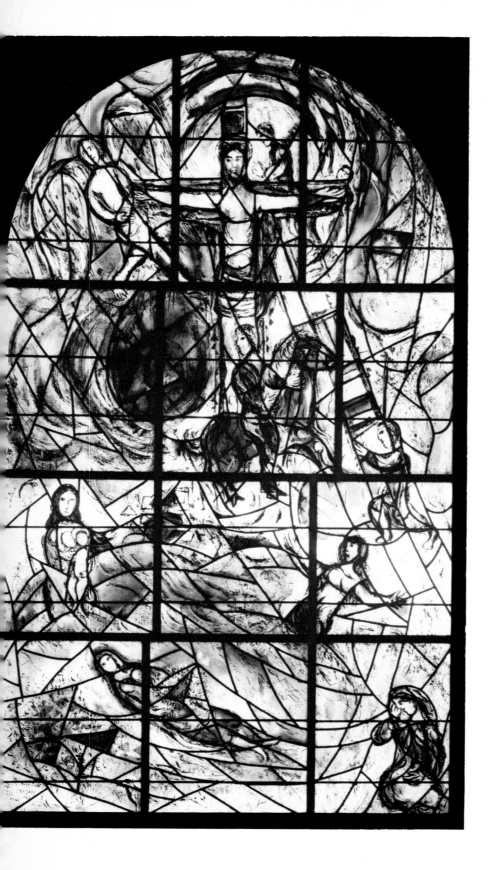

hills. The chapel appears between the elm trees, which keep the air slightly damp and impart to the atmosphere the subtle shades that can be observed on rose petals. It is not steeped in solitude, but in a particular silence, the living silence of nature stirred by the rustling of the wind, the whirring of wings, the songs of birds. You go in: the woodwork, the stone walls and the colors do not shut you in but make you feel welcome. Nature itself is made welcome in the same way, and you experience the rare happiness of hearing in the stained-glass windows the same praise of the sunshine that is whispered by the grass and the dew, the feathers, the branches, the blackbirds and the breeze. And this praise is the prayer to which everything invites you and in which it urges you to join. It springs from a feeling of nuptials and harmony; it blooms from the inside and quivers in each petal of the window. It is uninterrupted music, a brook, a river where the world is mirrored, where the fish scales echo the spotted wing; it is a fountain for the thirsty where the poet-prophets can deeply drink. They are the witnesses of the Spirit, the oracles of God. In the wanderings, in the ruins, in the fall and the exile, they maintain the prevalence of the light. The craftsmen of the Word, they relentlessly work, so that the crumbling walls should not engulf the Revelation. Where is the fountain from which they will draw up the water and the fire? Within themselves, for they are the transparent men of God. Through them the sun refracts its warmth and its light, stirs them up, moves them from fright to quaking. I see them shuddering as though the prophetic flux were still besieging their image. It is the greatness of Chagall to make visible by means of line and color that heaven which lives in them. Broken by history, they are reborn among the gems of the celestial City whose boundaries are measured by the angel with the golden rod. Men of visions, they are the precursors and the contemporaries of the singer of Patmos. History is not a riddle for them; it blinds the people and the princes, but it is a written book for one who keeps his eyes from the dust. In the blue, in the yellow, in the green of the windows of the Pocantico Hills chapel, time is transfigured: it is regenerated in its origin; like sunbeams it plays on the surface of water. Above and beyond the blood and the tears, what Chagall makes visible to the heart's inward eye is that flimsy and fragile plant, the prayer, a spot where colors reach the purity of that lily that Simone Martini and Leonardo da Vinci were fond of painting in their Annunciations.

In the great west window, dedicated to the memory of John D. Rockefeller, Jr., Chagall illuminates the insinuating ways of love and charity upon the earth. He knows how to fill a face with pity and sweetness, how to make a gesture carry the feelings expressed by the eyes. Everything is centered upon the Samaritan; the horse seems to be a messenger between two worlds, even as the

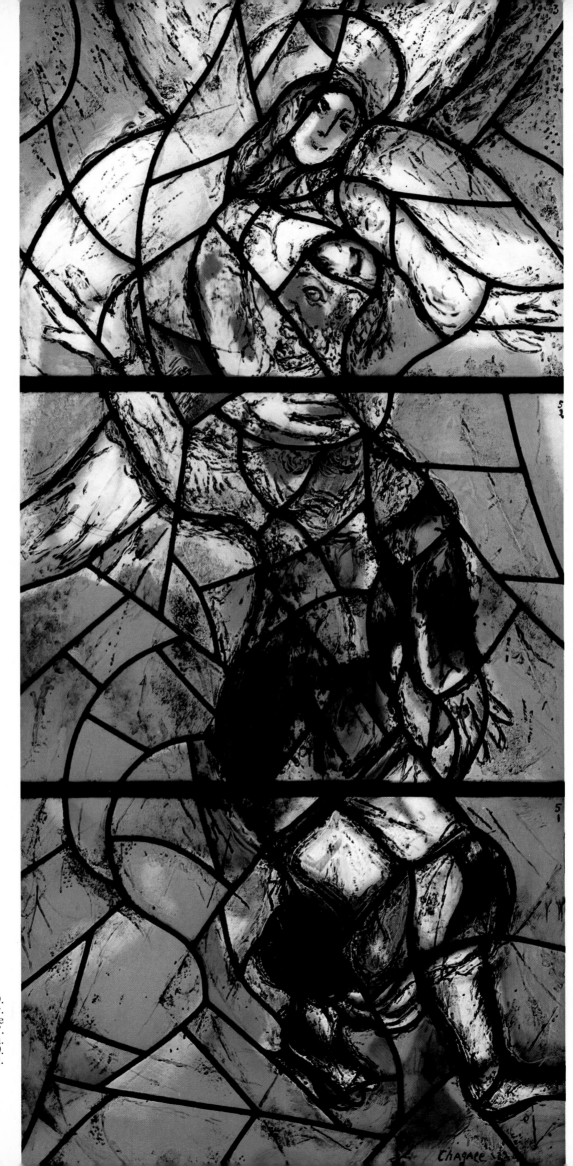

The Prophet Isaiah. 1969.
Detail of the bottom of the window.
"The Prophet Isaiah's Vision of Peace
and Suffering." 31'11 3/16"×3'.
Fraumünster Church, Zürich.
Group of five windows. 1969/70.
(Photo Jean Dubout).

First window of the north apse of the Metz Cathedral. 1962.
11'10¼"×3'. From left to right: Abraham's Offering,
Jacob Wrestling with the Angel, Jacob's Dream,
Moses Faces the Burning Bush. *(Photo Jean Dubout)*.

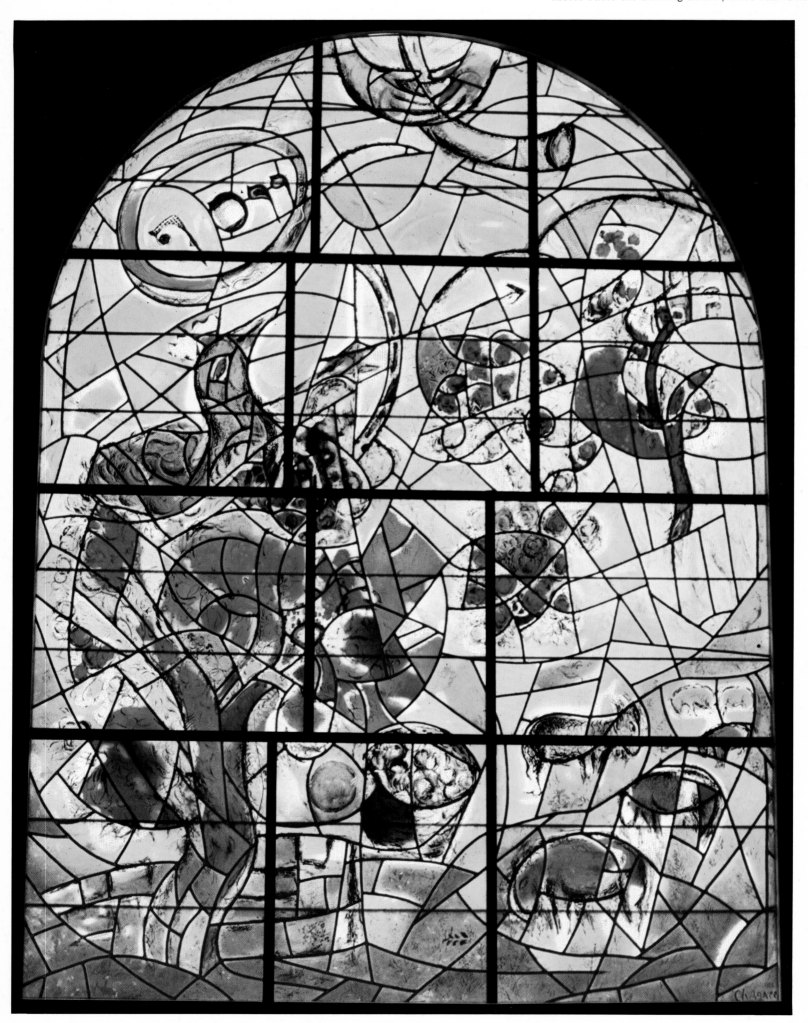

The Tribe of Joseph. 1961. Stained-glass window. 11'1"×8'2½". North window of the Hebrew University Hadassah Medical Center. *(Photo D. Frasnay)*.

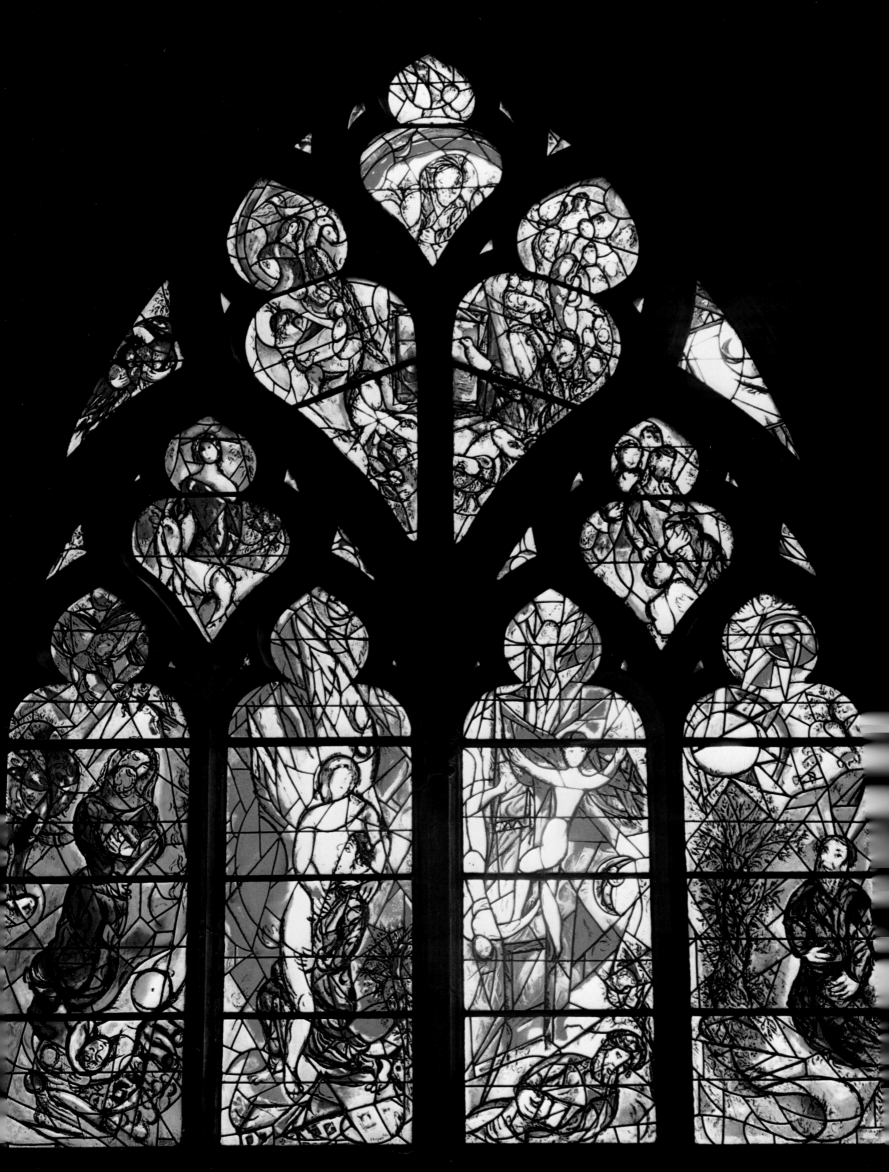

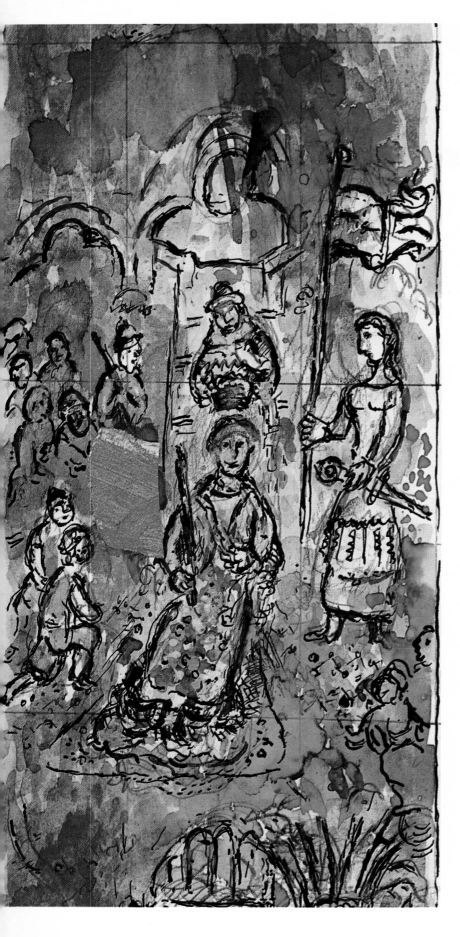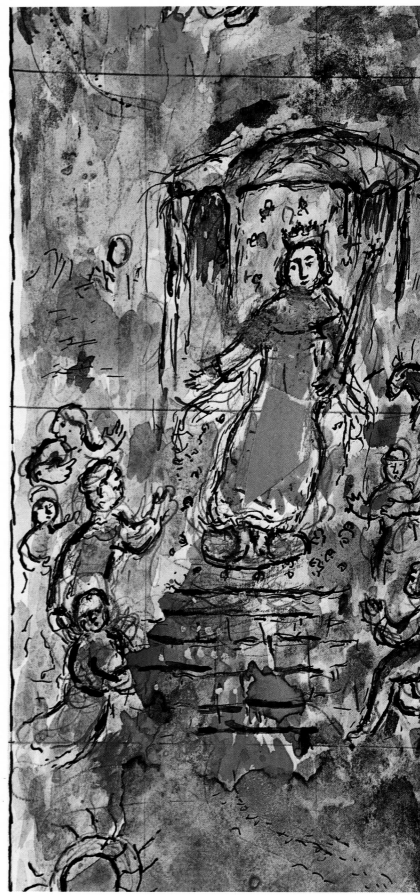

Studies of the stained glass for the three windows of the choir of the Rheims Cathedral, Rheims. Details. 1972. Gouaches. *(Photos Jean Dubout)*.

deed of the traveler causes the angels in heaven to be joyful and alleviates the sufferings of the crucified God.

The Fraumünster, Zurich

In Rheims I saw Chagall paint Christ. In Zurich I see his windows rise in a sky where sails and swans are twinkling. The Fraumünster turns its chevet toward the river and the chancel gets the first rays of daylight through five windows as slim as flutes. It is no longer summer, but it is not yet autumn. A cloudless morning; the air is damp like the iris of the eye. The five glass steles burn like firewood artfully arranged by a woodcutter who has subtly selected the various species to get differently colored flames. The twigs crackle, but no ashes soil the hearth. *Sol salutis!* Here, the highest flower in the tree is blooming, Christ whom the full orb cannot circumscribe, Christ who is the origin, who is in time and out of time. Descended into hell, dead, resurrected; after our earth plunges into each of its nights, the new sun of each day brings the earth its luminous offering, so that each dawn should be a spring and so that the regeneration of the soul through charity should be made visible in greenness.

It is the hour when the lark soars from the grass and rises with the dew toward the canopy of the sky; it is the hour when the birds join in their canticles to praise the ever-renewing light: man wakes up on the first day and every tree he sees tells him of the tree of Eden, the axle of the world, the tree of Jesse, made through Mary the tree of the incarnation, of death and resurrection; the tree of David that David is beholding while singing on the hills of Zion:

> *For thou art my lamp, O Lord;*
> *and the Lord will lighten my darkeness.*
>
> *He that ruleth over men must be just,*
> *ruling in the fear of God.*
> *And he shall be as the light of the morning,*
> *when the sun riseth,*
> *even a morning without clouds;*
> *as the tender grass springing out of the earth*
> *by clear shining after rain.*
> (II Samuel XXII, 29; XXIII, 3-4.)

"Bring measure into madness" Chagall whispers. Such was also the rule of the troubadours. It means to dwell musically in exaltation and enthusiasm; like the sail and the hull, to come to terms with the sea, the wind, the stars in order to succeed in the perilous voyage. Every man who enters that place for a moment sees the great Christ rise toward him with the sun. He sees. He sees the beginning, he sees the present, he sees the things to come. So in the deepest recess the spring comes to life and man, looking into himself, lets prayer seep into him.

From *The Stained-Glass Windows of Marc Chagall, 1957-1970* (New York: Tudor, 1973).

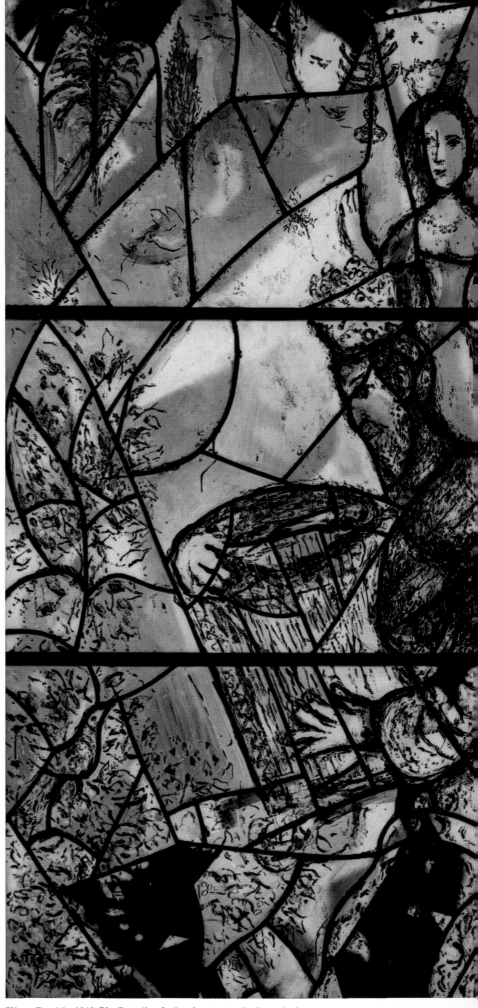

King David. 1969/70. Detail of the bottom of the window "Heavenly Jerusalem," 30'2³/₄"×3'1³/₄". Fraumünster Church, Zurich. *(Photo Jean Dubout)*.

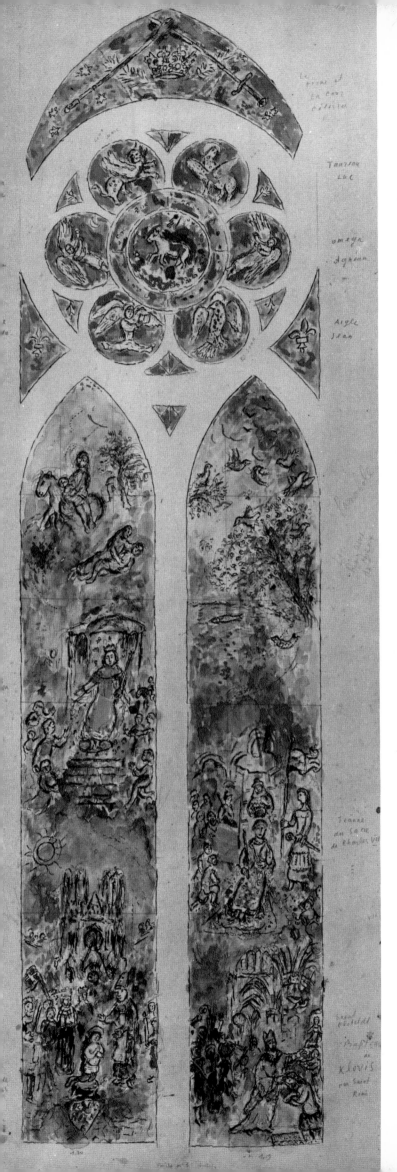

Chagall in Rheims

by Charles Marq

In 1957 Chagall came to Rheims for the first time. When he stepped into the workshop, the place was suddenly brighter than it had been, for he gave off the kind of light that every real artist radiates.

Since then Chagall has, so to speak, never stopped conceiving or executing stained-glass windows. As a result, he spends a good part of his life in Rheims. At dusk, after long days of work, Chagall has the habit of walking through the city, like a figure out of one of his pictures, strolling, breathing the fresh air, enjoying the contact with the street, with life, which the next day he will dream on glass. Sometimes I keep him company. And so for many years, while he was painting the stained-glass windows for Metz, Jerusalem, New York, Zurich and Nice, our steps would frequently lead us toward the Cathedral, a short distance away from the workshop. Chagall carries inside him all the varied aspects of this great dream in stone, which he has seen during the day and at night, in the dazzling light of summer and in the blue winter air.

Thus, he was not surprised when the Building Federation of the Champagne-Ardennes Region and the Association of Friends of the Cathedral of Rheims asked him to do some stained-glass windows for the cathedral's axial chapel. For him this came as an indication that he should leave his message of poetry and light in the heart of the city where he had done so much work. After Metz, where he had agreed to do the side windows, the prospect of having to work in the nave of the cathedral renewed his anxiety but also aroused his passion.

We climbed into the upper part of the building,

Studies of the stained glass for the three windows of the choir of the Rheims Cathedral. 1972. Gouaches. $38^1/_2''\times10^1/_4''$ each. *(Photos Jean Dubout).*

On the left: the Tree of Jesse and the Virgin and Child. *In the center:* Christ on the Cross, the Descent, the Resurrection, and the Life of Abraham. *On the right:* the Kings of France.

and from the interior of the triforium Chagall absorbed the character of the old stained-glass, studying it like a grammar and letting it inspire him. For his workshop in Saint-Paul I made him a small pane that included the full range of the ancient tones of the cathedral; he wanted to have this in front of his eyes when making his sketches.

Chagall admired the pure rigor of the Rheims Cathedral, whose unity of style makes it unique. But he also told me, with some humor, that he felt its "official character" and the cold temporal order of the royal ceremonies. Perhaps in reaction to this he first thought of doing a large composition for the group of three windows that would depict Abraham, the first seer of the Spirit, whose altar consisted of only a few stones piled up in the middle of the desert and rising toward the sky.

The principal events in Abraham's life are now grouped in the lower part of the central window; the composition in the upper part develops the theme of Christ on the Cross, of the Descent and the Resurrection. Since the Rheims Cathedral is dedicated to the Virgin, the window on the left represents the Tree of Jesse crowned by the Virgin and the Child. Counterbalancing the descendants of the kings of Judah, the window on the right shows a few events in the lives of the kings of France who were crowned in the cathedral in Rheims.

In the same spirit and with the same concern for preserving the exceptional unity of the edifice, Chagall adopted colored patches on a large blue background for this group, uniting the three windows and modulating the intensity of the blues from one window to the other depending on their orientation. From small colored sketches, in which geometrical pieces of tissue or of cut-out colored paper were placed on a background of various blues to large definitive sketches in which the composition achieved a balance, the design became more evident, the color was exalted, and Chagall achieved a mystical marriage with the building. There was no question here of adopting a form or a language already perfectly spoken by the old makers of stained glass. Without concern for physical substance or for the limits of time and space, Chagall relives, freely and spiritually, the dynamism of a distant age.

When I begin the execution of a window in the workshop, it is this creative force that appears and carries me along as the lead is cut and the color outlined. It is this inner life that the painter magically and mysteriously encloses within his work, and it alone permits the metamorphosis.

Marc Chagall and Charles Marq, the master glassmaker.

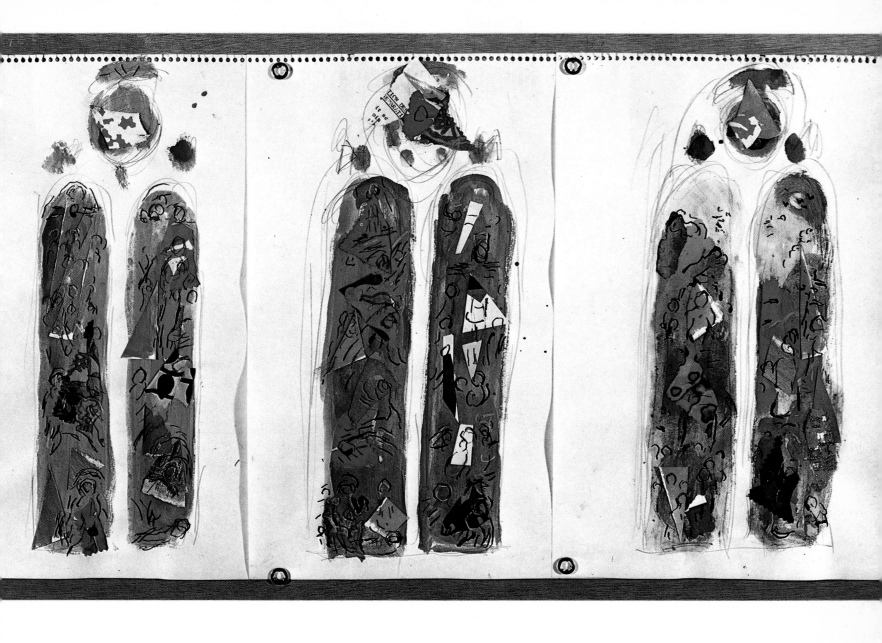

Study of the stained glass for the three windows of the choir of the Rheims Cathedral. 1972. Gouache. *(Photo Jean Dubout)*.

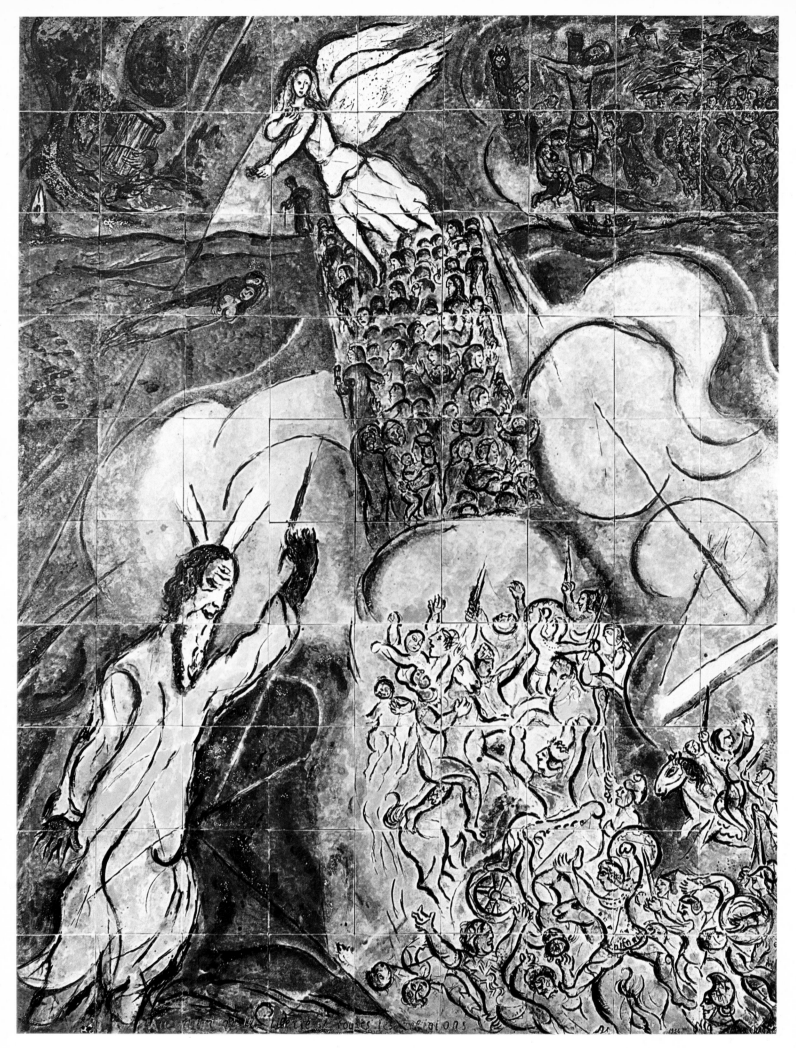

The Crossing of the Red Sea. 1956. Mural ceramic with 90 tiles. 10'×7'6³/₄". Church at the Plateau d'Assy. *(Photo Philippe Jouarre)*.

Frescoes and Mosaics

The Wall of Fables

by Charles Estienne

The days of the great hunts have returned. When we talk about painting—which usually consists of fencing in the arid arena of theory—we forget a little too often that the painter is not and has never been just a plastic artisan, a specialist in subject or non-subject, but is much more than that; he is, almost on the contrary, a man, a creator of concrete facts, whether they have been carefully stalked or captured by all the unexpectedness of improvisation. He is a creator of metaphors and, I might even say, a hunter of metaphors.

This is not literature; it is even exactly the opposite, because if literature only describes and structures the normal relations between facts, poetry—and I am waiting for someone to prove to me that painting is not an aspect of it—upsets the standard order, instigating invisible and up till then unheard of links between facts. The meeting of two facts—symbols, forms or colors—on a plane where *ordinarily* they would never meet, is not only one of Surrealism's discoveries, but the very definition of metaphor, the key to all poetry as well as to all painting.

Of course, the metaphorical constants of true painting are not always absolutely and clearly visible. Yet each great painter is great only because he has found new relationships between forms and colors, and we know that a great pictorial style is never an order established once and for all, but an order continually contradicted and re-created. Although the role of some painters is to insist more on the harmony between things than on the conflict between them, that of others— Chagall for example—is to open up the metaphorical space between colors and forms and to include simultaneously both love and war, whose apparent opposition is finally reconciled in the flare of plastic lyricism. Breton has already pointed out [1] that it was in Chagall's work that metaphor made its "triumphant entry" into twentieth century painting, and today when Chagall's world and language still fill walls with uncommon dimensions and techniques, we should not lose this wonderful opportunity to touch and define the profound, organic ambivalence of the Chagallian metaphor.

Yes, hunting time has returned.... But we other moderns have given up hunting except in the imagination; or rather, it is only in that re-creation of the world which we call artistic creation that we can again feel the violent sources of the great emotions experienced a long time ago by our prehistoric ancestors while tracking wild animals, both large and small. The epoch is truly astonishing—and yet it's our own; we seem for a few moments (the high points of the poetic act), to travel through time and, beyond neolithic abstraction, to find again that familiarity of love and war with animals that belonged to the great Magdalenians.

As at Lascaux and Altamira, where stags, bulls and horses make prodigious arabesques across the grotto walls, so before us rises Chagall's fabulous wall of fables, where fish and bird are involved in relationships that go far beyond the moralistic anthropomorphism of good old La Fontaine. And in the same way that the plastic reality of the marvelous bestiary of Lascaux has kept its freshness and presence intact under the natural miracle of crystallization (similar in its effects to the best and most transparent of varnishes), so Chagall's ceramics, which are paradoxical but authentic paintings save for the fact that fire has glazed them, allow us to see and touch a freshness preserved from that constant menace of fragility that hangs over every fresco and easel work.

Chagall's work asks to be touched. How not to feel the importance, not only of the touch, but of touching itself, in his art? Except for Renoir, there are few painters who address themselves as much to the hand as to the eye, to both visual and tactile sensations. Indeed, the tactile appeal of his work is such that in it the hand seems to be more an extension of the eye than an instrument. If one wants to really know his work, the most natural gesture would be to let one's hands and fingers move across and read and follow on the picture those accidents of matter that enliven it and provide its essence. However, it is not specially recommended (if only out of concern for the picture's conservation) to give into our urge to touch and caress it with the insistence that nonetheless is so desirable.

Greek Landscape. 1962. Ceramic plaque. 29$^1/_2$"×19$^3/_4$".

What good fortune then, and what a gift from the painter, to be able to caress and touch his ceramic paintings without any fear of damaging the material and also without the paintings being deprived of their lives, cut off from their original, vital source by the brutal surgery of a mechanical process. Let us pay homage here to the technique of ceramics (and in particular to that of the Ramié workshop) which, without breaking its own laws, has been able to transmit without mutilation a supremely natural pictorial gesture.

Thus we have a permanent but not sterilized touch and, if we carry the analogy even further, a mark or unique imprint. What is astonishing is that this touch found sufficient plastic resources in itself to support and create that ampleness of tone, script and form which mural art requires. I say ampleness, and not enlargement because the unique quality, the singularity of Chagall's ceramic murals, is that they conform to the pictorial discipline itself and were not born from the enlargement of a square (which is something quite different);

further more, the artist desired, as much as possible and to the very end, to be the master of his own work.

Everything then comes from the source, as in painting, and without any resort to that "planitude" (not to say "platitude") that is supposedly more mural than its contrary. Here are those sustained and continuous greys, at times flowing like the Nervalian river of Orgeval, at times calling the hand, as the fur of an animal does when caressed. Here are tones with color to them, bright and warm, frank and full, reminiscent of the oranges of Vence. The wall of fables sings and murmurs within reach of our hands, with the familiar majesty of that Freize of Archers that after many centuries brings to life in Paris all the marvels and the light of Mesopotamia.

From Derrière le Miroir, no. 44-45 (Paris: Editions Maeght, 1952).
[1] Cf. André Breton, *Les surréalistes et la peinture*.

The Sacred and Profane Imagery of the Mosaics

by André Verdet

The Lovers. 1964/65. Mosaic. 118¹/₈″×112¹/₄″. Placed on a wall outside the library of the Maeght Foundation in Saint-Paul-de-Vence, France. *(Photo Jean Dubout).*

Marc Chagall found in Lino Melano a first-rate assistant, an artisan who was perfectly suited to handle his mosaic works, just as he found in Charles Marq an ideal workshop associate for producing art in the stained-glass medium. For each of the different mosaic fresco projects that were proposed to him, he insisted upon having Melano at his side.

The mosaic for the Maeght Foundation in Saint-Paul-de-Vence, *The Lovers*, which Chagall dedicated to Aimé and Marguerite Maeght, was the first work that he made in the mosaic medium. It decorates the outer wall of the library, at the pediment of the museum entrance. One of the rooms of the Israeli Parliament in Jerusalem will be decorated with floor mosaics and a large wall mosaic, "The Wailing Wall," in addition to three tapestries. The musicality of *Orpheus* will make the yard of the house of a certain history professor, Mr. Nef of Washington, D.C., sing.

The Odyssean Message

In January, 1967, some friends came to Chagall, who was still in Vence, and asked him if he would be kind enough to consider providing a personal touch for the Law school in Nice that was then being built. It was in the name of university youth that the head of the school, Mr. Trotabas, approached the painter about this project. Chagall welcomed the idea and decided to carry it out in the form of a mosaic. Later, a visit to the site on a hill in the Magnan neighborhood, where the school was under construction, made it possible to settle upon a precise location for the mosaic, namely the largest wall of the reception room, opposite bay windows that opened onto a park.

Soon Marc Chagall was thinking of a message to youth that would have a content similar to that of the *Biblical Message*, which he had just given to Nice.

It seems that after reading an essay entitled "Ulysses or the Intelligence," by the poet and novelist Gabriel Audiso, upon whom none of the mystery and secret scintillations of the Mediterranean soul is lost, Mr. Trotabas suggested the theme of Ulysses to the artist, supplying him with a variety of source materials related to different scenes from Homer. The idea pleased the artist. The thought of recapturing the spirit of Hellenic antiquity excited his imagination, and when he left for a trip to the United States, Chagall was already on the look-out for Ulysses and his Mediterranean deeds.

When he came back to France, he invited Mr. Trotabas to his new wooden house, "the Gardettes," in Saint-Paul and showed him a cartoon for the mosaic. The artist had chosen all the scenes from the epic poem that had been suggested to him in order to unite them in a vast composition that followed Ulysses's itinerary.

Work began on March 5, 1968. It lasted five

Saint Paul. Mosaic in Chagall's garden in Saint-Paul-de-Vence. 1967. 11'1²/₃"

90

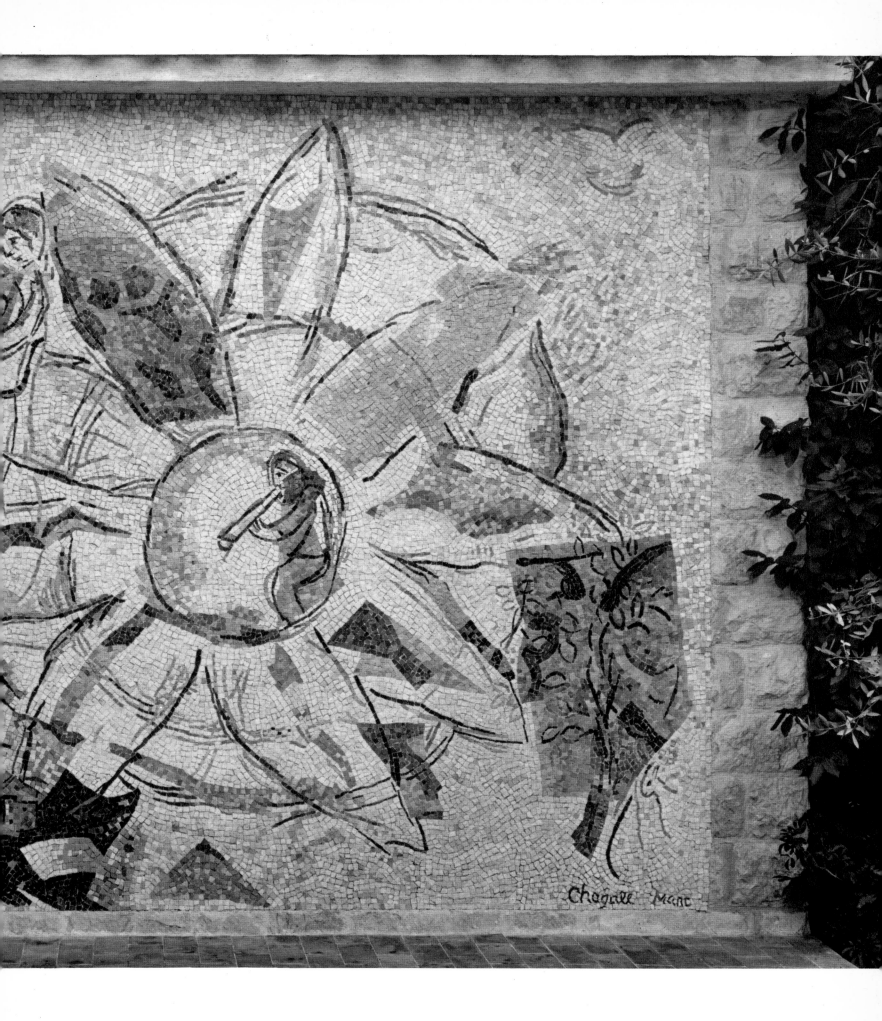

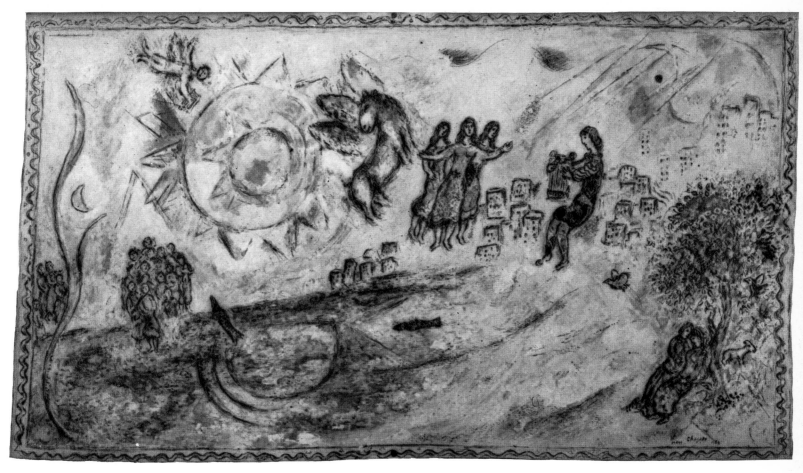

Orpheus. Sketch of the mosaic executed for Mr. Nef, a professor in Washington. *(Photo Jean Dubout)*.

months and required the cutting and inlaying of more than 200,000 pieces of stone and marble of every kind, with which were mixed pieces of glass, enamel, Murano golds and onyx.

The final panel, which was a good size (36 × 10') for a mural and was mounted on a concrete frame, had to be made from a 3 × 8' model. Its execution required a great deal of precision because of the rich complexity of the drawing, the color, and the chronological diversity of the scenes. Under Chagall's guidance, Lino Melano had already executed, among other things, the mosaics for the Parliament of Israel. Their collaboration was thus founded on and developed from a mutual understanding.

Chagall and the Students

Three of four times a week Chagall would come to check the progress of the panel and the precision of the translation. Looking over the fences enclosing the work-site alongside the auditoriums, students could see the processional comings and goings of the precious material. Whenever the painter arrived, they would applaud. In May and June, Chagall, brush in hand, often took charge of the placement of linear and chromatic units in order to bring out a certain hue or line. The aim of retouching was to harmonize everything by creating ruptures and dissonances, to establish

balance by means of counterpoint and to ensure the connections and transitions.

The Odyssey was completed on August 9, 1968. The general theme of the work was Ulysses' message: to develop a "soul illumined by intelligence and wisdom." Marc Chagall commented on it by engraving these lines:

May this message of Ulysses attest in Nice, which received it as a gift like the Biblical Message, to the multiple sources of the Mediterranean soul. Like the sacred splendors of the Bible, I hope that the beauty of Homer's poem and the friendship that this mosaic inspires will touch the hearts and minds of all the students to whom I dedicate it.

An Illustration of Intelligence

On each side of the long, flexible and central silhouette of Ulysses, the composition is broadly orchestrated. This orchestration, made up of a clash of polychromatic stones, invests the whole work with a combative, contradictory rhythm that gives us an idea of the eventful voyage and its passions. It is well known that the fable of Ulysses illustrates bewitching temptations and grandiose obstacles overcome; it illustrates at one and the same time the intelligence, cleverness, wisdom and courage that enabled the hero to triumph.

The scenes are arranged from upper left to

Chagall in front of the mosaic in his garden, "Saint Paul." Saint-Paul-de-Vence, 1972. *(Photo André Villers)*.

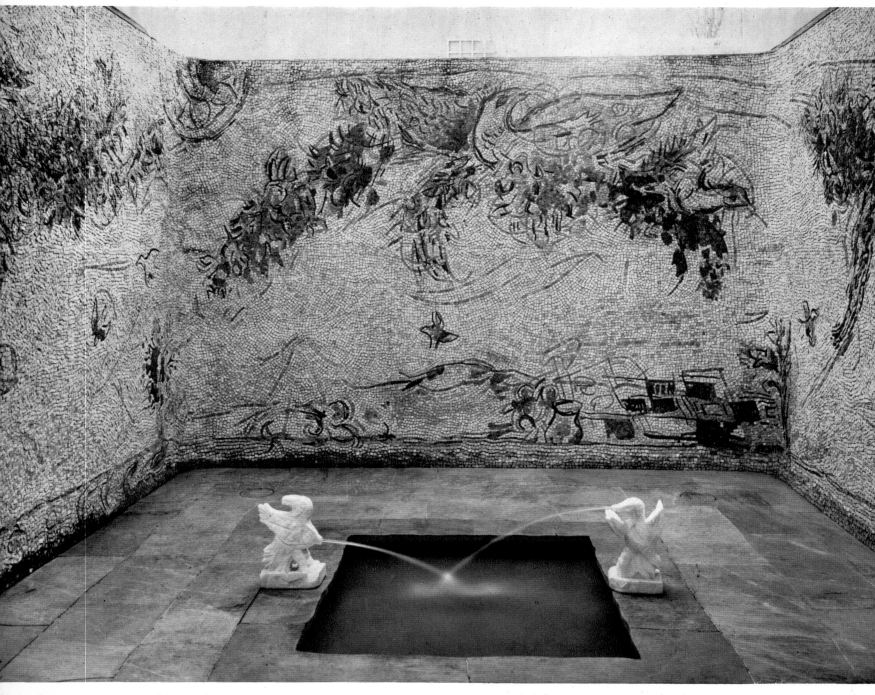

Mosaics for a winter garden. About 1966/67. Private Coll., Paris.

right, starting with, as in the text of *The Odyssey*, the *Meeting of the Gods on Olympus*, and followed by *Calypso, Polyphemus, Circe, The Sirens, Nausicaa, The Bow, The Marriage Bed* and *The Death of Ulysses*.

Sublime Love

The work as a whole has a greater physical impact than the mosaic of *The Prophet Elijah* in the Biblical Message Foundation, which is almost immaterial behind a dreamy blondness that softens shapes and colors. The locations of the two works dictated different techniques. *The Odyssey* is a panoramic view, a large fresco with an emphatic, sometimes brutal, rhythm, a cadence well suited to the dynamism, at once warlike, lyrical and loving, of the hero: episodes of repose, dreaminess and tenderness are contrasted with those of martial action. *The Prophet Elijah*—mystical, celestial and spatial—was conceived for an outdoor setting. *The Odyssey*—pagan, earthy and oceanic—was conceived for an indoor setting. The former mosaic is animated by the flux and reflux of the air. In the latter it is the undertow of the waters, the surf, and the outline of the coast that suggests movement; but the mystical aspect of Chagall expresses itself here and there through a seraphic form

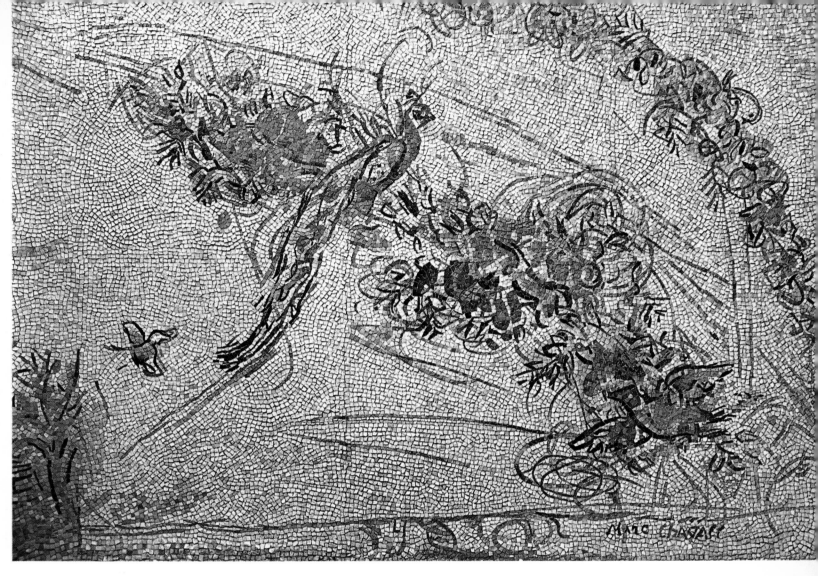

Mosaics for a winter garden. About 1966/67. Private Coll., Paris. *(Photos Jean Dubout)*.

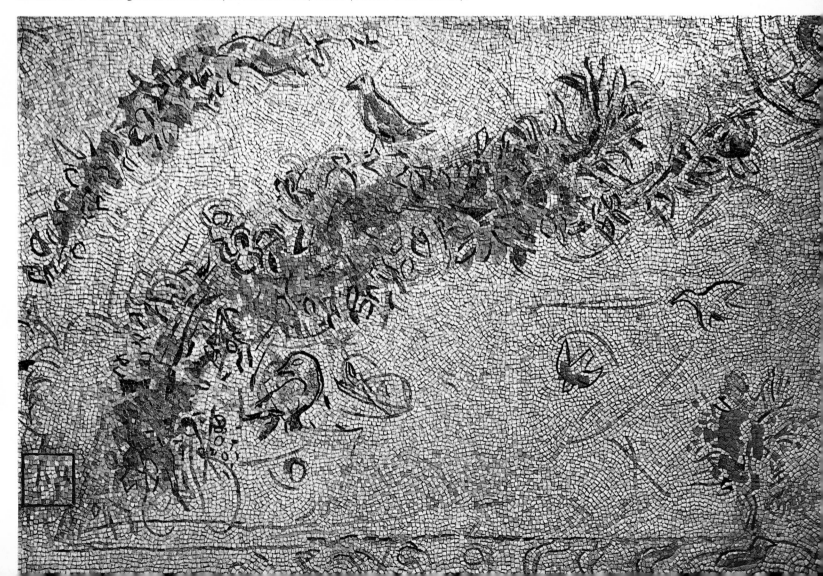

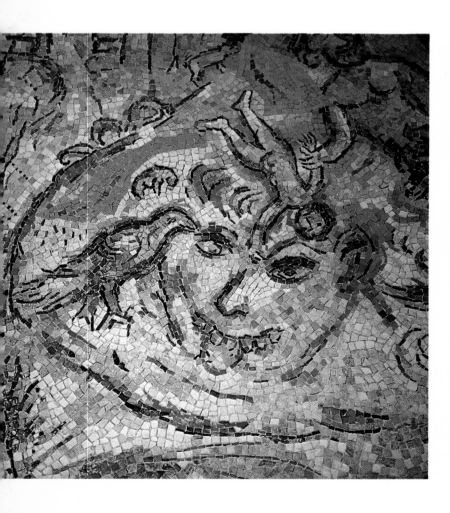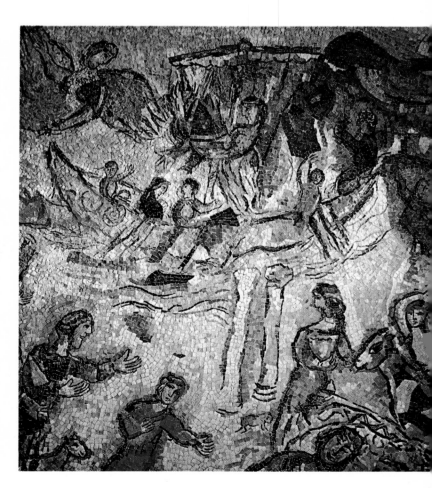

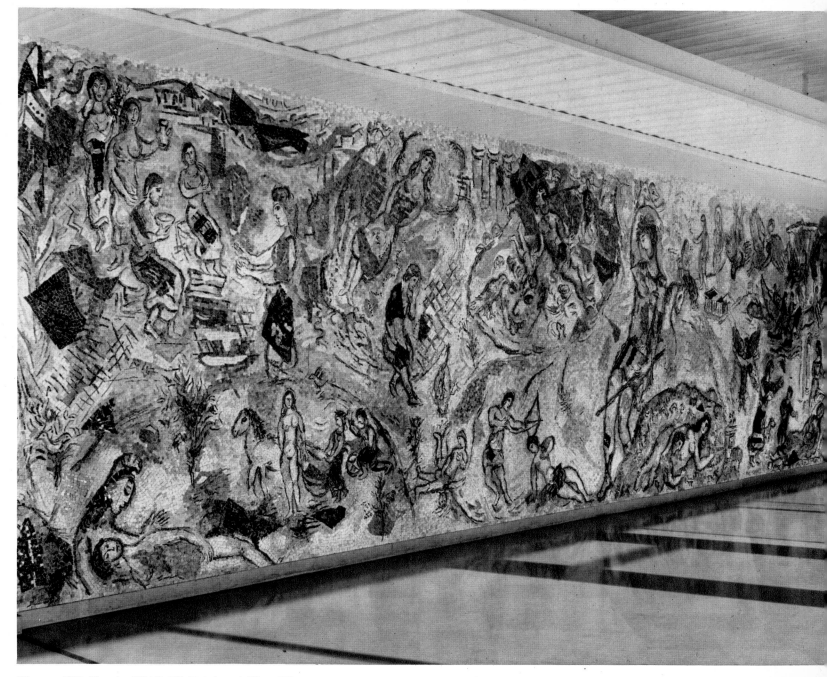

Ulysses. 1968. Mosaic. 9'9⁷/₈"×36'. Faculty of Nice. *(Photo Jean Dubout).*

◁ Ulysses. Details. 1968. Mosaic. 9'9⁷/₈"×36'.
Faculty of Nice, France. *(Photos André Villers).*

wandering in space. In Nice, the *Biblical Message* invites one to visit the *Odyssean Message,* and vice versa.

A sublime love of life guided the hand of the painter in his representation of the scenes, in their orphic transmutation. Without a doubt this love of life directed Ulysses' quest on his nuptial journey toward Penelope through time.

This sublime love vibrates, with its wings un-folded, in the mosaic *Homage to Saint-Paul,* a work dedicated to Vava Chagall and completed four years ago. A large sun with spiral-shaped rays fills the central area. A pair of intertwined lovers is carried away in its whirling. Below, the

97

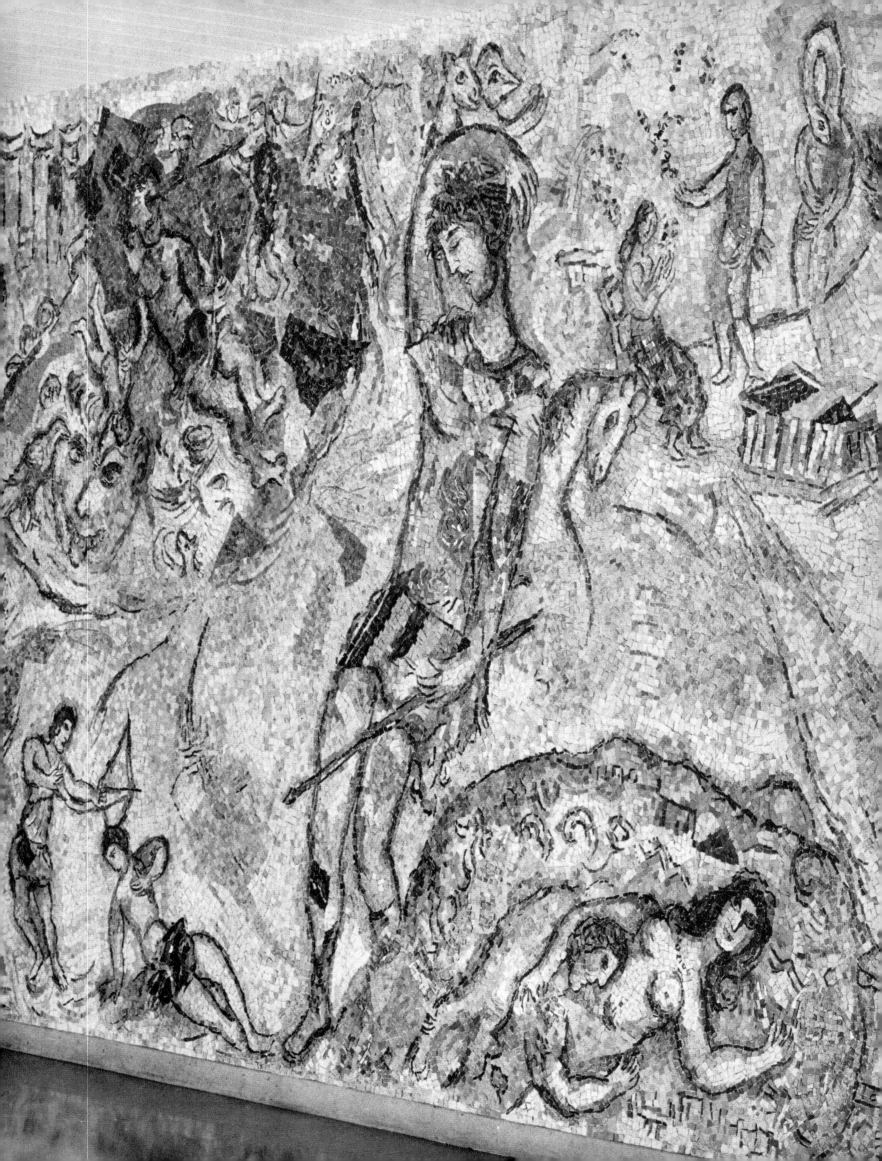

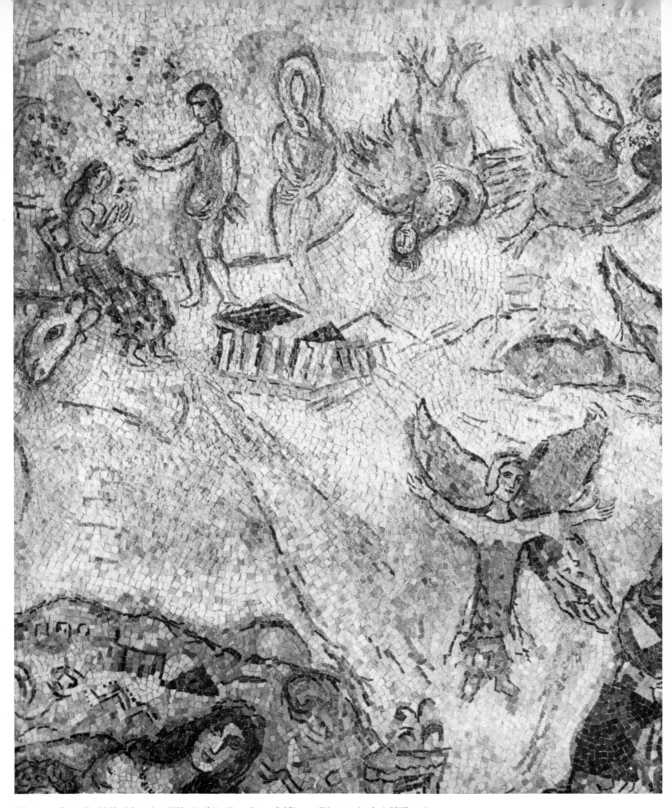

Ulysses. Detail. 1968. Mosaic. 9'9⁷/₈"×36'. Faculty of Nice. *(Photo André Villers)*.

village of Saint-Paul-de-Vence is blotted out in the light. Musicians and trees distill a perfume of happiness.

This work has for me the charm of a rustic song, of a lively pastoral outside the confines of time and space. Here again the refined shimmer, the freshness of the stones comes from the marvelous "toning" of the greys.

The Four Seasons of Chagall

Unfortunately, I was not able to see the cartoons for the large work planned for the First National

Bank Plaza in Chicago. This work, now in progress and entitled *The Four Seasons*, is of profane inspiration. It will be a monumental rectangular block: 82 feet long, 16 feet high and 13 feet wide. On one side will be "Spring" and "Summer"; on the other, "Autumn" and "Winter." Two other key mosaics of smaller size on the other two sides will provide a liaison between the four huge mosaics. The sun will seem to move on either side, depending upon the seasons. A mobile sun. An expression of life, its works and days, hopes and joys, leisure and loves, but also the human worries: a fresco of existence throughout the seasons.

Ulysses. Detail of the central part. 1968.
Mosaic. 9'9⁷/₈"×36'. Faculty of Nice.
(Photo Jean Dubout).

Monuments of a Return to th

View inside the Knesset in Jerusalem: in the background three tapestries, "The Entrance to Jerusalem," "The Exodus," "The Prophecy

Land of the Prophets by Guy Weelen

on the floor two mosaics by Chagall.

View of Jerusalem.

And it shall come to pass in the last days,
That the mountain of the LORD'S house
Shall be established in the top of the mountains,
And shall be exalted above the hills;
And all nations shall flow unto it.
And many people shall go and say,
Come ye, and let us go up to the mountain of the
 LORD,
To the house of the God of Jacob;
And he will teach us of his ways,
And we will walk in his paths.

Isaiah, II: 2-3

Impulsive, spontaneous, light-handed, quick-spirited painters do exist, but Marc Chagall is not one of them. A long meditation and often an inner unavowed drama always precede his work. Shut up within himself, overcome by doubts, he tries for a breakthrough, and, in order to go on any further, he must suddenly perceive a reality, but without disdaining or abandoning recourse to divination. As he himself admits, he recognizes this reality that is needed to trigger his painterly impulses by a sort of vibration, a sort of pig-mentation of matter similar to the hoarfrost on the fields.

In 1965 the Gobelins studio began work on three large tapestries by Marc Chagall intended for the Israeli Knesset. The term "Knesset" is generally translated as "Parliament," but insofar as Israel is concerned, I would prefer to translate it as "the seat of government." To my mind, and as I see the State of Israel, the term "the seat of government" conveys more accurately the historic will power of this people to exist, as well as the general behavior of this nation.

This group of tapestries as well as the mosaic floor which, for mythological and metaphysical reasons, only Marc Chagall could have undertaken, express his faith and admiration before the extraordinary phenomenon of the resurrection of Israel.

The tapestries constitute a vast triptych. *The Exodus* (15'6$^2/_3$"×29'5$^2/_3$") forms the central panel. The panel on the right is *The Prophecy of Isaiah* (15'6$^2/_3$"×17'7$^5/_8$"), and on the left *The Entrance to Jerusalem* (15'6$^2/_3$"×17'7$^5/_8$").

Taking into account the historical reality, the artist sought to unfold in this enormous woven fresco a large-scale organization of color and light, of radiance and rhythm where the revery of his

spirit could express itself freely, but without doubt he also wanted to portray in abbreviated form the destiny of the Jewish people.

The most striking thing about these great sketches executed by a hand carried away and enchanted by the magic it gives birth to is that all three are celebrations of energy.

It is easy, with respect to Marc Chagall, to employ the words "dream" and "revery," and they have not been used sparingly. But all too often dream and revery are considered to be opposed to action, and this seems to me to be an hierarchy of thought that is definitely outmoded. What we still refer to today as "dream" is so intimately connected with everyday reality that it provides a single, real image of man. How irritating to always hear dreams referred to as something mild, pleasant and ambiguous, and to have the images they secrete considered as the simple babblings of a man split in two. For Marc Chagall, energy and "dream" are one; they are the expression of the totality of man, and for this reason energy is not the opposite of the dream but its complement. Each instant bears the mark of engagement and decision, and it was for this reason that he chose his themes. *The Prophecy of Isaiah* is the triumph,

the everlastingness of Jerusalem. *The Exodus* is, at one and the same time, ordeal, rupture and agony. *The Entrance to Jerusalem* is the resurrection of the earth recaptured, the jubilation of homecoming!

Every great work is open to a great variety of possible interpretations and conceals multiple treasures; its ambiguity is the result of its complexity. Ambiguity has always seemed a virtue to me, and even a cardinal one; it is a reservoir of mystery and grandeur because, as nothing is fixed, everything can be, can happen. In its essence it is dynamism and the dynamic source of poetry.

The fantastic events that Chagall has tried to convey in wool are fleeting moments in history that have fundamentally affected man. Illuminating his destiny, they evoke the essential human truths. An ample gesture must stand behind such a design; a deep harmony must reign between the inspiration and its formulation.

Aware of the imperatives of his choice, Chagall established an overall compositional design; it is based on an enormous V supported by two strong points (Moses and David) that are connected by two large circles. In *The Prophecy of Isaiah* the compositional elements are distributed around a

The Knesset in Jerusalem.

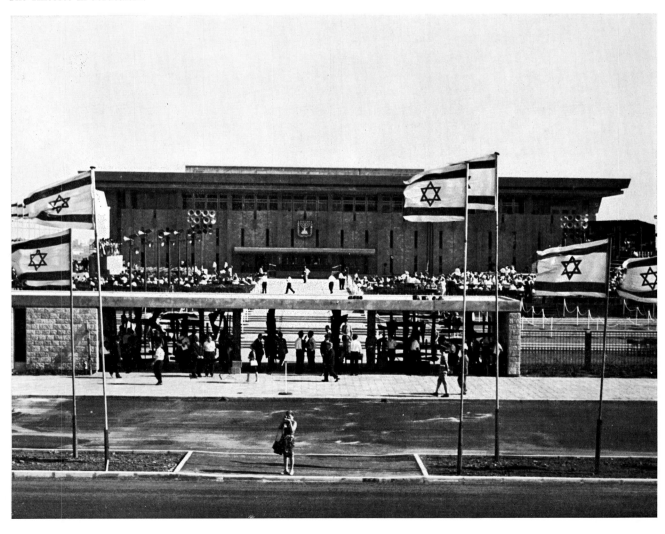

vast arena in whose center symbolic animals move. In *The Entrance to Jerusalem* the men advance in compact masses, whereas in *The Exodus* they traverse the surface in two intersecting diagonals. Internal dynamic bonds unite these three compositions and bring out a sense of tension which, rather than being broken, is continued by the two large figures: David playing the harp and Moses revealing the Tables of the Law to the people. Like caryatids, these two figures bear the weight of the architecture and their colorful vigor accentuates and controls the dynamic effect of the masses. Without hindering the eye's movement across the undulating lines and the bright motes of color, they reinforce the active vigor of the composition.

Once again, Chagall, master of his art, has instinctively embodied his plastic ideas. He detests using evidence, detests believing in the necessity of precision. He knows it and has doubts on this subject: "I'm not sufficiently precise, so-called precise," he has written. And he adds, not without irony: "But words are not precise!" Something else is involved, which he wants to attain, and he declares, "Divine fluidity, now that's truly precise: the fluidity of Monet, of Mallarmé."

In effect, to specify is to arrest, encircle, isolate, to find an affirmation only at the very end of the trajectory. This attitude is contrary to the very spirit of Chagall, for whom all things are interlinked and continually passing from one into the other, like communicating vessels. Hence, the comet in its lightning descent flaps wings like the cock perched on the roof, the bird pecks at the hours counted out by the old clock, and the streets of Vitebsk run through Paris as well as Jerusalem. In connection with this there is no need to evoke the fantastic: it is better explained in Chagall's own words: "I am against terms like 'fantasy' and 'symbolism.' Our whole inner world is real, perhaps even more real than the visible world."

Imagination is thus the key to the Chagallian conception of the world. Light, deceitful fantasy and imagination—which Baudelaire rightly considered to be "the queen of the faculties"—are two completely different things. Chagall's imaginary universe has its own coherence and internal logic which create a system of relationships and associations. Form and content combine in his work and produce new revelations. The V composition he chose with large open branches ending in circles is an attempt to unify, to fuse the various elements and forces; here, opposites, instead of being exalted, are abolished in the interest of the total composition. Moreover, Chagall is free, and to communicate his feelings he knows how to modify and diversify his means without being subject to any of them.

Jean Grenier has written pertinently: "A scattered appearance represents a succession of things in reality. Although events succeed each other in time, they cannot be shown that way on a spatial plane... Chagall brings together on his canvas events that one would experience in life step by step."

In effect, he does not let himself be burdened by the idea of time any more than he lets himself be caught in the constantly set trap of spatial description. He reinvents both according to his own feelings, but he naturally transgresses physical, rational unity, which can easily be both represented and measured. This is why he explores, with exemplary ease and using every means available, the realms of the supernatural. In the long run, Chagall appears to be a pertinent logician.

The concept of a mosaic floor posed a new problem. To start with, we should note that the flooring can be one of the most beautiful architectural elements of a building; think of the floors of the cathedral in Siena, the small church of Torcello, San Marco and Santa Sophia. A mosaic floor is a sort of carpet spread out under the feet of emperors and kings; it goes very well with the haughty gait of a master striding from the brightness of a large open door toward a sanctuary; it provides delicate ornamentation for women's baths and for patios where family members come together and around which social life is organized. Its humble postion below feet perhaps accounts for its being scorned or neglected, and yet all grandeur, all feeling for pomp and ceremony, extols it. Precisely because something in us rejects the lowly paving-stone, it is honored by those who want to set up a ritual and impress the traveler. But the organization of such stones into designs and figures should never act as an obstacle to the person who walks across them. His eye must not be encumbered and his step must not be hindered.

Considerations of this kind were probably behind Chagall's making a very special decision. Rather than stretching a geometrically shaped garden under the feet of the visitor, he preferred to embed the elements in a mass of stones from the Negeb that were of slightly different hues of the same color. As a result the huge State Reception Hall of the Knesset of Israel is sprinkled with unexpected mosaic forms. Furthermore, the floor can be visualized as having another, poetic aspect: couldn't what is involved here be a collection of broken and rearranged archaeological elements bearing the traces and wounds of time, the avatars of a long struggle, of battles throughout the centuries? It seems also that in establishing the coloration Chagall recalled the Greek and Roman mosaics he had had a chance to see during his travels, as well as those he saw in Israel (at Heptapegon and Tabgha, Beit-Guvrin, Shavey Zion and Beit-Alpha) from the fifth and sixth centuries.

It was tempting to use the Eilat stone from the Negeb, which has such lovely coloring. But since it was a matter of mosaics, some tiles had to be imported from Italy. Mr. and Mrs. Milano, assisted by Messrs. Guardini and Leoni, took charge of transposing Chagall's sketches into mosaics, carrying out the task with the skill of unusually sensitive craftsmen who are aware of the many different

The Wailing Wall.
Mosaic. Knesset, Jerusalem.

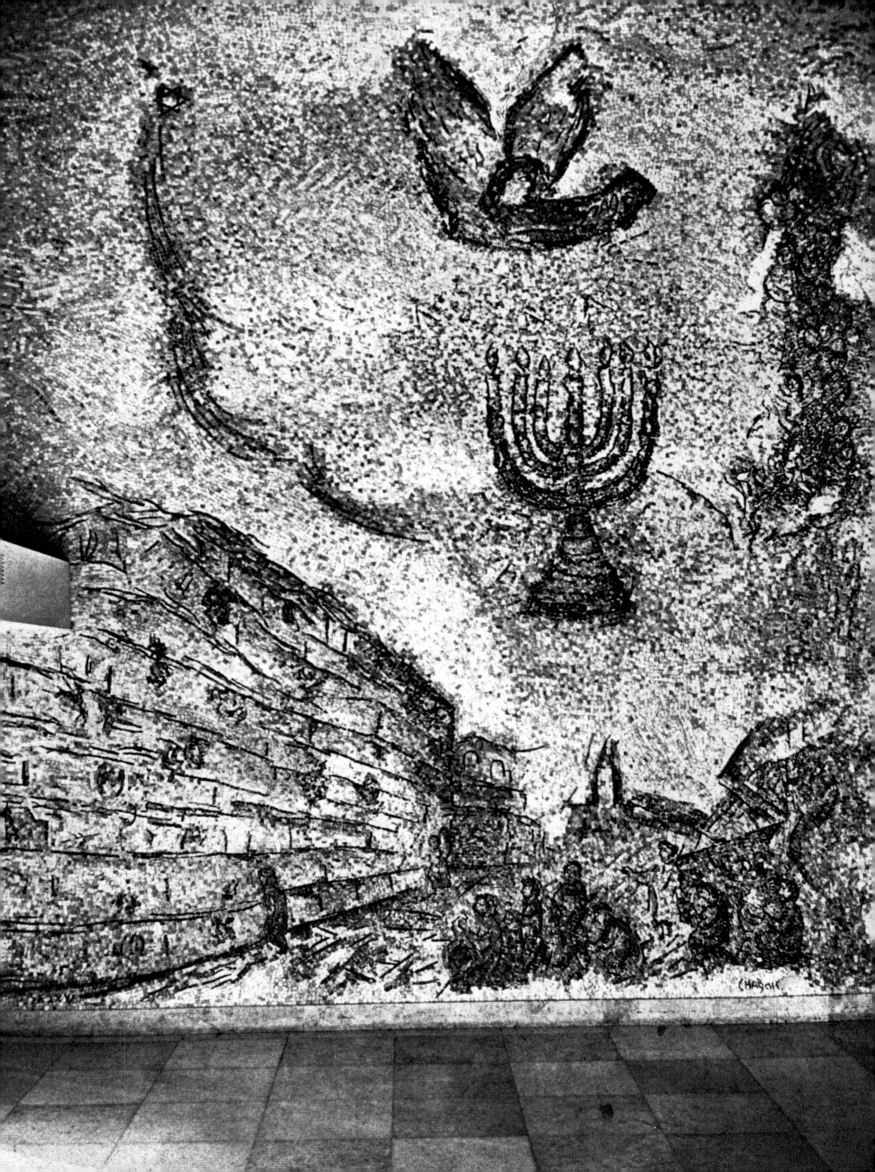

possibilities of their craft. The hues range from grey-blue to pale yellowish to burnt Sienna, punctuated by bursts of white. Transposing sketches into mosaics is always a very delicate business. The vague, imprecise nature of the sketch, which gives it all its charm, must nonetheless be captured and very often formulated. All the know-how of an alert, sensitive craftsman is necessary to establish the transitions that a small, simple square that is either too dark or too bright can break. And yet even more than elsewhere, the drawing must be present without being too heavily accentuated. The craftsmen seem to have resolved these problems very well.

Mythic, sacred themes are not suitable for mosaic floors, which are better served by free or geometric ornamentation, as many artists realize. But we know that Chagall, if he uses geometry deliberately, does not really want to indulge in it. He encloses within forms that tend to be elliptical images that belong to the everyday world. However, the commonplace in Chagall, as we have learned, is full of complexity, and consequently we discover many unusual aspects in it: trees weighed down with fruit; overflowing baskets of produce that recall the time when Palestine was an orchard and the animals of nomadic tribes grazed on the rich grass; baskets of fish like those which the fishermen of long ago used to haul in plentifully on the shore, just as they still do today; branches of flowers; scattered grain; a bird caught in a trap, which an anxious hand comes to free; goats cropping the fragrant herbs on the hillsides; mysterious signs; checkerboards with their ends cut off; stars shining in the feathers of a partridge. These simple rustic and bucolic scenes illustrate the work of the pioneers who retimbered the hills, made the abandoned terrain green again and with enormous effort were able to repeople these lands that for centuries had been worn away by the blazing intensity of the sun. Even the use of Eilat stone is symbolic. Once calcined, split and unused, today it is hewn, shaped and assembled under the feet of the visitor, where it unfolds like a prairie ripe with possibilities and future wealth, charged with the history of men.

Finally, resuming the theme of a 1932 picture, *The Wailing Wall*, today in the Tel Aviv Museum, Chagall also created a large mosaic panel for the northern wall of the huge Reception Room of the Knesset. He took advantage of the considerable distance imposed by the architecture, and the wall-panel can be seen at the opening to a staircase where it underlines the perspectives of the stones of the temple and accentuates the effect of flight. The center of the composition consists of a flamboyant seven-branched candelabra above which an angel is poised. On the left is a comet with a long wavy tail; it is contrasted on the right with a human garland that originates in the center of a group of figures in prayer.

There are no superfluous details, but there are

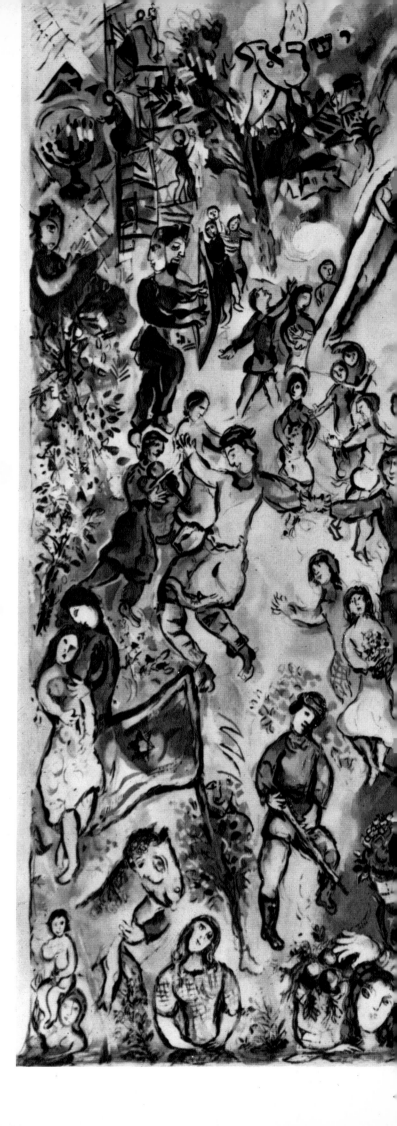

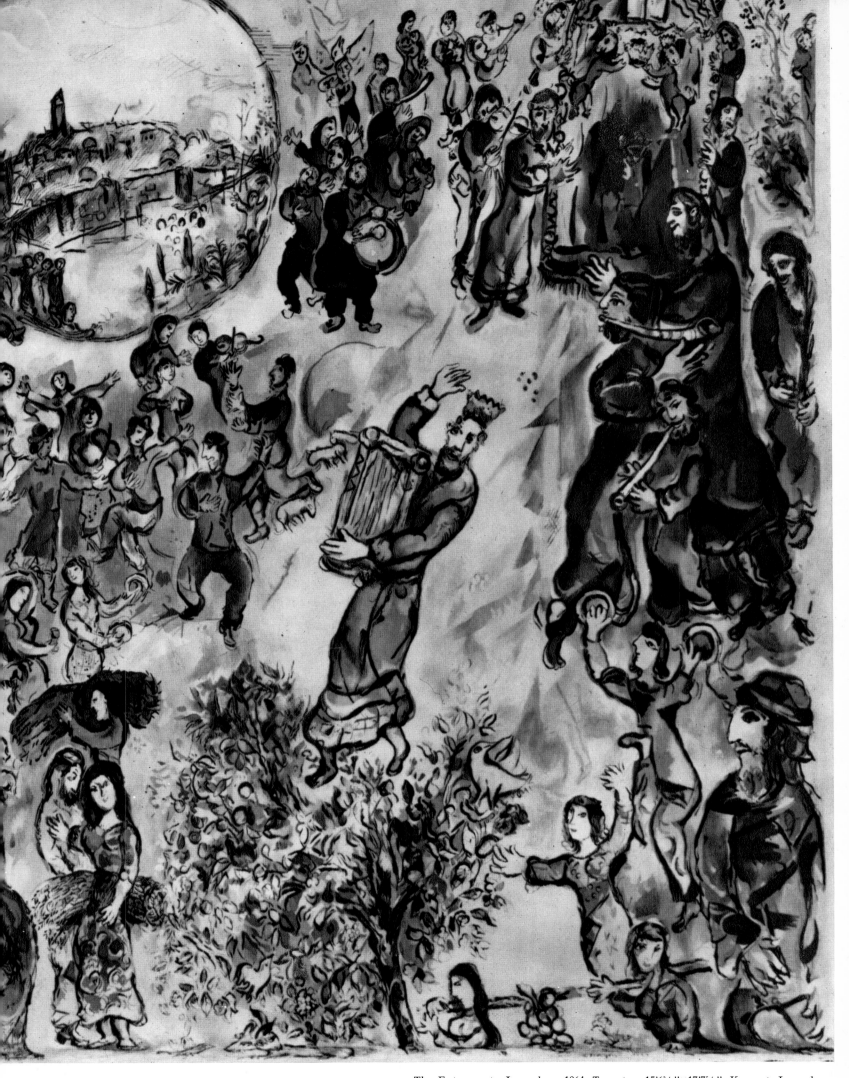

The Entrance to Jerusalem. 1964. Tapestry. 15'6²/₃''×17'7⁵/₈''. Knesset, Jerusalem.

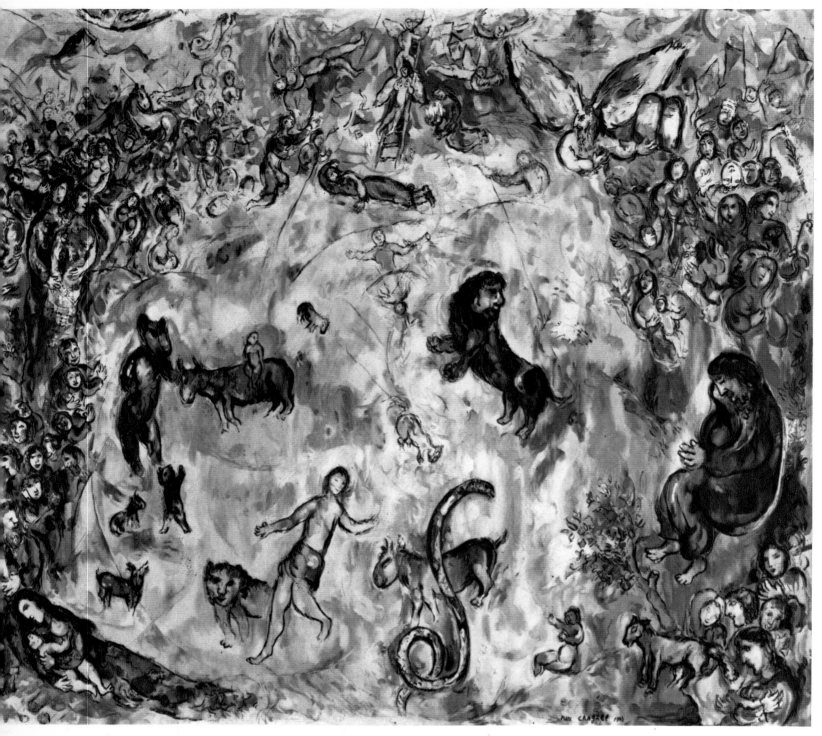

The Prophecy of Isaiah. 1964. Tapestry. 15'6²/₃''×17'7⁵/₈''. Knesset, Jerusalem.

four or five essential figurations charged with obvious symbolism, with heavy echoes and deep meanings. In its simplicity of form and color, by the particularly intense scintillation of small juxtaposed cubes, this wall has the calm character of certainty. Isn't it, in a way, Chagall's response to the question that could be the caption for his picture *The Gates of the Cemetery* of 1917? "Wordless. Everything hides in me, is convulsed and hovers like your memory. The paleness and thinness of your hands, your dried out skeletons tighten my throat. Whom to pray?"

Two mosaic floors from the Knesset in Jerusalem.

The Exodus. 1964. Tapestry. 15'6²/₃"×29'5²/₃". Knesset, Jerusalem.

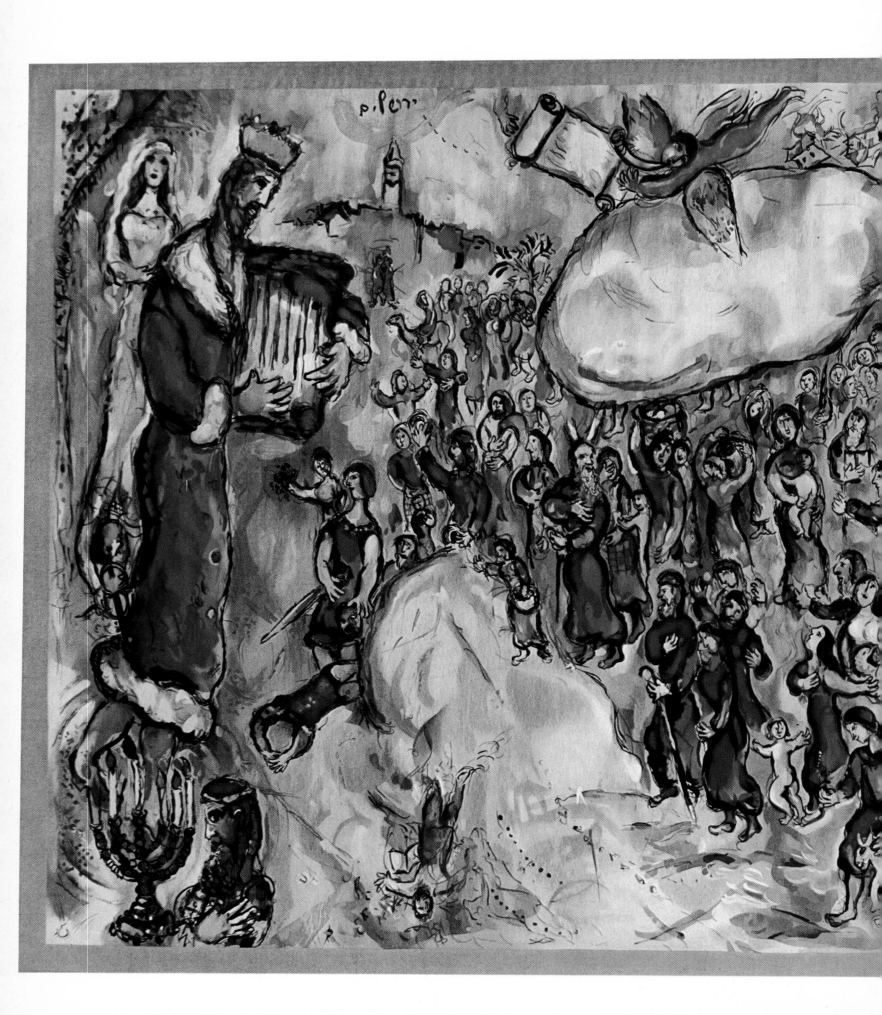

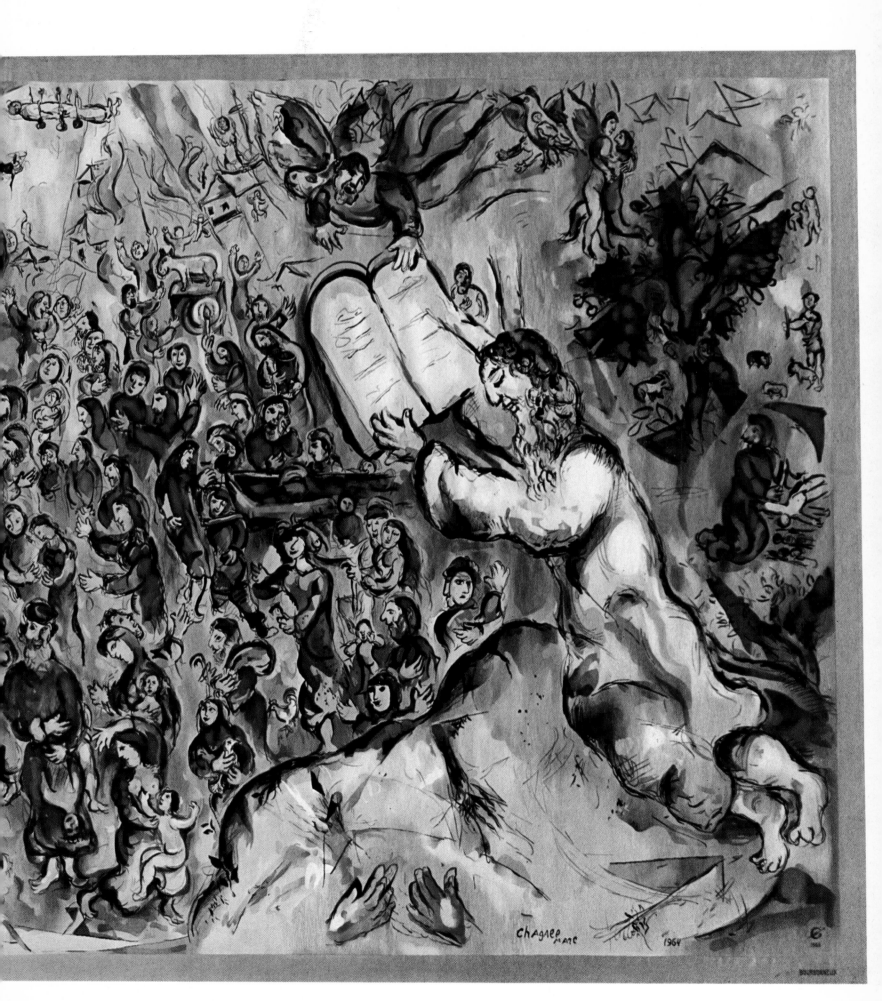

Chagall
Marc 1964

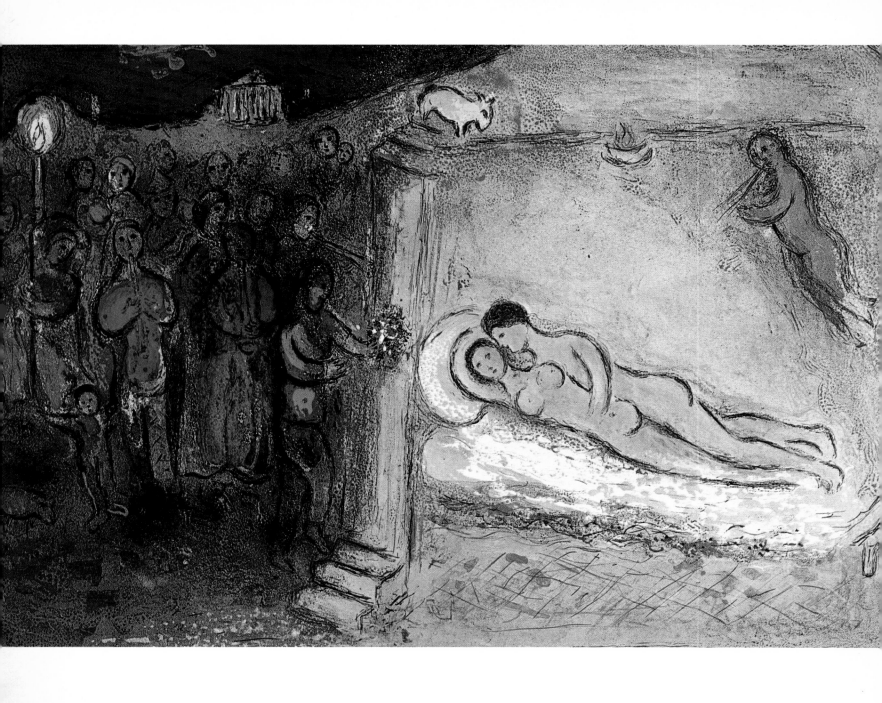

Hymenaeus. Original lithograph for "Daphnis and Chloe" by Longus. 16¹/₂"×25". Paris: Ed. Verve, 1961. *(Photo Jean Dubout)*.

A Masterpiece of Graphic Art

The "Daphnis and Chloe" of Chagall

by Charles Sorlier

In order to indicate the prominent place that Chagall occupies in the history of lithography, we should first briefly review the history of this art.

Lithography was invented in 1796 by Alois Senefelder and is a method of engraving. For the artist, it consists of drawing on the surface of a fine-grained chalky stone (Munich stone) with ink and greasy lithographic crayons. After this, the stone is prepared with a nitric acid solution in such a way that it will pick up the ink only where it carries the image; a sheet of paper applied to this stone is run through a special hand press; the proof is thus printed by direct contact with the drawing. These prints, limited to a small number of copies, are then numbered and signed by the artist.

Today, a zinc sheet (zincography) is sometimes used instead of a stone, since it is both lighter and less fragile. The conception of the work and the results obtained would be identical in both cases.

As early as 1812 Charles Philibert de Lasteyrie du Saillant studied this technique, and in 1816 he founded the first lithographic printing shop, in Paris. Goya, one of the very first among the great masters of lithography, executed his four so-called Bordeaux plates on the theme of "The Bull-Fight" in France in 1825.

Nearly all the artists working around the 1830s were tempted by this new engraving method: Ingres, Delacroix, Géricault. But one name especially stands out in this field: Daumier; he eclipsed all the others and left us a considerable number of masterpieces, such as *La rue Transnonain* and *The Legislative Belly* (1834).

In 1837, Engelmann, a printer in Mulhouse, patented his technique for "Lithocolor printing or color lithography imitating painting." This method is identical to one-color lithography except that by the superimposition of plates inked with different colors the artist achieves a result that is without a doubt much closer to the painted work.

But it was not until twenty years later that Jules Chéret understood the real meaning of this discovery and made the first polychrome lithographic poster *Orpheus in Hell* in 1858, preceding by sixteen years the first color print by a master: *The Punchinello* that Manet did in 1874. Save for a few plates by Renoir, Degas and Pissaro, this method was somewhat neglected by the Impressionists; it is true that print-lovers of the time were only interested by bad, eighteenth century style interpretative engravings, hand-colored and horribly mannerist. Neither *The Races* of Manet nor Redon's admirable plates caught the attention of the public.

Influenced by Chéret, Bonnard in his turn created his first color poster, *France-Champagne* (1889). Contrary to what is generally accepted as a fact, it was on Bonnard's suggestion that Lautrec became involved with lithographs. In *Le Bonnard que je propose* Thadée Natanson noted, "Little Lautrec made a lot of efforts to discover the author of *France-Champagne*, and Bonnard took him by the hand and led him to Ancourt who shortly after printed the famous *Moulin-Rouge* (1891)." (This anecdote is confirmed by Bonnard himself in a letter dated January 7, 1923, addressed to Claude Roger Marx.)[1] Vuillard has also left us a substantial number of very beautiful color lithographs.

These three great artists mark the beginning of the contemporary print. Claude Roger-Marx has written regarding them, "Along with *Elles* by Toulouse-Lautrec and the *Landscapes* and *Interiors* by Vuillard, the series entitled *A Few Aspects of Parisian Life* (by Bonnard), which Vollard published in 1899, constitutes the most valuable and precise chamber music that has been orchestrated with four to six colored stones." With Chagall we leave the quartets and sextets behind to rise toward the symphony and the summits of *The Magic Flute*.

Certain purists have insisted for a long time

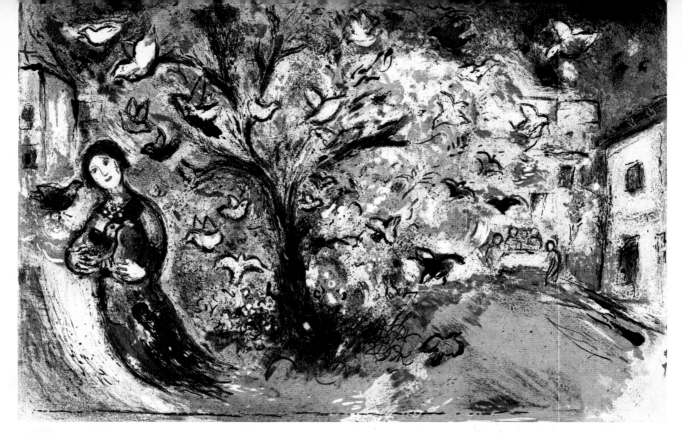

The Bird Hunt. Lithograph for "Daphnis and Chloe" by Longus. 16½"×25". Paris: Ed. Verve, 1961. *(Photo Jean Dubout)*.

that color lithography should employ a great economy of means. In their analysis they forget three important factors: in the first place, the influence of Japanese prints toward the end of the nineteenth century, with their refined tones and sparing use of color; secondly, the cost price of the printing—one proof in twenty colors being twenty times more expensive than a one-color proof—at a time when print-lovers were almost nonexistent. Finally, and perhaps most significantly, a lack of the necessary technical skill, which can only be acquired after long months of work in the workshops of specialized artisans.

With Chagall everything is different, for we are in the presence of the greatest painter-craftsman in the history of art. He executes ceramics, sculptures, mosaics, tapestries, stained-glass windows and graphics with equal assurance. But make no mistake, Chagall never improvised anything in any of these fields; his works are the fruit of long sessions spent in specialized workshops studying and trying to pierce the secrets of copper, stone, glass, enamel and marble.

Nor are Chagall's lithographs the result of a short-term effort. His first plates (thirty-five to be precise) date from his Berlin years (1922-1923) and were simply executed with lithographic crayon on transfer paper. In 1946, a refugee in America, Chagall accepted Jacques Schriffrin's proposal that he illustrate *The Thousand and One Nights*. The thirteen plates of this portfolio represent the beginning of his work in color lithography. All of these illustrations required from six to eight pulls apiece and were almost entirely done with crayon.

Although the technique is still rather rudimentary, pure color has begun to be incorporated in the drawing in a stunning way. As his technical knowledge of lithography increased, Chagall was able to draw an enormous amount out of it.

When he returned to Paris, Chagall immediately started working with Fernand Mourlot, the printer who was largely responsible for the development of lithography after the war. From 1950 to 1952 Chagall came regularly to the old workshop on rue de Chabrol, and he came not as a famous master but as a young beginner. Untiringly, he studied, with Georges Sagourin, his pressman, every facet and possibility of the craft: working on zinc, stone and paper; using washes, brushes, scraping, etc.; making countless states of certain plates "to see how far one could go." Some of these test prints were printed in editions of several copies, but most were destroyed, as Chagall's purpose was not to produce but to learn how to make lithographs.

In 1952 Tériade, the publisher who had already published *Dead Souls*, *The Bible* and the *Fables of La Fontaine* (books which had been commissioned by Vollard), suggested that Chagall illustrate the pastoral poem *Daphnis and Chloe* by Longus; the artist was so interested in this project that he made two trips to Greece (one in 1952 and one in 1954) "in order to touch the earth behind the poem." The notes he brought back enabled him to make lovely gouaches that served as the starting point for the illustration of the work. Jacques Lassaigne has written:

Perhaps Chagall never felt such a direct shock, with the intellect playing so small a role, as that

The Lesson of Philetas.
Lithograph for "Daphnis and Chloe"
by Longus. 16½"×12⅝". Paris: Ed. Verve, 1961.
(Photo Bibliothèque Nationale, Paris).

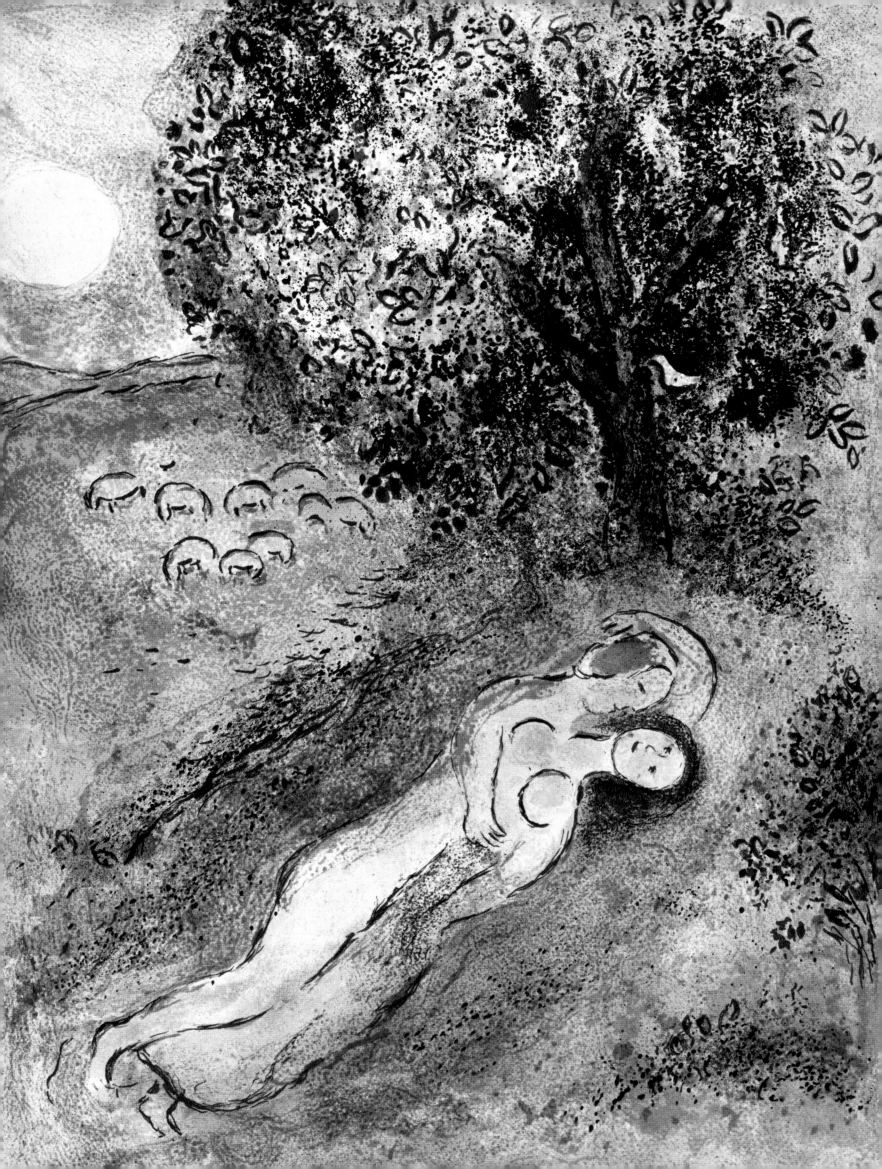

Marc Chagall and Charles Sorlier.

A study of this work from the first to the last page is a long journey toward perfection. The first plate, *The Bird Hunt*, stays within a range of cold tones dominated by blues, greens and violets; the technique indicates absolute mastery, but we can see that Chagall is still at the beginning of his adventure; the major notes of the symphony to come have not yet been struck. In the other illustrations the color suddenly starts to scintillate, stream and explode, embellishing the dream; Chagall the Visionary once again becomes the Thief of Fire.

Another one of the fundamental qualities of this work is the painter's humility before and understanding of Longus, the poet.

The poem ends this way:
Then, when it was night, they all led the bride and bridegroom to their chamber, some playing upon whistles and hautboys, some upon the oblique pipes, some holding great torches. And when they came near to the door, they started to sing, and sang, with the grating harsh voices of rustics, nothing like the Hymenaeus, but as if they had been singing at their labor with mattock and hoe. But Daphnis and Chloe lying together began to embrace and kiss, sleeping no more than the birds of the night. And Daphnis now profited by Lycaenium's lesson; and Chloe then first knew that those things that were done in the wood were only the sweet sports of children.
Hymenaeus, the last plate of the work (and, in effect, the last worked on) scrupulously follows this description, but the creative talent of Chagall is so great that he remains entirely himself while serving the poet perfectly.

No illustration in *Daphnis and Chloe* should or can be detached from the whole. Chagall is simultaneously painter-engraver-illustrator. This success is one of the monuments of publishing and will remain unequalled for a long time to come. Chagall can be proud of the "little apprentice" lithographer he was at the beginning and who found the following thought of Michelangelo so applicable to himself: " 'Where are you going in this weather and with that white beard?' 'I'm going to school to see if there's still something for me to learn.' "

which he experienced in Greece. He thus certainly captured the spirit of Longus's pastoral poem, the feeling of youth and the innocence of a world without sin.

Daphnis and Chloe[2] consists of forty-two lithographs without text on the sheets, twenty-six in a 16¹/₂"×12⁵/₈"format and sixteen in 16¹/₂"×25", or double-page, format. Each plate has between twenty and twenty-five colors, which shows the enormous work involved, since the artist had to work on about a thousand plates, not counting the numerous tests that did not wholly satisfy him.

The book is enchanting. In it, light is trapped in a stream of colors. No one prior to Chagall had attained such perfection, allying inimitable inspiration with a total mastery of a craft that had revealed all its secrets to him.

[1] *Bonnard, Lithographer*, by Claude Roger-Marx (Monte-Carlo: Editions du Livre, 1952).

[2] *Daphnis and Chloe*, a pastoral poem by Longus, translated by Amyot and revised and completed by Paul-Louis Courier; illustrated by Marc Chagall (Paris: Editions Verve, 1961). The work consists of two boxed 16¹/₂"×12⁵/₈" volumes. The edition was limited to 250 copies on Arches paper, numbered 1 to 250, and 20 *hors commerce* copies, numbered I to XX; all these copies were signed by the artist. In addition, 50 signed and numbered suites with wide margins were printed and reserved for the artist and the publisher.

Summer at Noon. Original lithograph for "Daphnis and Chloe" by Longus. 16¹/₂×12⁵/₈". Paris: Ed. Verve, 1961. *(Photo Bibliothèque Nationale).*

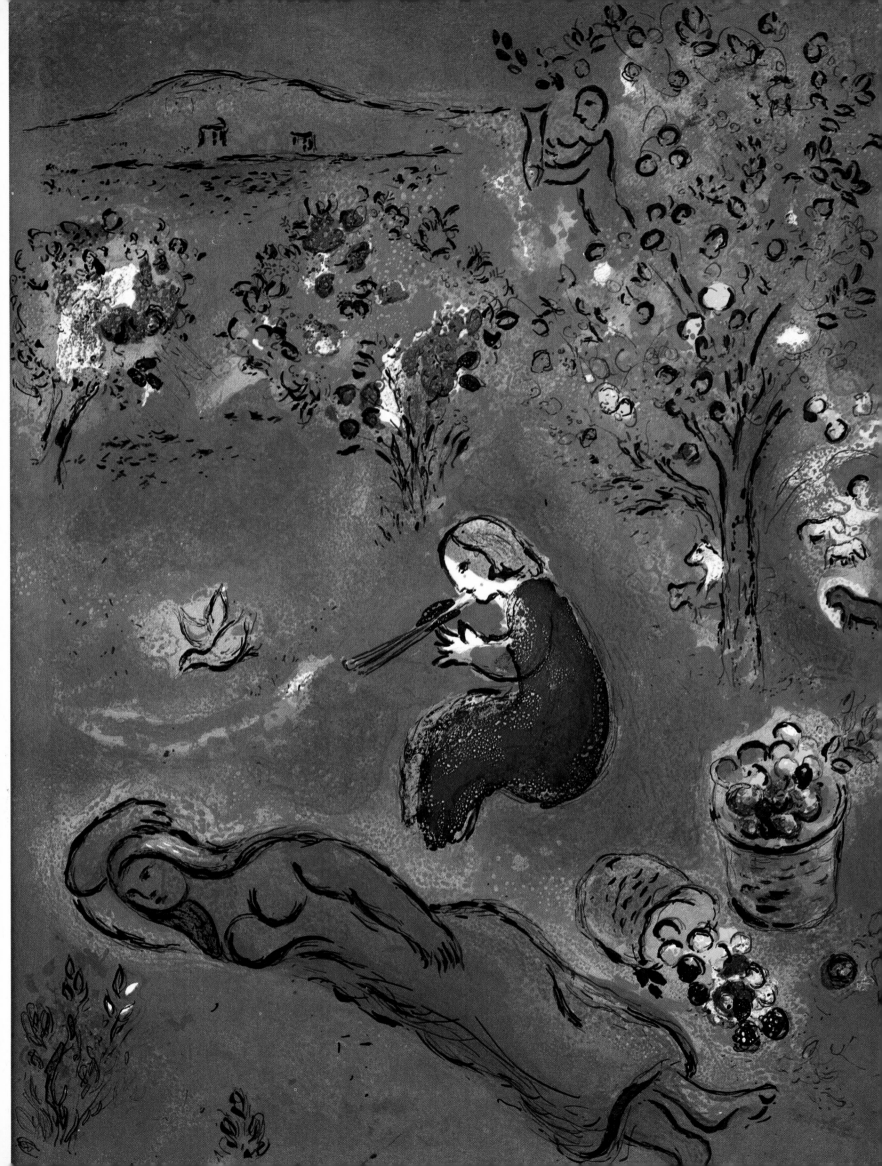

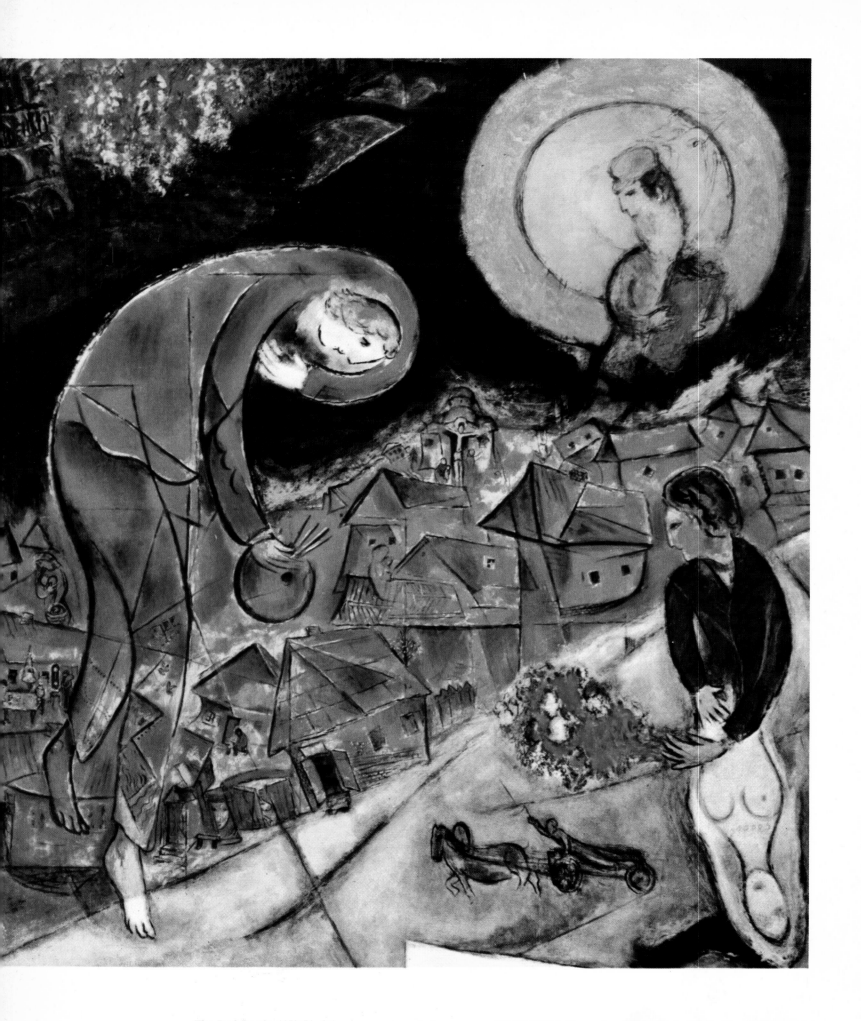

The Red Roofs. 1953/54. Oil on paper mounted on canvas. $90\frac{1}{2}''\times83\frac{7}{8}''$. Property of the artist. *(Photo Daniel Frasnay)*.

André Malraux:
ANDRÉ MALRAUX'S HOMAGE
TO MARC CHAGALL

Who, among the masters of our time, has been more misjudged than Chagall? The main reason for this is that today, when subjects are violently rejected, Chagall cannot be entirely separated from his. It is of no moment that he is the greatest image-maker of this century, for the age does not like image-makers. What do the images of Matisse, Braque or Picasso mean? Their genius quickly renounced them—with the possible exception of Picasso, who knows however that the imagery of his youth was only the setting for his future genius.

So let us speak first of this imagery, as Chagall's work is intoxicated with images. Should we compare it to Rouault's work? Rouault's images were the heirs of the biblical world; Chagall's are on the fringe of the world of Israel. Does Chagall illustrate the Bible? Everything he represents belongs, directly or indirectly, to a popular Bible that he has invented with affection. But the Ox and the Donkey, present throughout many centuries of Christian painting, are not in the Gospel. Chagall is the first painter who dared to invent apocryphal pro-

phets by making use of the apocryphal poetics of the Old Testament. Just as the geniuses of Assisi knew that the donkey would cross his ears and the ox his horns to pray, so Chagall invents an innocent people of the Scriptures: rabbis on the earth, betrothed couples in the sky, and a few wandering clocks. Is it the world of childhood? The Ox and the Donkey would not have lasted so many centuries if they had belonged only to childhood. And Chagall's creatures would not have spread through the whole Occident if they represented only wonder.

Marc Chagall and André Malraux in 1961 at the opening of the exhibition of the Jerusalem stained-glass windows at the Musée des Arts Décoratifs in Paris. *(Photo Daniel Frasnay)*.

Let this ingenuous wonder not lead us astray: such art is not defined by the fantastic but by painting, the type of painting that creates poetry. What other living painter would have been capable of painting in a like manner the ceiling of the Paris Opera? But, as this painting creates poetry, so this poetry creates painting. I am indeed sensitive to Chagall's poetics (which resembles painting). Had he simply invented the trembling and artless domain of his biblically inspired work, the Ox and the Donkey of the Prophets, he would be a great artist. But I am afraid that this domain might become a screen between his work and his public. Although Chagall is a poet (like Hieronymus Bosch, Piero di Cosimo and many others), he is first of all one of the chief colorists of our time and would be so even if he had never painted a rabbi or one of his tricolored canvases alive with phantoms. His poetic power is the same in the works of his youth and in *My Life*; what has changed in the interval is not the poetry but the color. The great play of color entered late into his work. By color I mean the passion which binds the late Monets to the late Titians and to so many others. The list is long, and I only want to distinguish Chagall's genius from that of Rembrandt, Caravaggio or Vermeer. Is it the orchestration? That's Grünewald, not Fouquet. For three hundred years we have distinguished the two families. We have been told that Chagall discovered his genius as a colorist in stained-glass windows. However, transparency creates the light of the windows. Chagall had to invent his, and the unity of a picture is not that of transparency. All the figurative painters of the past were familiar with spectacles. However, they knew the *Liseuse* of Vermeer, but not *Notre-Dame-de-la-Belle Verrière* of Chartres; they knew spectacles that light illumined but did not pass through.

Several of our greatest masters have made a brilliant return to the stained-glass window and the tapestry, re-establishing a dialogue with medieval art. At the churches of Assy and Saint-Paul-de-Vence, this art deliberately ignores the progressive shading off of color. Stained glass and tapestry will exist before and after Chagall, just as they existed before the twentieth century, because Chagall is the first to have accepted the progressive gradation of hues with shadow, which are obviously not the colors of the nineteenth century and not even those of Evreux.

His imaginary world (an *allusive* world, for Chagall never intends to produce a truly dreamlike universe in the style of, let's say, Hieronymus Bosch) is often born from plastic elements: the couple does not become an arabesque, the arabesque becomes the couple. There is, without doubt, a constant expression of the imaginary in Chagall, from his early paintings of the Jews of Vitebsk to his large recent pictures; I believe, however, that this realm of the imaginary belongs less to the picturesque than to what he calls "Love." But if the pictures of his youth are moving and the talent displayed in them brilliant, they differ in nature from the great pictures of the *Biblical Message* in Nice. Had he died at forty, we would not talk about him as we do today. A dialogue between himself and color has been established similar to that which existed between Venice and color around 1550, when Titian set the sovereign right of pictorial lyricism (in his *Callisto* of Vienna) against the *amber* of his youth. Many of Chagall's paintings as well as the ceiling of the Paris Opera provide, as we know, an imagery that belongs to the major poetry of our time, just as Titian's work belongs to the greatest poetry of his. In comparison with *The Nymph and the Shepherd*, Ronsard seems light; and, after all, the last heir of Apollinaire is perhaps precisely Chagall. Nevertheless, the figures on the Opera ceiling are painted on a light background. The nature of Chagall's chromatic invention changes when he sets color against color—first of all because every light background is subtly an heir of illusionism and distance, whereas the contrast of a blue and a red, *provided they fill the canvas*, creates a world that is only related to painting.

Let us imagine that Chagall's latest pictures were even less figurative, even more allusive. His effects would then be clearly manifested—as happens each time we see his latest works together. His present color has no precedent. The

Illustration for André Malraux's *Anti-Memoirs*. 9"×6¼". Ed. Gallimard, Paris, 1970.

masters of the preceding generation, Bonnard for example, pretended to relate their color to a vision. Throughout the whole period that one can use the term "Impressionist"—with the exception of Ensor's fantastic pictures, which are not impressionistic—the field of color (the "palette," as painters say) remains acquired and more or less constant, in Van Gogh as well as in Bonnard and even in the Fauves. The palette changes when the reference of painting changes. But early Cubism was monochromatic, as were the first pictures by Chagall. Most of Picasso's major works, even *Guernica*, are monochromatic. It took a few years before color—which seems suddenly to have forgotten the Fauves—gained *the right to be arbitrary*, which the picture and drawing had already won. "Modern art," I have written elsewhere, "is not legitimate, it is contagious." But its discovery of the contagion of color came late, notwithstanding the victory of Matisse and afterward of Rouault, not to mention Braque. Until illness restricted him to doing cut-outs, Matisse developed a color which is related, despite his genius, to a refined Fauvism. Rouault's grandiose and murky world is certainly transfigured, but it is not wholly arbitrary; it suffices to recall the "Old King." As for Braque, his infallible color is linked to his drawing in another way. The color in Chagall's masterly canvases continues to engender its forms in the same way that the previously mentioned arabesque created the couple in the sky. It is, on occasion, wholly arbitrary. And also controlled, of course, although it does not seem so. Chagall is the most lyrical of the masters we have been talking about—which obviously means, as we would say of the Delacroix of the sketches, that he subjects color to an unreality similar to the mysterious play of music: large raspberry patches, pictures in which red and blue are contrasted as in certain stained-glass windows of Chartres. Whom does Chagall's latest paintings recall if not the Stravinsky of the *Rites of Spring*?

A painter of genius can often be defined by his ability to escape from the coloring style of his time. In what way do Chagall's most striking pictures (often the most recent) break away from their illustrious predecessors? Above all, by rejecting harmony in favor of a dissonance related to that of modern music. Upon leaving the exhibition of his windows and the retrospective of his work at the Grand Palais, we felt that his predecessors who differed the most from each other seemed to belong to a single family. The literature concerning color is limited because color was not talked about with precision until after the birth of color reproductions. Consequently, the drawing and the poetical world of the greatest masters were studied in much greater detail than was their color, and for centuries the field of color was confused with the field of vision. Everyone knows that a difference *of style* separates ancient and Byzantine drawing, but only painters are aware that the color of Rubens differs just as profoundly from that of Giotto. In his stained-glass windows and the pictures of the second half of his life, Chagall establishes an interrelationship of colors that is as different from the preceding one as the Impressionist palette was from that of Delacroix (that is, from that of Venice). There is an acidity, a dissonance and an antagonism of tones in his pictures as well as in his stained-glass windows. Who could confuse Chagall's color with that of, let's say, one of the great Cubists? Where in the whole field of painting can a similar stridency be found?

I used to dream of organizing an exhibition around the theme of *The Masters in Old Age*, which would have consisted of the last works of Hals, of Rembrandt (who died before he was seventy, however), of Titian of course (the *Dark Chateau*), and of a few great Impressionists perhaps. It would have been a disconcerting exhibit, for *the Regents* does not resemble an early Hals any more than *The Nymph and the Shepherd* resembles *Profane Love*. This project came to my mind in Vence when I was standing before ten of the latest Chagalls; if my successor succeeds in bringing these mysteriously related masterpieces together, I would like to see represented among them the work of the greatest living lyrical colorist.

Illustration for André Malraux's *Anti-Memoirs*. 9"×6¹/₄". Paris: Ed. Gallimard, 1970.

Preface by André Malraux to Les céramiques et les sculptures de Chagall. (*Monaco: Editions André Sauret, 1972*).

Jacques Maritain:
THE POETRY OF THE BIBLE

The magnificent triumphs of the art of the first Christians and the Middle-Ages and then of Rembrandt seemed to complete the task of illustrating the Bible. It is remarkable that a modern artist should have again risked this undertaking.

Chagall was the ideal master for this. His success is perhaps due to a fortunate encounter between Jewish culture—which was ignorant of painting—and modern painting—to which the Bible meant nothing. A constantly alert receptive faculty prepared Chagall for this work. He is one of the rare modern painters who have been able to include the whole range of their feelings and thoughts in their work. This occurs more frequently in poetry, but painters in their enthusiasm for the modern, revolutionary plastic possibilities that have opened up before them and in their desire to create an individual work often end up by excluding large sections of life from these works. On the contrary, from the start of his career Chagall has painted, in addition to love and sadness, scenes of festivity and imagination, the culminating points of life: birth, marriage and death.

In illustrating the Bible he transcended what seemed to be the limit of his possibilities and perhaps those of all modern art. He represented themes of a more ancient tradition not in a spirit of curiosity and competency but with a noble devotion. The work shows no trace of systematic constraint: its beauty is not the result of a desire for formal innovation. Although his etchings are marvels of patient and scrupulous execution, there is no attempt at adroitness or technical innovation in them but a total absorption in the subject, whose value the artist convinces us equals or often surpasses the work of art. The style seems natural, it is frankly subordinated to the text, with the result that scenes which are not easy to read come to life thanks to Chagall's unquestionable power to create expressive forms. Each, or almost each, image reveals some aspect of his feelings: veneration, sadness, joy, translated by the melody of forms and the scale of hues particular to each composition.

If his Bible were all we possessed of Chagall's work, we would still consider him as one of the great modern artists, but also as an anomaly in an age where art seems impermeable to the contents and the spirit of the Holy Book. This proves that contemporary artists have many more possibilities in them than modern times allows them to reveal, possibilities they themselves often ignore but which would make them greet with joy—one can suppose—the prospect of having large walls to cover or monuments to build. And they would have no lack of subjects for projects of this size, if their art remained open to everything that they feel and love.

From Verve, *Vol. VIII, no. 33-34 (Paris, 1956).*

Meyer Schapiro:
CHAGALL'S BIBLE

Illustrating the Bible provided a singular test for Chagall's art. Was there some substance hidden in his art that could be analyzed, or, as some thought, was it only an extravagance of poetry and anxious tenderness? There was certainly little doubt in the minds of those who had divined the important role the heart plays in the paradoxes of this painter maliciously in a hurry to lock everything in a mutual embrace.

The forty etchings done for Genesis and reproduced in *Cahiers d'Art* showed that the painter had acquired the upper hand. He had renewed himself while remaining himself.

Reduced, concentrated, forgetful of the aggressive foliage of color and freedom, his art testified all the more to the human and aesthetic quality and the depth of feeling that makes it dear to us. Abstract without being cerebral, he did not methodically guide the burin according to the techniques of the old masters. His ingenious technique dictated by a constantly aroused sensibility made the white and the black and the black in the black sing with marvelous veiled modulations like the songs of the synagogue.

Certain Greco-Buddhist sculptures bear a strange family resemblance to those of the Christian Middle-Ages. More Jewish than ever, Chagall rediscovered here in quite a different world something of that grave and naive medieval inspiration whose lofty tradition is taken up again today by a Rouault.

Yet the difference remains profound. At the height of its perfection Gothic art was able to preserve the intellectual purity of the Hellenic form by incarnating it in a universe of body and soul. Chagall's art has none of the proportions of the Greek form; indeed, it is diametrically opposed to it. Out of a sort of fluid chaos traversed by the soul signs are born, all the more moving because they are less sure of themselves and more involved in the discords of matter, of the apparently living forms that resemble the gestures of agile hands raised from below and imploring God's mercy. And at the same time grandeur comes forth, as in the descent of the angels to Abraham or in Moses's vexed solitude, or in that admirable *Creation of Man* that has such noble movement to it.

It is in this sense that I said a short while ago "more Jewish than ever." And yet Chagall in his etchings did not *want* to be Jewish. I imagine he does not know very exactly what is the Jewish or Christian dogma of the Old Testament he illustrated. He was listening to the poetry of the Bible, and it was that alone which he wished to render, but that poetry is the voice of someone.

I would reproach myself for seeming to advocate in any way an art that is religious, so to speak, only in spite of itself. However, that is what Chagall's Bible is, at least in its most unformulated sense. I would like to observe that it is precisely because it did not search for or desire anything in this sense that the plastic world of Chagall's Bible, so deeply and painfully rooted in the earth, not yet released and as if groping forward in a sacred night, testifies unknowingly to the figurative value of the great lyricism of Israel. The more this world is Jewish and entangled in the laborious speculations of the three great Patriarchs who are the image of the three divine Persons, the more an evangelical call echoes secretly in it. Look at those three angels at Abraham's table: what promises are they bringing to the old man from whom God can hide nothing because he is His friend?

From Cahiers d'Art, *no. 114 (Paris, 1930).*

Bernard Dorival:
BIBLICAL ICONOGRAPHY

God chooses certain men for the benefit of all humanity. This leitmotiv running through the *Biblical Message* of Chagall explains its iconography—an iconography so new that he scarcely borrowed anything from those who had painted these scenes before him. Franz Meyer was correct in insisting on Chagall's independence in relation to his predecessors, whom he only seems to have thought of occasionally. Here and there one finds a Russian icon in an episode concerning Abraham and the three angels, and elsewhere one is reminded of drawings by Rembrandt and engravings by Goya.

If the originality of his interpretation is the primary characteristic of his *Biblical Message*, what strikes us next is his extreme faithfulness and unfaithfulness to the very text of the Scriptures; both are evident in his illustrations of various episodes. Hence, in the painting and in the gouache of Abraham receiving the three angels, he does not neglect the biblical oak any more than he overlooks the respectful attitudes of Abraham and Sarah, who brings a plate to her husband's guests. But they are served wine, not curdled milk. In the same way, not all the details are respected in the two gouaches depicting Abraham and Isaac, one showing them on their way to the mountain where the latter is to be sacrificed and the other showing Isaac about to be sacrificed. Nor are they strictly adhered to in the gouache depicting the Passover; here the diners are seated whereas they should be standing, and around the paschal lamb there is no unleavened bread or bitter herbs as described in Exodus. It would be easy to give similar examples, but the ones we have mentioned should be enough to establish the fact and incite us to look for the reason.

I myself see the explanation in the real absorption of the author in the text; he knows it so intimately that he has no need to consult or reread it. It is retained in his memory, but sometimes he makes a mistake, omitting one detail, introducing another from a gloss, or from a previous representation of the subject, or from some other source. As a result, Chagall can be both literal and inexact—with a literalness and inexactitude that likewise attest to how much the young boy from the ghetto of Vitebsk was nourished by the Holy Book, for which the adult in Paris and the old man in Vence kept their admiration intact, fed by the literary and spiritual beauty of an ancient, familiar text.

It is indeed so familiar that Chagall has expressed every facet of it in the *Biblical Message*, which in this respect well deserves its name. Sometimes Chagall enjoys telling an oriental story, rich in picturesque details, humor and a fantasy worthy of the *Thousand and One Nights*—or of the charming story of Joseph. In other cases, as in the works that recount the Mamre episode, the story takes place on the plane of an eclogue or a familiar idyll. In still other works it rises to the level of tragedy, as in the picture of the plagues of Egypt, where man's will power clashes with God's, giving birth to a drama whose grandeur Chagall vividly narrates. There is also grandeur in certain epic scenes—those depicting the Exodus, for example—and even more in certain works like *Abraham Mourning Sarah*, where a poignant, simple, true sense of humanity is attained. But the works in which Chagall soars the highest are those in which the power of God and the fervor of man are confronted most intimately: *The Covenant with Noah, Jacob's Dream, Jacob's Struggle with the Angel, The Burning Bush* and *The Tables of the Law Given to Moses*. If we then think of the ardent pictures of the Song of Songs, streaming with the same passion as the text that inspired them, how is it possible not to admire the painter and his ability to excel with the same ease in the most opposed subjects and to make himself as varied, as fully human as the biblical text itself?

God's Forgiveness Prophesied to Jerusalem. Illustration for the Bible. Ed. Verve. vol. VIII, no. 33-34 (Paris, 1956).

From the catalogue published on the occasion of Chagall's donation of his Biblical Message *to the National Museum (Paris: Réunion des Musées Nationaux, 1967).*

Claude Esteban:
LIKE A PERFECT CHEMIST.....

It would be a definite mistake to see in Chagall's work a deliberate quest for the incongruous. Although his pictures may astonish, they never seek to surprise or disorient as is demanded by the canons of Surrealist painting. Here, there are no arrogant enigmas, there is no maleficient Sphinx demanding an immediate, impossible answer from us. The marvelous conceals no brutality; there is nothing but a voice, an appeal similar to that of the sailor in the old Spanish *romance* by the Infante Arnauld: "My song is only for the one who departs with me..." This also holds true for the crucified Christ stretched out on a clock whom an enormous pensive fish carries up into the depths of the sky. Chagall does not confront us with one of those innumerable rebuses of the unconscious, more labored than difficult, which some people find charming. Beyond the tables opulently set with fruit, flowers and candelabra—life shown through its visible luxuries—an effigy, seemingly invoked but not imposed, provides a sense of ambiguous mystery; this image, which blends joy and grief, is totally foreign and yet familiar to everyone. Whoever wants to, should take a good look at Chagall's work: it does not offend anyone's conscience.

Without doubt, we have been taught too well to fear the worst in ourselves; we imagine horror lurking everywhere in the dark unknown. This is a kind of inverse puritanism that gains confidence through anguish. Chagall ignores, one might say, these baser yearnings. Sometimes a gigantic eye is opened on the façade of his houses; but on closer inspection the house turns out to be nothing but the abundant fur of a fantastic animal profiled against the dark sky—which is, in its turn, perhaps the pupil of an even larger eye.... What a dizzying invitation to delirium for some modern adept of Hieronymus Bosch! Others would have quickly brandished all the gaudy tinsel of the supernatural. Chagall though, finds not a demon but an aerial figure of the world, like a subtle metaphor of breath, inhabiting and ranging without bounds over the stones and plants, the animals and people. It is as if the force of gravity had been diminished and everything spun around without ever touching the ground, due to the musical virtue of a new star—that cello or child's violin which irradiates the *blue air* of so many pictures. Under Ariel's wand our fragile galaxy takes flight.

Then, across the dark canopy of a sky no longer lit up by baleful comets, new constellations arise, new signs heartier than Aries and Libra: the Woman-Cock, the Bouquet, the Torch, a peaceful and fabulous zodiac where our torn destiny is written, renewed, oriented. These pictures are not addressed to our eyes alone; they do not offer a sort of static landscape, childish or whimsical depending on one's taste, for the fleeting pleasure of a spectator. They are intended as a voyage, provoking in us, if we accept, a liberation, an exaltation of the spirit of adventure. When Chagall's painting suddenly comes into focus in my mind, it resembles a man who walks along in the evening with all the travail of the hours on his shoulders. A wandering Jew or Saint Christopher—what does his face matter?—he has just passed through our town and is disappearing down the road, leaving strange drawings engraved on the trees and stones that point the way to a castle whose glitter can be seen in the far distance, as in stories, or perhaps only beyond the next hill.

The space of the Middle Ages was curved. Within its confines men and things seemed to be woven together by a transcendent purpose; they lived and grew interdependently, as though they were part of the same will. In his work Chagall, after the manner of the Byzantines, Cimabue and Duccio, and without our being able to discern anything except a spirit of harmony, has recaptured the life of a world integrally turned inward upon itself.

The discursive intelligence will surely read in the large colored pages that Chagall unfolds before us merely a discontinuous exposition of themes or concepts: the donkey and the fiddler and the woman-bird in the sky and a few floating isbas... A similar interpretation, which confines itself to the juxtaposition of the painter's motifs, will invariably neglect the very style of these pictures, in which everything is a matter of relationship, coordination

The Bird. Marble bas-relief. 43$\frac{1}{4}$"×23$\frac{5}{8}$". Baptistery of the church at the Plateau d'Assy.

and exchange. It seems to me that Chagall proceeds somewhat in the manner of the biblical story of Genesis, which places things and beings side by side and develops them in time—but which simultaneously weds them in love with the unifying phrase: "And God saw that it was good."

Chagall is a painter not of the Diaspora but of the Promised, and already shared, Land. In his work one finds a joyous intermingling of the sensible world and an interpenetration of realms—from the immense to the minute, from the earthly to the celestial, from the remembered to the imagined. He sets on the stage before us a kind of polymorphic mystery play about the creation in which happily indifferent actors play all the roles instead of being confined to a narrow identity by some supreme hierarchy. And if God himself were to come out to speak, he would be dressed neither as a Judge nor as a Creator (that being an ancient role he perhaps prefers to forget...); he would be caught up in a whirlwind of angels and humans, with their violins and huts and caps. Next to us is that bearded Christ, moujik, strolling fiddler or Apache, similar in appearance to the image of the *poverello* of Assisi fostered by his disciples. And the vast circle of the sky is like an arm coiled above the heads of everyone.

But if Chagall discovered how to reintroduce the deeds and the time of men in a musical sphere, he also became aware of how individual, and therefore how threatened and precarious, is the act that establishes this harmony. However, we have only this

act to build upon. The consciousness of exile, when it is manifested in Chagall, is inseparable from his fierce determination not to let it dominate his painterly destiny. Stretching the resources of his genius to its limit, he always strives for an improbable union of the world in color. Many of the works he has undertaken, especially since the war, indicate this clearly. For example, *The Painter and his Models*, in which a waltz of the artist's favorite archetypes—the sun, the donkey-musician, the bridge, the village—swirls around an easel. Feverishly, they assault the picture on which the painter, unaware of their presence, is working. But everything on the canvas finally takes shape due to the skill of hand that associates the whorl of stars with the quivering of flowers—until they are resolved in a single blazing bouquet. When a common ground is lacking and reality seems, even to the most faithful, as worn-out as an old coin, the artist, if he can resist being discouraged, is at least able to believe in the manual, material value of his acts and to guide the conceived work toward its unknown completion, in keeping with Baudelaire's wish, *like a perfect chemist and a holy soul....*

Chagall definitely belongs to that family of spirits, quite rare today, who make no distinction between the most elaborate craft and the simplest faith, not using one to the detriment or humiliation of the other, but on the contrary, clearly demonstrating by means of assembled forms and colors that mastery is not an end in itself; rather it is a personal, and craftsmanlike, manifestation of fervor. The "chemistry," accord-

ing to Chagall, is the tangible flesh of the Poem; it is the pictorial interpretation of a Poem that should be shared—not some laboratory secret.

In a world where the gods are silent, Chagall continues to make his art an act of devotion. Yet this piety is not at all founded on nostalgia; it pays homage to the living man, to a "light come from elsewhere" that passes through him and illumines him but that cannot be separated from him. I believe we should welcome his pictures with similar confidence. To try and interpret them or apply a logical system to them would definitely be not to recognize their specificity as works of art and their transcendental dimensions. Chagall must be read literally, like our favorite childhood books—not in order to pierce the mystery but to share in it from page to page.

His painting portrays the moving profile of man in the timeless varieties of the fable. And the fable requires a circular development, a repetitive lyricism, a liturgy. So one dreams for Chagall of a time when frescoes will again decorate the walls of churches. Without doubt the great cathedral, proud of its singular message and soaring above the dust of the city, would not be the best suited to these human lessons of hope; white chapels dotting a hillside, like the monasteries of the East, strung out along chalky paths for the footsteps of the faithful, the prophets and beggars, would be more appropriate.

From Derrière le Miroir, *no. 182 (Paris: Editions Maeght, 1969).*

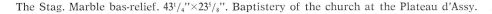

The Stag. Marble bas-relief. 43^1/$_4$"×23^5/$_8$". Baptistery of the church at the Plateau d'Assy.

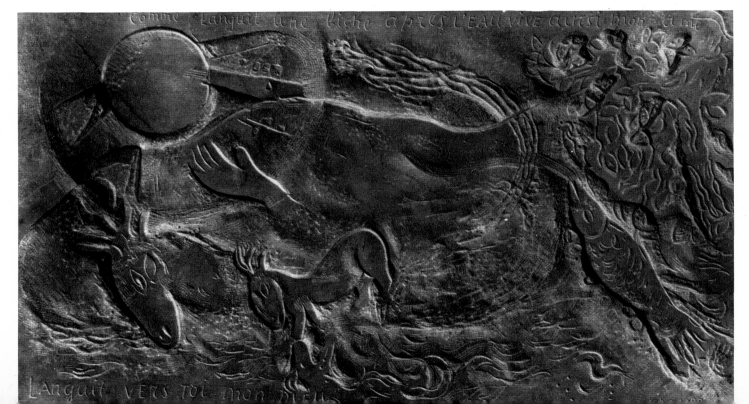

TWO ELASTIC POEMS
by Blaise Cendrars

I. PORTRAIT

He sleeps
He's awake
Suddenly he paints
He takes a church and paints with a church
He takes a cow and paints with a cow
With a sardine
With heads, hand and knives
He paints with an ox's nerve
With all the dirty passions of a little Jewish town
With all the exacerbated sexuality of the Russian
/ country

For France
Without sensuality
He paints with his thighs
He has eyes on his arse
And abruptly it's your portrait
It's you, reader
It's me
It's him

It's his fiancée
The corner grocer
The cowherd
The midwife
There are tubs of blood
In which the newborn are washed
Skies of madness
Modern mouths
The Eiffel Tower like a corkscrew
Hands
The Christ
But Christ is he
He spent his childhood on the Cross
He commits suicide every day
Suddenly he stops painting
He was awake
Now he sleeps
He strangles himself with his tie
Chagall is astonished to be still alive

II. THE STUDIO

The Ruche
Stairs, doors, stairs
And his door opens like a newspaper
Covered with visiting cards
Then it closes
Disorder, nothing but disorder
Photographs of Léger and Tobeen one doesn't see
And in the back
In the back
Frenetic works
Sketches, drawings, frenetic works
And pictures...
Empty bottles
"We guarantee the absolute purity of our tomato
/ sauce,"
Declares a label
The window is an almanac
When the gigantic cranes of lightning
Noisily unload the barges of the sky
Dumping sacks of thunder
There come tumbling down
Pellmell

Cossacks the Christ a rotting sun
Roofs
Somnambulists and goats
A werewolf
Pétrus Borel
Madness winter
A genius halved like a peach
Lautréamont
Chagall
Poor kid next to my wife
Morose enjoyment
The shoes are worn out
An old pot full of chocolate
A lamp that looks like two
And my drunkenness when I pay him a visit
Empty bottles
Bottles
Zina
(We talked a lot about her)
Chagall
Chagall
Astride the ladders of the light

October, 1973

From Nineteen Elastic Poems (*Paris, 1919*).

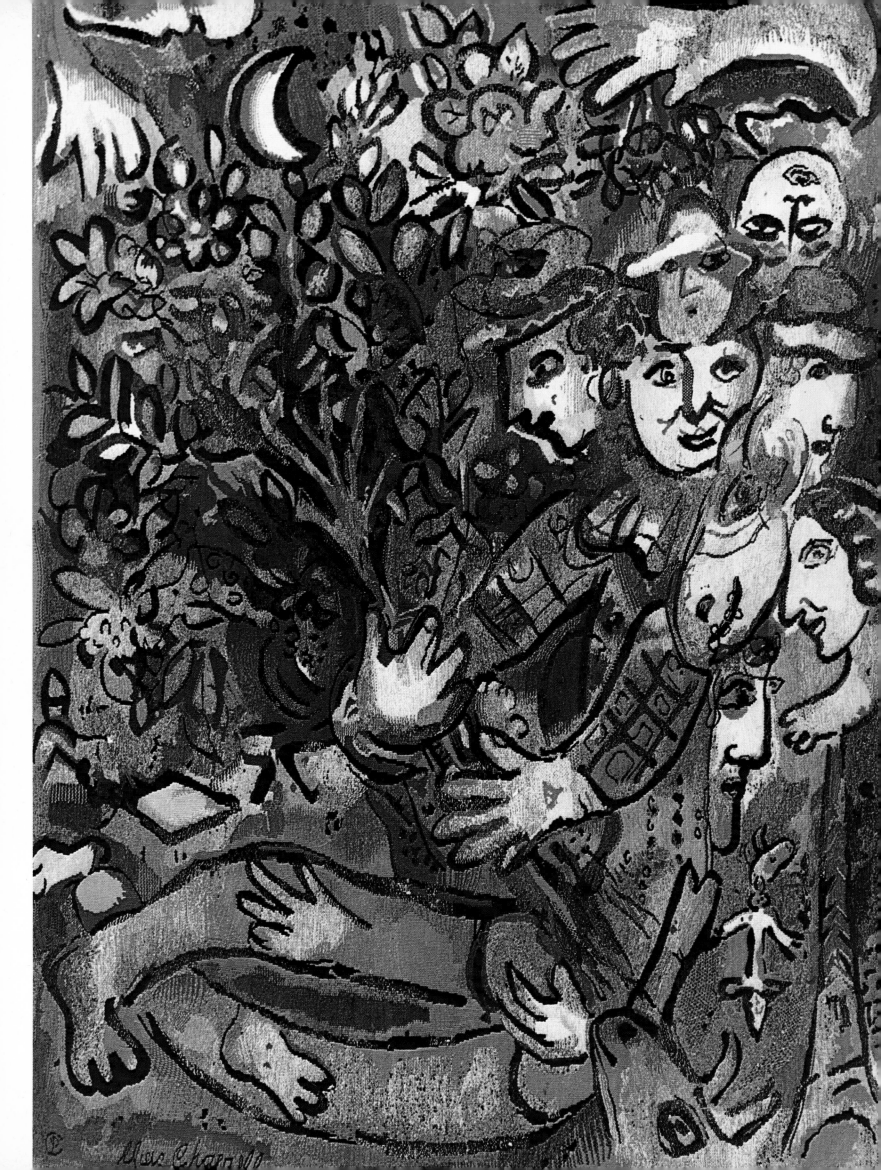

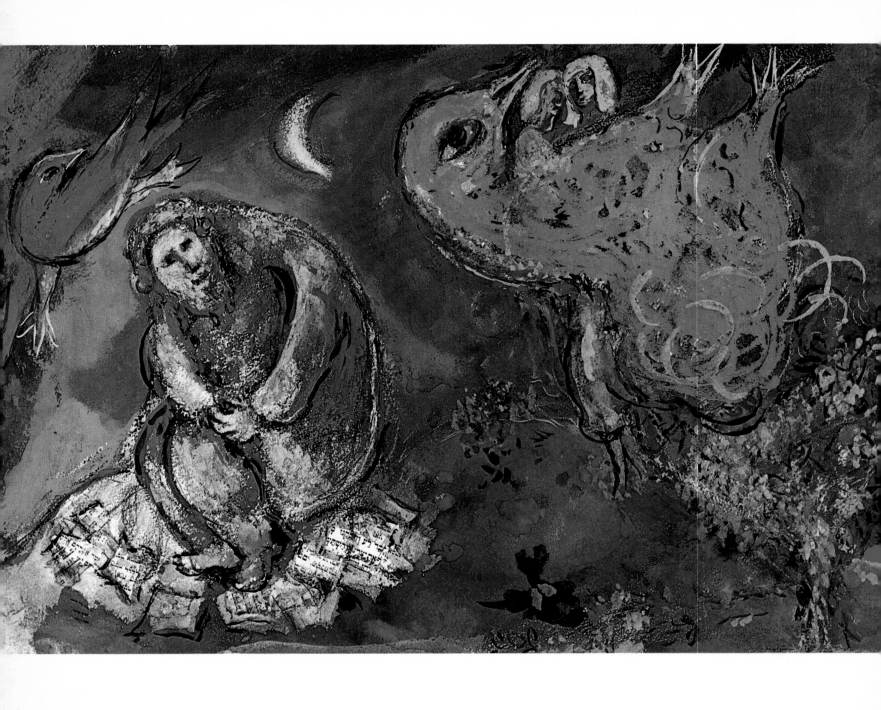

The Prophet Jeremiah. Study of the tapestry for the Helfaer Community, Milwaukee (U.S.A.). 76¹/₄ sq. ft. *(Photo Henri Tabah)*.

ODE TO MARC CHAGALL

by Philippe Soupault

At dusk
when the sky turns night-blue
and a drizzle begins to fall
I left Montrouge
where a souvenir of you still hangs on the walls
of a small house
Lost in the mist
I wandered with my eyes closed
Someone grabbed my arm
it was the vendor of red balloons
he said let's go
And I went
And while we were walking
we discovered the corner florist
and the man who peddles ties on the street
following us silently
Soon the hawker of fruits and vegetables
the little telegraphist and the little pastry-cook
the old beggar who offers withered flowers
the baker's wife and her minicar
were falling in after us
And we walked very quickly
as if someone were calling us
after having set a bonfire ablaze
The driver stopped his bus
and offered us a ride
We climbed on to go more quickly
The florist said it's Noah's Ark
And suddenly all the little donkeys of the
/Champs-Elysées
galloped behind the bus
and a big purple-colored ox
escaped from the slaughter-house
followed us from afar

the bus jolted along at top speed
but the driver stopped before each monument
Notre-Dame and the Eiffel Tower
rose up suddenly out of the mist
as well as the Invalides and the Sacre-Coeur
and the Zouave of the Alma bridge
and Jules Simon in his beautiful stony frock-coat
the Obelisk and the Madeleine
all those memories you couldn't forget
Auteuil and the Saint-Lazare station,
the Panthéon and La Halle aux Vins
Then the phantoms appeared
women clothed in their hair
poets in grey woolen gowns
dogs carrying a red heart in their mouths
empty-handed children
The stars began to shine softly
I didn't know we had a rendez-vous
that June night
in a salon white as a sepulcher
when all the others had left
the moon no one was expecting
joined the party
She knocked on all the windows
Just in case
the knife-grinder had brought a bouquet
He rang his bell for us to be silent
And we grew silent
Far away a clock reminded us
it was midnight or eleven o'clock
Someone opened the window
and a butterfly entered
slipping in on a moonbeam

The Concert. 1957. Oil on canvas. 55$^1/_8$"×94$^1/_4$". Maeght Gallery, Paris. *(Photo Claude Gaspari).*

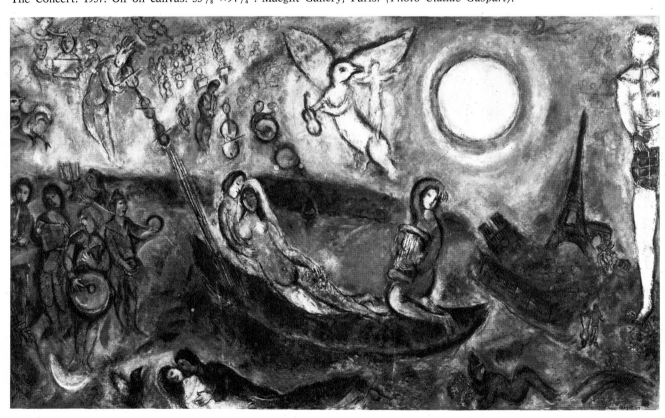

Gaston Bachelard:
THE ORIGINAL LIGHT

It is endlessly repeated that the fables of La Fontaine are condensed dramas, that the fabulist was an observer who ran about the fields and listened to everything. Throughout his work he tells what he saw. Conversely, Marc Chagall sees what he is told. Better yet, he quickly sees what he is about to be told. Being restless to paint, he is always creating new visions. As a result, he shows us light that is simultaneously profound and mobile. By placing the brightness where it is necessary, he narrates.

This wonderful gift for synthesis enabled him to further condense in his etchings the already very condensed fables of the fabulist. With confidence and good fortune he was able to capture the *dominating moments* of the stories. Look carefully at one of the etchings, and it will begin to recount a fable all by itself. Chagall was able to capture the very *seed* of the fable. Before your eyes everything buds, grows and flowers. The fable is about to emerge from the picture. For example, when the painter shows you two dumb goats, horn to horn, on the narrow plank that serves as a bridge above the abyss, you know everything. If you don't remember the fable, look at the picture closely and it will tell you the moral of the story. By making you see, Chagall makes you talk. If you prolong the pleasure of looking at the two goats confronting each other, you will uncover the rhymes. The painter's genius will turn you into a talented poet.

Sometimes it was very difficult to illustrate the comedy. But the Chagallian eye can see into the depths of the heart. Look up at the top of the page where you will see the cobbler who must eventually tell you the misfortunes of the financier. I myself can hear Gregory laughing! I can hear him laughing with the very laughter of Chagall, a laugh full of the sap of life and the energy of being alive. Not until Chagall's etching did the cobbler Gregory strike the vamp so hard or twist his head so vigorously to draw the wax-end through. Can you guess why? It is because Chagall, swift Chagall, caught the worker in his ultimate gaiety, in a gaiety never experienced before, in a super-gaiety that is evidence of a release—it comes *after* he had given up the treasure and not *before* he received it: a mountain of worries! The cock can sing. The thieves—those jolly fellows—can come and visit the cellar of the cobbler. They will be nicely caught. The day before, Gregory returned the cursed coins to the financier, the coins that make it impossible to work. Chagall knows that, says it all. He tells it with the needle that furrows the polished copper, with the brush that adds additional joy to lively rhythms. He narrates, he composes fables with his eyes open. Seize the Chagallian moment then, and you will see the proof of the forces that have accumulated in a unifying vision. Chagall is a condenser.

But let us look at another fable, *The Fox and the Grapes*, that La Fontaine compresses into eight verses. Here it occupies a full page. The grapes are swollen, like the frog in another fable, to excite the fox's desire. But the Chagallian fox knows how long the diagonals are in a big book and hence rests calmly in his corner. Doesn't he have a spot of red at the tip of his snout, and on his face that flame that can be seen on the nose of a good vinegrower? The wine from the entire grape arbor would not add a bit more color. *Chagall's fox is drunk with the joy of aloof scorn.* Chagall, like La Fontaine, knows that is "much better than complaining." Here again the moral emerges by itself, with the help of the lines and the colors. Chagall's sharp eye has "heard" the whole dialogue between the animal and the fruit. It has thus been proved: pictures are narrations. They recite the most elegant fables in their own way. The space, amply filled with volumes and colors, sets the personages, the men and the animals, in motion. In a picture by Chagall nothing remains immobile. The clouds float by slowly or quickly in the sky, depending on whether a sheep is drowsing or a lively weasel is climbing a tree. We feel that the storm will calm down as soon as the oak is uprooted. Now that the drama has been enacted, the reed can rise again. Chagall knows how to say everything about aerial movements, to put just the right lining on the edges of the tossed clouds. Chagall's sky is never an empty space; it is always doing something. Chagall activates everything.

If we examine a black and white etching, we can understand this art of outlines that is so visible in the Chagallian clouds and those hurricanes Chagall renders with expressive force. The etcher must use a thousand fine lines to weave his shadows and bring them very close to the centers of brightness. Very close but not too close, for Chagall would never want to violate the fringe or stop those incessant contour vibrations which impart life to everything illuminated by daylight, be it a pitcher on a table or a landmark. Notice, feel how gently Chagall tightens the shadow around the swan's neck. With what skill he works in the black that is necessary to produce a similarly vivid whiteness!

Truly we live in a marvelous time when the greatest painters enjoy becoming ceramists and potters. Here they are cooking colors, making light by means of fire, learning chemistry with their eyes; they want matter to react so that they can have the pleasure of seeing it. They divine the glaze when the matter is still soft, dull, hardly shining. Marc Chagall is a master of this satanic painting that goes beyond the surface to enter the chemistry of depth. He knows how to keep his vigorous animalism alive in stone, earth and paste. Once again we have the proof that he was predestined to write fables, to inscribe them in matter, to sculpt fabulous beings in stone.

A visit to Chagall's ceramics will show you how fraternally all the animals of the world were bunched together. Chagall's philosophy consists precisely of a belief in this community and eternity of life. And the proof of this philosophy's concreteness, the proof that it is so real that it can be painted, is evident if you compare, in his work, Leda caressing the swan with the woman teased by the cock. Ah! What would Chagall's cocks do if there weren't any women? And their beaks, what beaks they have!

A primitive sculpture—is it Chagallian or Assyrian?—that Chagall did before the fable illustrations leads us into an enormous revery. The woman-cock gathers all the ambiguities, formulates all the syntheses. We are here at the very source of all the living images, of all the forms that, in their eagerness to be, mix together, jostle and cover each other. What is alive is linked with inertia. Stone and wood objects become beings of flesh and muscle: the cello player *is* a cello, the pitcher *is* a cock.

The patriarchs return from a remote time to tell us the most elementary legends. Marc Chagall has so many images in his head that for him the past preserves all the colors and the light from the origin of time. Once again, he visualizes everything he reads, drawing and etching his meditations, writing them in matter, making them burst with color and truth.

From Derrière le Miroir, *no. 44-45 (Paris: Editions Maeght, 1952).*

Ambroise Vollard:
I PUBLISH THE "FABLES" OF LA FONTAINE

When I became a publisher, one of my most stubborn ambitions was to publish a worthily illustrated La Fontaine. With Chagall I finally was able to carry out this project I had harbored for such a long time. How well I succeeded can be judged by looking at the *100 Fables*.

I did this, believe me, not for the vain pleasure of adding one more edition to all those that already exist. There are some that are quite remarkable; many are masterpieces, both typographically and artistically. I fully realized their value, but I had my own idea. It seemed to me that none of the interpretations of the *Fables* that had been made depicts them fully; none, for example, expresses the magnificence, the restrained compassion and the profound lyrical resonance of certain of the verses. I thought of these lines, for instance:

From the abode of the gods the bees descend.
Legend says the first went to dwell
On Mount Hymettus and fill
Themselves on the treasures the zephyrs tend.
When the ambrosia their chambers contained
Was taken from the palaces of the heavenly daughters
Or, to speak plain English, after
In the honeyless hives there remained
Nothing but wax, many candles were made....

I also recalled the apostrophe of the poet to the peacock:

You who sport around your neck
A rainbow tied with a hundred silks;
Who strut and outstretch
Such an opulent tail and remind
Us of a lapidary's shop....

And verses full of images like these:

On the wings of time sadness flies away...
Pretense is a country full of desert spaces...

How many other examples I could invoke!

In short, I said to myself, those who have illustrated the *Fables* have usually only focused on such and such of their merits and sometimes the most secondary ones. For a few, La Fontaine is only a likeable teller of anecdotes, a lover of the picturesque, of nature and the episodes of rural life, a satirist, a painter of animals; for others, only a cruel observer of the human comedy, a censorious spirit with the gifts of a caricaturist, a dilettante with a background of bourgeois morality. Each side reduced him exclusively to one or the other of these viewpoints, not understanding that he was all of them together and even something more. Thus, it seemed to me that his basic, profound unity, veiled under an accidental diversity, was being wrongly criticized. In any case I felt that no one had yet rendered the evocative and at the same time plastic aspects of "this comedy with a hundred different acts" that comprise the *Fables*.

That is why I believed it was both desirable and possible to attempt a less literal, less fragmentary interpretation of La Fontaine's work, that would be at one and the same time as expressive and more synthetic than other renditions.... And who could accomplish this transcription if not a painter, and a painter endowed with creative imagination rich in colorful inventions?

"Fine," I will be told. "But what a singular fantasy, or rather what a wager, to go looking for a foreign artist to illustrate and interpret the work of a genius so specifically French!"

I would certainly agree that La Fontaine should only be considered as an authentic representative of the French spirit. But I feel that this also diminishes him, amputates a part of his fame, restricts the power of a genius not limited in time or space. I would even say that La Fontaine is being wronged when he is considered only as a writer characteristic of the age of Louis XIV. If we enjoy him so much today, it is not just on documentary grounds but for our own reasons, just as his contemporaries, for their own reasons, did not accord him his rightful place. It is safe to say that great poets participate in their time, but they also transcend is to that each epoch experiences and discovers them anew. Had Racine just painted the court of Louis XIV, he would only be admired today by a few scholars. Our love of Racine and La Fontaine is based not on an archaic veneration but on their particular relevance of the thinking and emotions of our time.

La Fontaine is not limited by geographical boundaries. He has become a universal genius whose name, or in any case whose influence, can be felt everywhere. In Russia, for example, in the first half of the nineteenth century Ivan Krylov made such good translations or adaptations of most of the fables that La Fontaine became a sort of national fabulist. In schools where most students are not even aware of his existence, his work is a classic. I said a short while back that we Frenchmen of the twentieth century have our own reasons for admiring La Fontaine, but I am convinced that there are also Scandinavian, English, Belgian, Italian and Spanish reasons for admiring him, for liking or even disliking him.

In short, all that is specifically oriental in the sources of the fabulist—namely in the works of Aesop or the Hindu, Persian, Arabian and Chinese storytellers from whom he borrowed not only the themes but often even the setting and mood of his adaptations—led me to think that the artist who could give the best plastic transcription would be one whose origins had made this wondrous Orient familiar and natural. And now if I am asked, "Why did you choose Chagall?" I respond, "Precisely because his aesthetics seem so close and in a sense related to the naive and subtle, realistic and fantastic aesthetics of La Fontaine."

In a new language have I
Made brother wolf talk and brother lamb reply.
I've gone further still: tree and plant
In my domain have grown conversant.
Are there any whom this does not enchant?

The enchantment of La Fontaine! The enchantment of Chagall!

From Derrière le Miroir, *no. 44-45 (Paris: Editions Maeght, 1952).*

E. Tériade:
CHAGALL AND ROMANTIC PAINTING

Chagall is a painter who was *born romantic*. But he is a painter above all, because he sees everything in terms of painting. That is what's important. His romanticism, yielding to the painter-seeker of balance and beautiful colors, assumes its predestined place only in the spirit of his work, not in its plastic unity, which remains fundamental and pure. In this way his work belongs to the tradition of romantic painting.

What more precious joy could we wish for than to see the world through bouquets, huge bunches of flowers, lavish, echoing, obsessive, to see it only through these plentiful bouquets gathered by chance in gardens, inexplicably harmonized and naturally balanced—well-bred flowers that have discovered relationships among themselves and developed late-blooming and hazardous friendships.

We will look at the world through the optics of this sumptuous vegetal life, from a forgotten mediocre childhood and a town enhanced by poignant memories to the tender details that make our slow discovery of things so precious. Why persist in refusing to look at life through the brightly colored joy of bouquets? Why always want to see it face to face or close-up and seek to justify false realities? Make a decision. Memory is everything. And dreams express things better, embellishing them to the point of re-creating them. Dreams enlarge our mental images to the limits of our desires.

Chagall places a luxuriant, vital bunch of flowers in front of himself, contemplates them and yields to the sensations given off by their abundance. Their closeness and constant presence finally makes him drowsy. He dreams. Figures move through Chagall's pictures to the rhythm of a light imagination. We succumb to the imperatives of his soul. And when ultra-rapid means of communication take us into the vast unknown, it is not only our spirits but, we vaguely feel, also our bodies, that take leave of us. Chagall catches us precisely at the moment we are crossing friendly landscapes. He stops in full flight to catch up with himself.

Because he is an explorer of unusual types of balance, nothing keeps him from hanging himself in order to try to obtain a good position in the void which he would fill with his own kind of cries or from taking onto his fragile shoulders the weight of those he loves. We can compare him to a magician who makes unforgettable objects pop out of his hat, from Russian landscapes with grey wooden planks to eccentric dancers, entwined couples and cows grazing in green pastures. The only trouble is that, once having produced them, he cannot make them return again into the bottom of his hat and disappear. The magic that emerged begins to live and Chagall continues.

His characters bathe in the favorable settings that were created to enclose them. They no longer belong to life but are disguised as plastic characters, and as such they receive the homage of confetti, bits of shadow and color that create an enviable position for them in the domain of painting.

Abstraction is a constant in Chagall's work. But instead of reducing things to geometrical elements, first abstracting them so as later to construct the unity of his plastic world, he prefers to leave them as they are. As in a continuous dream that spontaneously associates things on an imaginary plane, Chagall arranges his memories of beings and objects according to a directive he receives from his soul, and with the feeling that he is establishing a reality that belongs to him.

His work is a continuous drama that is full of tenuous connections; it is an uninterrupted quest for perilous unities. To bind, to unite these two so basically different elements, these delicate scumblings whose tones are softened by distance with the thrusting bursts of the oily impasto, to relate planes worked with devoted care to the primitive hardness of sketched in surfaces, and to see that the arabesques of the latter circulate freely through the anomalies of the former is work that only a painter can achieve successfully.

As crazy today about blues as he used to be about violets and yellows or blacks and whites, Chagall, since returning to France, has become a commentator on the ability of the color blue to transmit light. Through it he has recaptured that purity which only exists in the air of France, the azure in which the most beautiful kinds of dreams would be lost by being incarnated in definite forms. But here as well Chagall accomplishes miracles, placing his drunken soul within the invisible limits he has created. The feeling for spectacle inherent in every good Russian is increasingly simplified in his work, which is comprised solely of the elements required by plastic expression, pure organizing values. Chagall takes life with its appearances and endows it with the intimate logic of his creation. His powerful inspiration is sustained by his innate generosity. No sooner has he brought forth a work than it begins to live its own life with its own individual structure alongside other works, beings and objects. And this makes Chagall so happy that he will paint another picture.

From Cahiers d'Art *(Paris, 1926).*

The Chicken. About 1920. Gouache. 18⅞"×25¼". Private Coll., Brussels.

Jacques Lassaigne:
CHAGALL IN GREECE

The unusual characteristics of Chagall's work stand out so clearly that we believe we can easily recognize and qualify them, for example, as being a part of Russian or Jewish folklore. Nothing could be more illusory. The climate and the landscape of the places he has lived in have influenced him to a tremendous degree. But it is difficult to realize this, since such influences are almost never directly expressed (except in certain watercolors and intimate paintings done when he returned to Vitebsk in 1914 and when he stayed in French country towns and in Peira-Cava between 1925 and 1930). There is often a considerable lapse of time between the impression received and its materialization, and this allows for subtle transpositions to take place. Thus the series of fantastic views of Paris takes up again and develops, after many years, the sketches the painter did when he came back from America at the beginning of 1947. We are made to realize that Chagall's physical perception embraces nuances and unsuspected details that no one else sees. These acquisitions undergo a long mutation in the painter's unconscious before they adopt their definitive form, which is not always clearly legible.

That is one of the consequences of the way Chagall works. He never paints directly from a subject but ceaselessly interrogates nature, particularly during the solitary walks that all his life have led him across fields and down paths and roads. To guide his memory later in this labyrinth of received impressions, he makes sketches and secret, condensed notes, unintelligible to others, rejecting any form that would reveal its contents too early. (In the same way, a writer often builds his initial plan on paper in microscopic and almost indecipherable characters.) These references to reality preserve all their mystery when Chagall begins to paint, but they imperceptibly enrich the themes he has carried inside himself for such a long time. That is why the work is finally embodied with great power in space and time without a realistic detail ever being recognizable in it. The same process occurs when Chagall paints a city he knows and loves like Vitebsk, Paris or Jerusalem. Reality has undergone a total transformation and yet the best of it has been safeguarded.

It is interesting to rediscover in Chagall's work (sometimes after countless detours, countless delays) the decisive moments that have renewed him and governed his future creations. A short visit to Mexico in 1943, during his stay in America, transformed the painter's vision. If the works I saw in his workshop in Vence are any evidence, in particular the astonishing *Open Window*, I believe that the discovery of Greece was no less important for Chagall. It established a familiarity between the world and himself on the basis of a new openness and freedom, appeasing and softening as never before the painful and uncertain anxiety that had so often gripped him.

Chagall went to Greece in 1952 and again in the autumn of 1954 at the request of Tériade, who wanted him to illustrate *Daphnis and Chloe* with color lithographs and who dreamed of placing this marvelous story in the setting of the island where he was born. Chagall did not leave without some uneasiness about his ability to communicate with a world he did not know and that had never attracted him. But is it possible to judge a land, a climate, so steeped in history and legends before one knows it physically? From the first moment of contact Chagall was overwhelmed and knew he had retained his freedom, his enthusiasm. Greece seemed as incredible to him as Palestine— that is to say, to his surprise he found in it a similar fusion of live and real elements with everything one could know or imagine about the past and myth. Athens was a new Jerusalem; the Acropolis and the Temple were the two pillars of the ancient world: two conceptions of life, equally true and complementing each other. In the colors of Greece Chagall also discovered something phosphorescent, a brightness similar to his impressions of Galilee. Part of this feeling of being refreshed passed into the etchings for the Bible, which he resumed and completed after his first trip to Greece.

Chagall is profoundly receptive to new impressions. Without doubt, the secret to his artistic achievement is related to his ability to keep this spontaneity, this freshness and openness, despite that fact that he already has a body of such complex work behind him and still has so many projects to carry out in the future. While an impression is still vivid he immediately begins a series of sketches which may or may not be finished but which already contain their essential movement. Hidden in reserve in his workshop are many sketches waiting for the right moment to emerge into the open and be usefully resumed and completed. In the meantime the received message may be transformed, may become tragic or gay, no doubt responding less to the accidental events of life than to the deep meaning it has borne inside itself since its reception, and which the painter himself begins to understand only after a long time.

Perhaps Chagall never felt such a direct shock, with the intellect playing so small a role, as that which he experienced in Greece. He thus certainly captured the spirit of Longus's pastoral poem, the feeling of youth and the innocence of a world without sin. A long voyage took him around the islands, each of which, enveloped by sea and sky, bathed in the same blue whose intensity alone varies, has a richness resembling Eden. A few works from this period permit us to follow the artist's method. First, drawings full of precise notations are made: temples emerging out of the ruins of broken stones, towns rising in tiers above the sea. Then other drawings, in which greater emphasis is placed on a line of prevailing color, divest the landscape of its accidental features, show it in its original purity, waiting, ready to become the setting of a new and eternal mythology: a hill with its vines, a little cove in the evening. The vision soon takes on form between the first planes of the foliage. The outlines are harder, more absolute than in reality; supple extended bodies, prolonging the rhythms of nature, appear in the large compositions; the tone is firm and controlled, and gouache is employed to enliven and brighten the pastel.

A second trip allowed Chagall to broaden and deepen this experience. The decor became richer, the themes more lyrical, the perspective widened, and other islands appeared, characterized by more fluid colors. Great multi-colored flowers and baskets of marvelous fruits blossomed in nature, and a huge Bacchus-like sun filled the sky, a red face with curly green hair. Under a dazzling light full of lunar reflections, the painter saw living gods surge up; the enlaced forms of gigantic couples rose above the mountains or, taking the form of boats, dwelled in troughs between the waves.

It is the beginning of a world and, without doubt, the start of a new blossoming of the great painter's work.

From Prisme des Arts, *no. 15 (Paris, March, 1956).*

Jean Leymarie:
THE MAGIC CIRCLE

...Chagall's art revolves around the mythical and supernatural world of childhood, whose mystery is destroyed by adult intelligence. There are two prevailing themes to his work, the Circus and the Bible, which are developed in true cycles, in organically linked units in which each element stands by itself in relation to the whole. Brought up in a pious family in one of those modest Eastern European Jewish communities strongly impregnated with Hasidic mysticism, Chagall has always had an intuitive knowledge of the Bible which naturally gives him access to the sacred. For the Jewish people, the Bible represents the complete historical and transcendental cycle that subjects the concrete particularity of individuals and events to its ultimate end. The symbolic creation of Chagall tends to be identified with this turning biblical space where everything has an echo and which reflects and justifies in its course all human experience. Since 1950 he has executed a grandiose series of seventeen thematically arranged paintings that form the *Biblical Message* he gave to the State in 1967, and which will be housed in the "place of devotion" being built for it on a hill in Nice. It is striking to observe that, while twelve of the paintings refer to distinct episodes in Genesis or Exodus, the Song of Songs has five successive versions....

Like many Jewish artists and thinkers, Chagall has been deeply moved by the solitary image of Christ assuming, beyond dogmas, the highest humanity; by dying, His arms spread out on the Cross, in a supreme gesture of love and sacrifice, He ushers in the fullness of reality redeemed. For Chagall, Christ is, in his words, "The man with the deepest understanding of Life, a central figure in the mystery of Life." The theme of the Crucifixion appeared for the first time in 1909 and was crystallized in the mysterious masterpiece of 1912, *Golgotha*; for Chagall it combines the symbols of the Old and the New Testaments and incarnates, starting in 1938 with the poignant *White Crucifixion*, the tragedy of the world.

Chagall is without doubt the only artist of stature in our age who has resumed an uninterrupted tradition and drawn from the Bible with such scope and continuity. On the other hand, all the great contemporary painters are excited by the ritual of the circus in which they see a metaphor of the world and a reflection of their own activity. Without being able to explain why, Chagall feels, as Rouault did, the deep relationship that exists between religious and circus subjects. Sitting next to him at a circus is as revealing as watching a bullfight with Picasso. In Russia the circus has always been very popular. "The strolling acrobats," wrote Franz Meyer in his basic monograph, "were without doubt the first 'artists' Chagall met, the first beings whose special knowledge made them able to give form to the wondrous." The circus ring is the magic circle that denies gravity and creates within the limits of strict discipline a total freedom of movement and feeling. Circus scenes appear in Chagall's work in 1913, become more frequent in 1927 and 1937 and since 1956 form a continuous cycle parallel to that of the Bible; works like *The Big Circus* and *Traveling People*, done as recently as 1968, also belong to this cycle.

Circus animals have a symptomatic place in Chagall's mythology. The cow and the goat appear mainly in works done prior to 1914, the donkey and the horse after 1924, and since 1928 the cock and the fish predominate, mutually linked by their cult value and opposition, sun and moon, water and fire. Chagall believes in the reconciliation of the wild animal and all creatures in the Messianic kingdom prophesied by Isaiah; he revives as well the world before the Fall, the "primitive and maternal Nature" Mircea Eliade talks about, when man lived familiarly with the animals and understood their language.

The flowers also have their language which is that of love and the paradisiacal hymns. "I just opened the window of my room," Chagall said at the time of his betrothal, "and the blue air, flowers and love filled it." Since his childhood in Russia, he has constantly and everywhere painted flowers, incarnations of color and love's messengers. But, as he himself admits, their meaning was only fully revealed to him in the Mediterranean area, first in the south of France in the spring of 1926 and later in Greece in 1952 and 1954. Initially, placed in a window—another recurrent motif—they acted as mediators of the landscape, between near and distant space, but eventually they signified the landscape itself and, blending with the lovers and the flying figures, they wove the entire space with their luminous emanations and the soft emotions they give birth to. "What joy," wrote Jean Paulhan, "and how far it reaches! It is as if he were not ashamed to tell us what in fact we all think, what we never cease imagining. He himself is totally surprised: wonderstruck. However, it is not the satisfied, sensual joy of a Rubens or a Renoir but bears within it some indefinable melancholy, as if Chagall were sorry to have cut the flowers." This joy, constantly benign although somewhat tinted with a secret nostalgia, isn't it what man has called happiness? In a time of crisis and rupture, Chagall has preserved its secret.

Vava and Marc Chagall *(Photo Daniel Frasnay).*

From the preface of the catalogue for the Marc Chagall Retrospective at the Grand Palais, Paris, Dec., 1969-March, 1970 (Paris: Editions Reunion des Musées Nationaux, 1969).

THE APOCALYPSE ACCORDING TO MARC [1]

Aragon

I

By what name as fire comes out of flint
By what cry as fear comes out of the throat
By what blood as sorrow comes out of the child
Do you call this sombre redness divided between heaven and earth?

Houses are made for their ashes
Happiness for the great smoking coals
Everything falls into pieces, both life and the garden fence
The blueness of tears is nothing more than a pool of little streets
From far away, high up in the crimson sky death comes
An implacable idea you can hear growing with
The redoubled noise of clogs
The sparks of the paving stones
The cruel wind that seems to laugh
And suddenly rears in the trees
At its feet life bleeds with the daisies
Will it always be so but that
Is the way it is

II

What was the painter dreaming of, for how long
Had he been imagining, since ancient times
The times beyond, the destined times?
 He whose heart
Seems to be a violin on wedding evenings
In a tiny village about to fall asleep on the edge
 of the deep blue night
The moon has already risen but there is still
 a little daylight on
The flowering tree and the horse's nostrils
Here only the flowers whinny that were cut in the skies
A couple high above the world perpetuates
The mute song of loving
 Perhaps
Somewhere that no longer exists, a place
Of words abandoned at the bottom of old dictionaries
Perhaps the painter's mission was to put
Clumsy bouquets in a blue vase on a table
And nothing else except to walk along the roofs like
a song

III

We were not given a chance to choose the setting of life
Neither the season nor the calm of the prairies
Painting, like people, has seen so much that it is stretched apart
And as far as the centuries reach this one only sees
Details of martyrdom and the destruction of man
You only reflected people hounded by a divine whip
Houses ripped open like a belly and the hour trampled
Woman after the soldiers have passed through
The soiled dream, the convoys of despair
The scarecrow after the massacre arms stretched out
The only conscience still standing
You paint what you see like an apple on the table
The Crossing of the Red Sea or the angels
Preaching at Abraham's where the floor is the color of a butcher's shop
For you narrate the Bible better than anyone
And do what the priest was told
If the wound is leprosy he washed it in vain
As only fire can purify
Painting evil so that it disappears from the earth
You paint the prophesied torture and punishments
The war of Kings and the tempest
The pest and its black sails in the harbor
I could recount here the thousands of pictures
You would paint tomorrow if only the imagination
Used for killing were as quick as your brush.

[1] Two gouaches for *Le Cheval roux ou Les intentions humaines*, by Elsa Triolet (Paris: Œuvres romanesques croisées, Vols 21 and 22).